W9-CIO-862

PAINTING
IN
WATERCOLOR

THE ARTIST'S HANDBOOK SERIES

PAINTING
IN
WATERCOLOR

KATE GWYNN

CHARTWELL
BOOKS, INC.

A QUANTUM BOOK

Published by Chartwell Books
A Division of Book Sales Inc
114 Northfield Avenue
Edison, New Jersey 08837
USA

ISBN 0-7858-0737-3

This book was produced by
Quantum Books Ltd
6 Blundell Street
London N7 9BH

Printed in Singapore by Star Standard Industries Pte. Ltd

CONTENTS

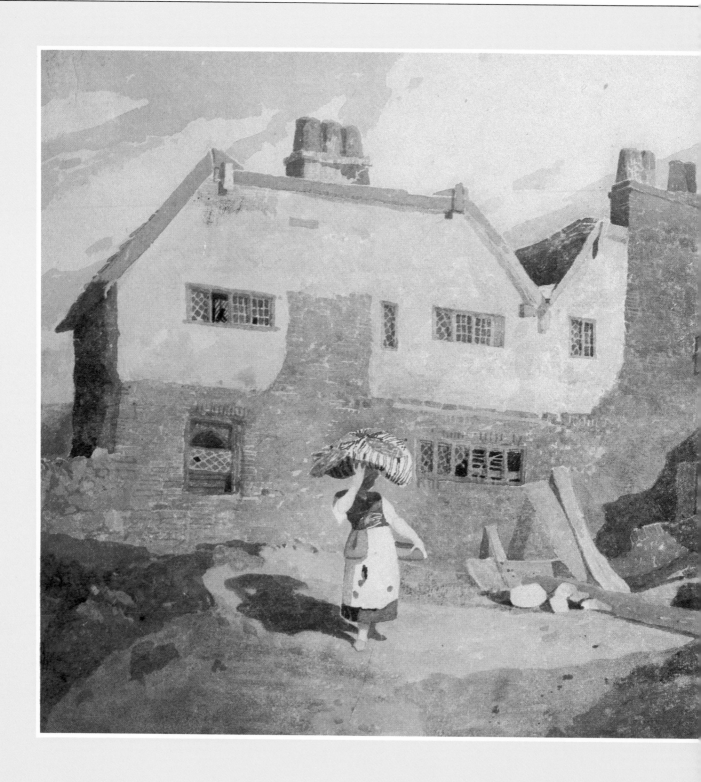

Above: The impression of sunlight in this watercolor, *Cottages with Washerwoman* by John Sell Cotman, stems largely from the vivid white in the clothing of the figure and the heavy cast shadow behind. From this focal area of the picture the tones spread evenly from foreground to background, heightened by the darkly shadowed patches at either side which enhance the warmth of the brickwork.

INTRODUCTION

WATERCOLOR IS one of the most attractive forms of art. As its name implies, it relies on water; it is a method of painting in which the pigments are transferred to the picture surface by mixing them with the liquid. Water is the vehicle used by the artist to control the paint; once it has evaporated the pigment remains behind as a stain on the paper.

Though it does not have the scale, richness or presence of oil paint, watercolor has always held a fascination for artists, so that there is a long tradition of Great Master paintings in the medium. One of the chief reasons for this popularity is its unpredictability; there is always an element of risk to be taken into account. Watercolor painting, therefore, provides a challenge which is constantly changing, requiring a high degree of practical foresight and the ability to make quick decisions.

HISTORY AND DEVELOPMENT

There are basically two types of watercolor painting – the classical watercolor, and gouache or the opaque method, also known as body color. The results produced by the two methods are very different, although many artists prefer to mix them, or to use them in conjunction with other mixed media.

The main characteristic of the classical watercolor is the transparency of the various skins of paint laid as washes over each other on a white or near-white support. Transparent colors are composed of pure pigment mixed with a little gum arabic to make them adhere to the surface of the paper. This transparency allows the white of the support to shine through, thus producing the characteristic clarity and lucidity associated with the technique. By overlaying one wash on another, the underpainting is qualified by the subsequent layers and infinitely subtle variations of tone and color can be produced as a result. Furthermore, no matter how lengthy, intricate or elaborate the picture may be, the prized quality of freshness can be retained.

Transparent colors can be adapted to make them more opaque by adding Chinese white, but opaque colors proper, sold as 'designers' colors', are composed of pigment and gum mixed with a medium which enables them to cover the surface completely. This means that the same result can be obtained on black paper as on white. The thickness and opacity of this gouache can be modified by the addition of water, even when it has dried onto the picture surface. This makes correction and adjustment easier. For the same reason it is also possible to use the reverse process from that used in classical watercolor – in

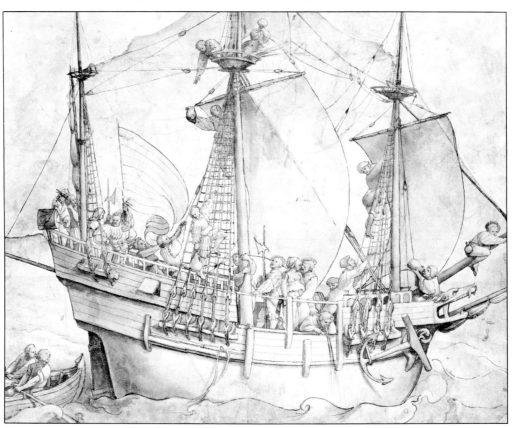

Above: This drawing by Hans Holbein, *Ship with armed men,* is delicately colored, mainly with monochrome washes of paint. The carefully judged tones give substance to the figures and clarify the complex linear drawing which describes the structure of the ship. A hint of local color is included in the clothing of the figures and the surrounding sea.

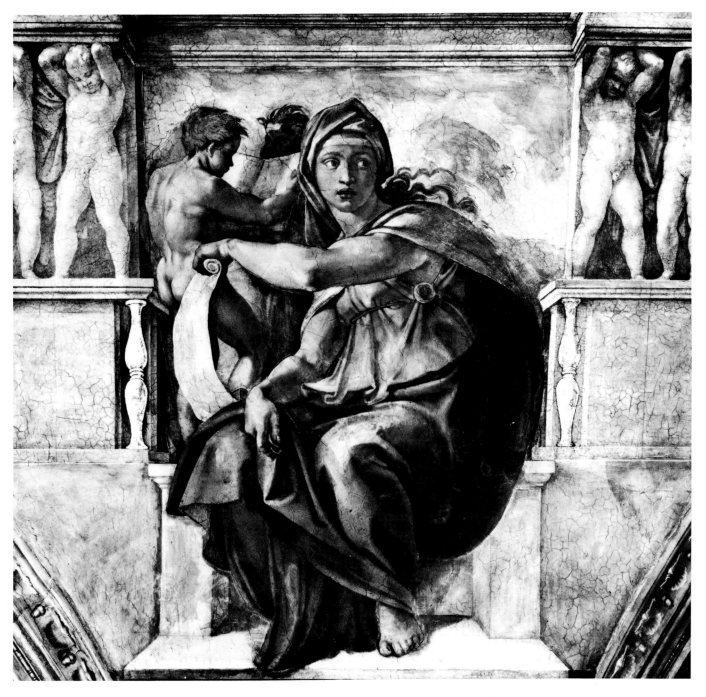

Above: *The Delphic Sybil* is a detail from one of the finest examples of fresco painting, the ceiling of the Sistine Chapel, a vast work by Michelangelo. Fresco is akin to watercolor in that the paint is laid in thin washes of liquid color. However, it is applied to fresh plaster and as the plaster dries a chemical change occurs which fuses the color into the surface. The technique is laborious and is little used by contemporary artists.

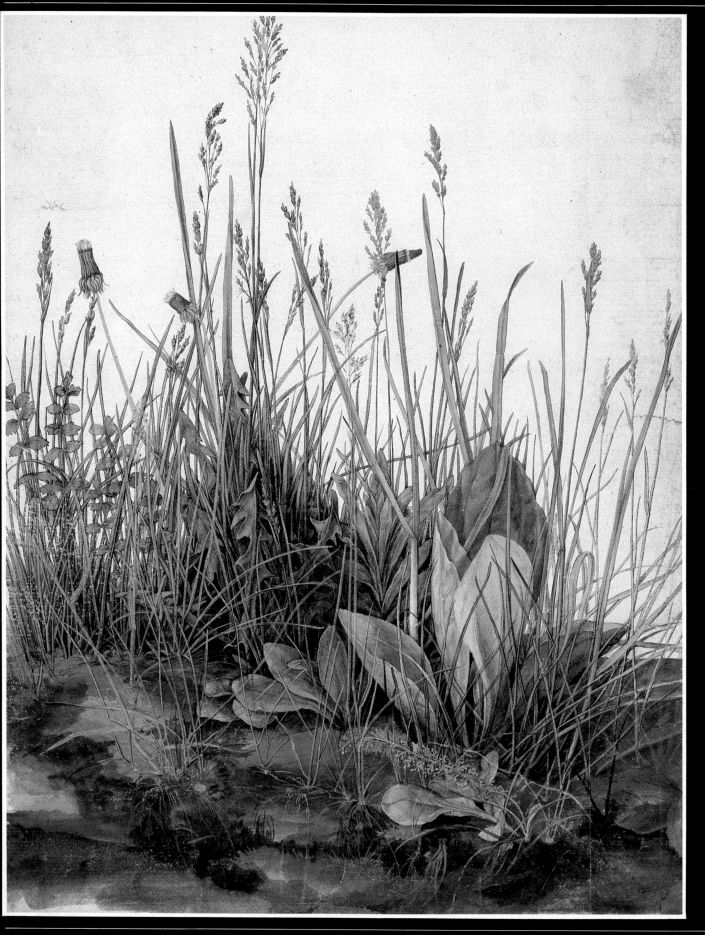

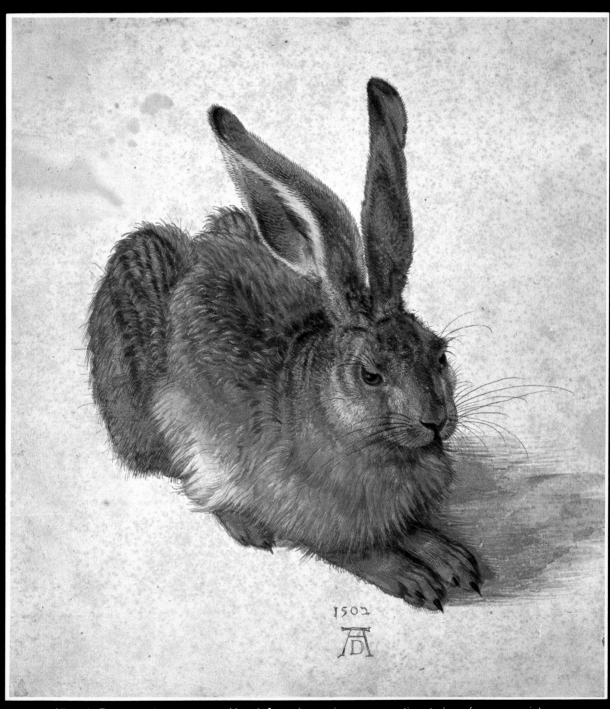

Albrecht Dürer used watercolor extensively and was one of the first artists to appreciate fully the subtle efficiency of the medium in rendering effects of color and atmosphere. *The Great Piece of Turf* (**left**) and the *Young Hare* (**above**) are prime examples of his painstaking technique and have achieved a classic status among studies of this kind. The combination of thin washes of color, line drawing of remarkable delicacy and details overlaid in tiny strokes of opaque paint forms a comprehensive translation of the natural tones, colors and textures in the subjects.

other words painting from the darker up to the lighter tones as well as from the lighter to the darker, which allows greater technical flexibility and requires less foresight.

Gouache can be applied in a variety of ways: in solid touches; dry and thick; in wet, opaque washes over large and small areas; as thin, semi-opaque skins, often effectively overlaid on even thinner washes. Its range and diversity extend beyond those of oil or pure watercolor. It is particularly useful for either quick rapid studies, where its opacity makes correction easy, or long drawn-out paintings which require much elaboration. Body color has as one of its main characteristics the ability to be laid in very flat clean washes which reproduce extremely well. It is therefore often used for illustrations for full color reproduction in magazines and books. It is commonly used by airbrush artists as the pigments are less finely ground and are less likely to clog up the brush.

The support

The nature of the surface to which the paint is applied is a highly important factor. A wide range of papers is available, from machine to hand-made, differing in weight, color, texture and, naturally enough, price. The choice of support depends on an artist's personal likes and dislikes, style and pocket. But it must be remembered that whatever support is selected, it has a significant effect on the result in pure watercolor painting.

The brilliancy of pure watercolor arises from the fact

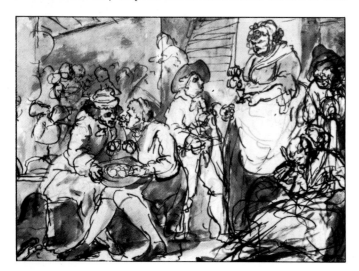

Above: A delicate watercolor wash has been laid over ink line to capture the robust atmosphere of this tavern scene by William Hogarth, the 18th-century painter famous for his depiction of moral scenes.

that transparent colors never quite hide the white surface of the paper; a full tint of any color shows darker than a thin tint only because less of the white ground shows through. A coarse granulated paper causes wet paint to precipitate into the valleys and gulleys of its surface, whereas a smooth surface such as gesso or white card allows the paint to slither across the surface, giving a totally different effect. A good white hand-made paper allows minute areas of white paper to reflect more white light, enhancing the luminosity of color, and is generally found to be the most suitable support for pure watercolor painting.

When using gouache, the choice of support is far wider as the translucence of the paper is not a prime factor; if it is to be completely covered by thick layers of gouache then it does not really matter whether the paper is black or white as either will be obliterated by the opacity of the paint. But good use can be made of the paper, either to tone the semi-opaque washes or as an element in its own right. The range is extensive and it is worth experimenting with different textures and tones. Papers such as Ingres and Michallet are often used, becoming an integral part of the composition, while manila wrapping paper or rough unsized cardboard with a thin coat of gum to prevent the paint penetrating are more unusual alternatives.

A long tradition

Watercolor is the oldest medium known to artists. In prehistoric times the cave painters of Altamira and Lascaux were grinding with water reds and ochers from the soil and black from the carbonized wood from fires to enliven their depictions of bisons and other beasts. Many of the ancient civilizations used pigments ground in water and bound with either gum, starch or honey to record great and everyday events.

As far back as 4500 BC the painters of ancient Egypt were using a watercolor-on-plaster technique, known as fresco, to decorate the inside of their tombs. They painted in flat colors, predominantly red, yellow or brown ochers, the intensity of which diminished the more they were diluted.

Another great flowering for the medium came with the work of the painters of 15th- and 16th-century Florence. Fresco, as used by the Masters of the quattrocento and cinquecento, reached a peak of creative imagination. One of the finest examples is the Sistine Chapel ceiling by Michelangelo (1475-1564), which is, without question, one of the world's greatest watercolors. Nevertheless, despite its long history and use by such distinguished artists

Above: The British painter John Constable worked continually out of doors making sketches in watercolor and oil paint which supplied the information for his major works. This study of Dedham Church makes use of a dramatic tonal emphasis to create atmosphere. A vivid impression of the natural light emerges from the overlaid washes.

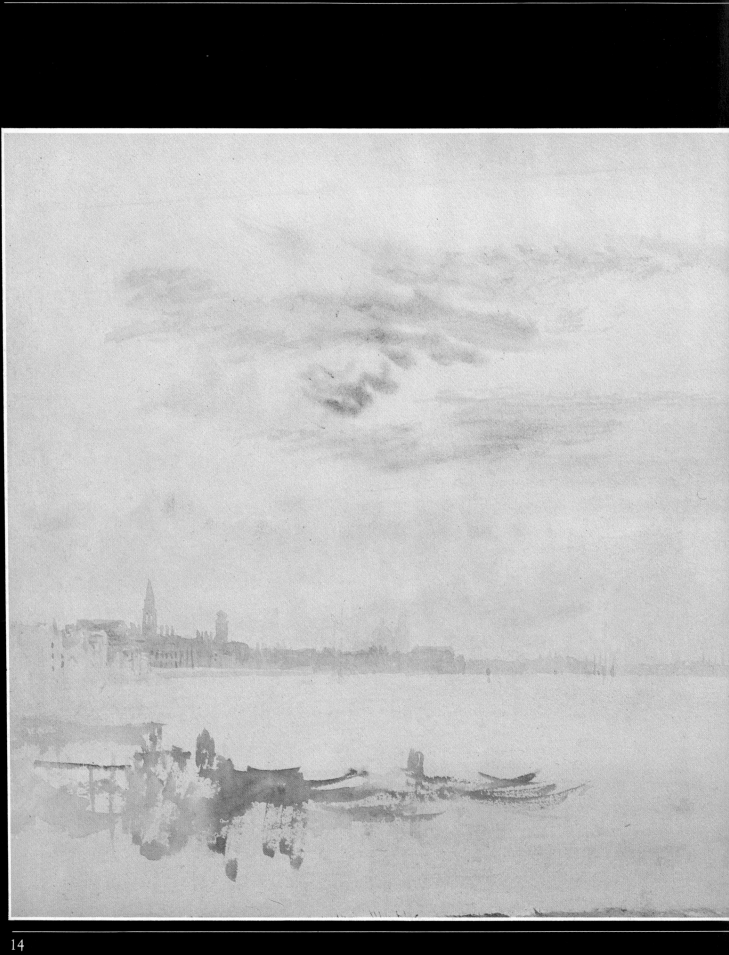

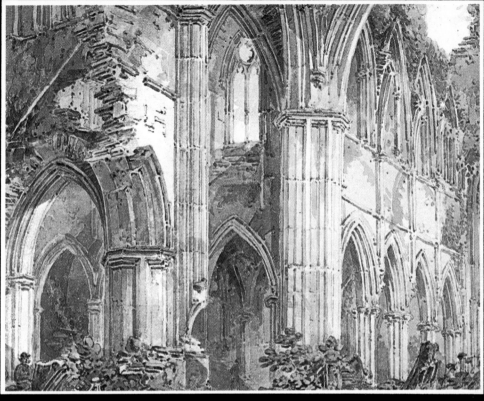

The extraordinary variety in the watercolors by J.M.W. Turner is a testament both to the versatility of the medium and to his own powers of observation and technical skill. In topographical and architectural studies he was capable of portraying a complex subject with methodical intricacy. The detail from a study of Tintern Abbey (**above**) shows a careful handling of tone in overlaid washes of warm and cool color which gives depth and texture to the stone edifice. Patches of bare paper provide the highlights and the merest tint in the pale tones is illuminated by the white support. This forms a notable contrast with the atmospheric treatment in *Venice from the Guidecca* (**left**) in which the sense of distance is created with thin layers of paint, quite even in tone, with a heavier build up of color suggesting details of buildings and small boats. This economical use of the medium presents a more personal vision than the faithful representation of the abbey. From an early stage in his career Turner found it easier to sell watercolors than oil paintings and much of his work was commissioned. In later life he used his command of watercolor technique to investigate color theory and an experimental approach to composition.

CLXXXI

as Dürer (1471-1528) and Rubens (1577-1640) watercolor was used in the main for sketches on which more important oil paintings would later be based.

The English landscape school

During the 18th century, the painters of the English landscape school of painting thoroughly exploited the possibilities and resources of watercolor. Paul Sandby (1725-1809) and John Cozens (1752-99) are notable examples, and J.M.W. Turner (1775-1851) and John Constable (1776-1837), the two greatest masters of English landscape painting, made it evident that the medium was capable of a surpassing power and lyric beauty. John Sell Cotman (1782-1842) used the classical method with great skill and sensitivity, the feeling of monumentality in many of his works belying the smallness of scale. Any Cotman painting shows how important is his ability to assess tone. Using a very limited palette, in common with many of the Old Masters, he conveys a sense of airiness and grandeur to the English scene.

Although most fine watercolorists painted landscape, it was by no means the only subject considered suitable for the medium. Many of the landscapes could be transformed into mythological or biblical studies by the addition of relevant figures, while the sea has also been a starting point for many great watercolorists. Somehow the free flow of watercolor washes captures the roar and swell of the waves, or the sea's vast flat wetness. Other subject areas are equally suitable for both watercolor or gouache – still life portraiture and figure compositions among them. Dürer examined carefully the detailed world around him (*The Clump of Grass* is a prime example); Graham Sutherland (1903-80) used watercolor to create a sense of Celtic magic; Thomas Eakins (1844-1916) graphically captured the tension and drama of competitive rowing. All such examples are worth studying, not simply for an insight into technique but also to see how far a great Master can stretch his materials to create the end result he is determined to achieve.

New developments

Watercolor is just as much a living tradition as a historic one. Every artist can break new ground and devise fresh techniques to bring novel, modern ideas to picture-making. Masking-off areas required to remain white, for instance, is now both easier and more effective than ever before. Masking fluid can be used as a resist, while Cellulose tapes have been devised to allow clean crisp edges when used as masking devices.

Spraying watercolor, as another example, was previously only possible through the use of a discarded toothbrush (or something similar) and a knife edge. By combing the surface of the toothbrush, previously spread with paint of the required color, a spattering spray could be spread onto

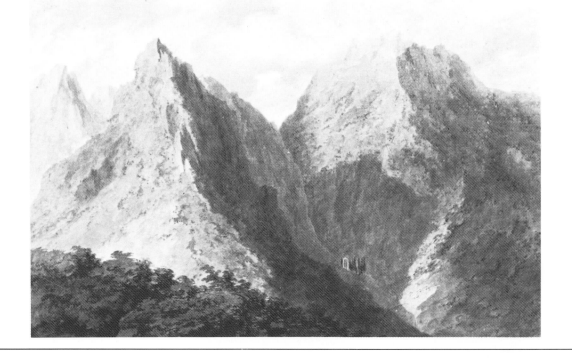

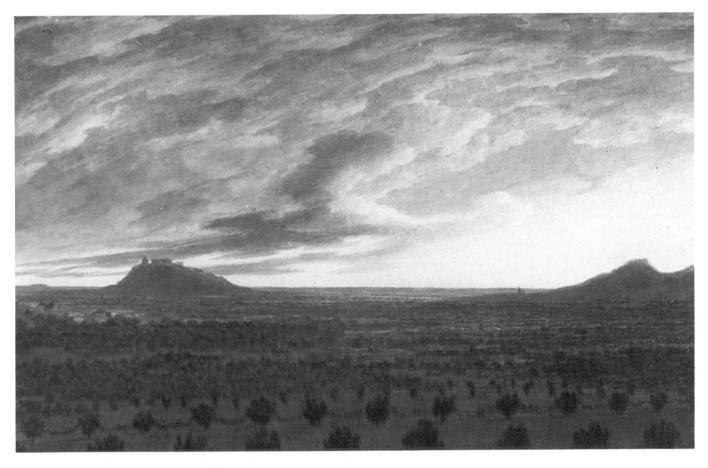

Two fine examples of the work of John Robert Cozens show his absolute mastery of tone and the use of a limited palette. Through watercolor sketches made during his travels in Italy and other parts of Europe he learned to record landscape atmospherically and in both these paintings there is a deep sense of grandeur, enhanced by dramatic treatment of the light in the sky and falling across the land. In the *View from Mirabella* (**above**) the two broad areas within the picture space are given texture and variety by the subtle dispersal of blues and grays. *View in the Island of Elba* (**left**) has a similar color range but more delicately handled to evoke the height of the rugged mountains.

the picture. Now, while this remains a useful technique, it has been largely replaced by the airbrush and spray gun. These instruments, using compressed air, discharge a fine consistent spray of this paint, creating an effect completely unlike anything that can be achieved by other means, especially in the blending of tones and the clear transparency of colors. This technique, together with others, designed specifically for commercial reproduction, has been adapted to fine art uses in modern times, thus extending the options available to today's artists. This blending of the best of old and new is one of the main reasons that one of the most traditional of the media flourishes in the third quarter of the 20th century.

Watercolor, then, is a medium of considerable flexibility and great character both in its classical role and as gouache. Whether fresh and crisp, allowing the whiteness of the paper to gleam through the pigment, with the richness of opaque washes smothering the surface with variable colors, or one of the many possibilities in between, there is no doubt as to its beauty and versatility.

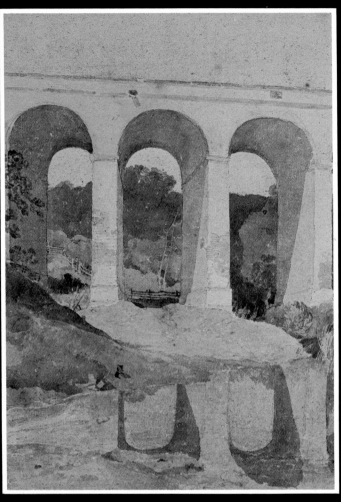

Strong architectural forms in a landscape setting enable the watercolor artist to make full use of the luminous tones and colors which the medium can provide. *The Viaduct* (**above**) by John Sell Cotman has a bold, symmetrical design and the warm color of the stone bathed in light is clearly described against more heavily shadowed areas. In *St Benet's Abbey, Norfolk* (**right**) also by Cotman the spacious feeling of the landscape is evident through the large expanse of sky and hazy blue tones of the distant horizon. The foreground is emphasized with warm earth colors but the blue used in the figures and the small area of water on the right of the painting echoes the sky and gives the image an overall coherence. The curious form of the broken stonework and the tall windmill rising into the sky provides a vertical stress, balancing the stark horizontal division of the picture plane. Layers of overlapping brushstrokes result in a dense textural effect in the foreground tones.

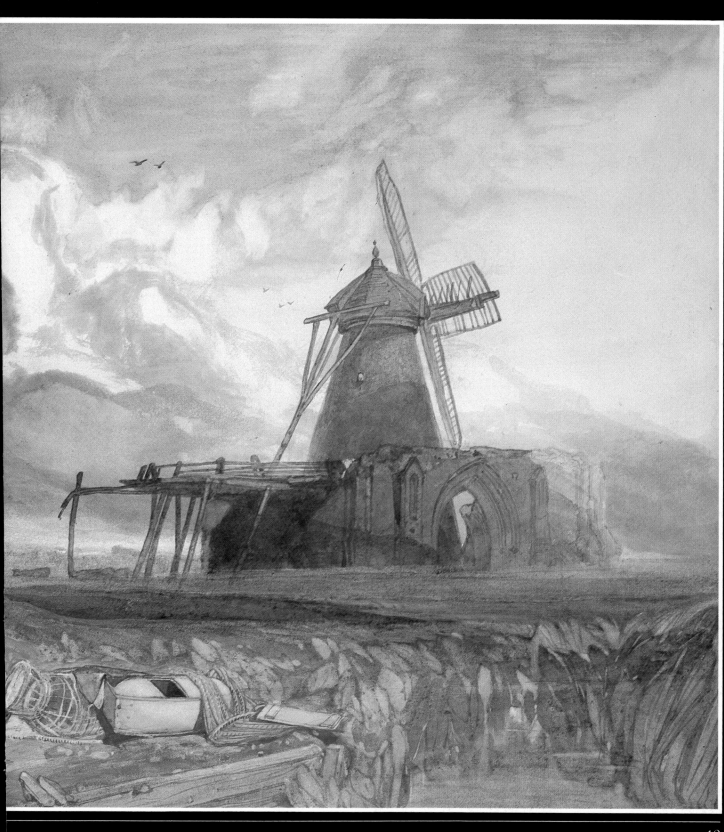

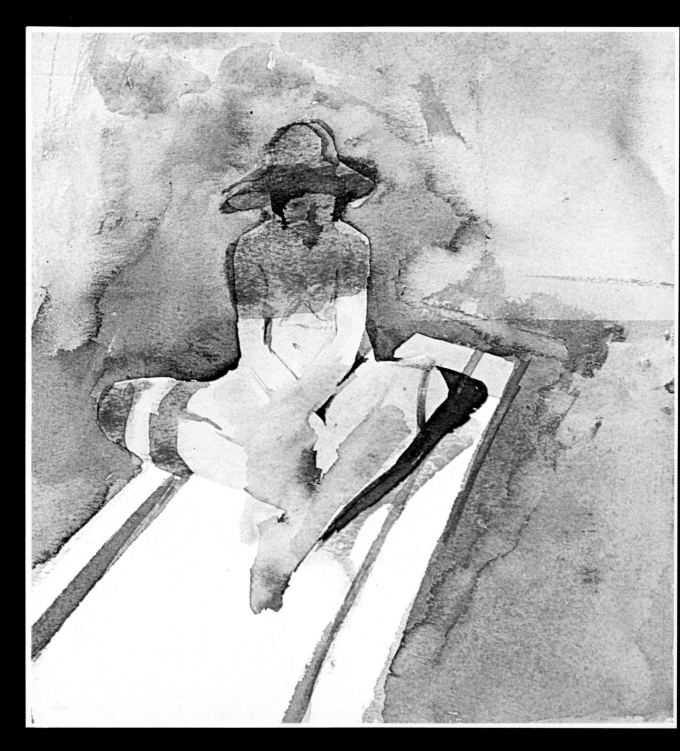

Modern watercolor artists are free from many of the pictorial restraints apparent in the work of their predecessors. *Italian Sunlight* (**above**) by Stan Smith, is almost abstract in its treatment of the figure as planes of light and dark tone formed from overlaid color washes.

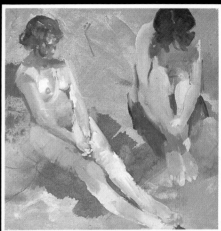

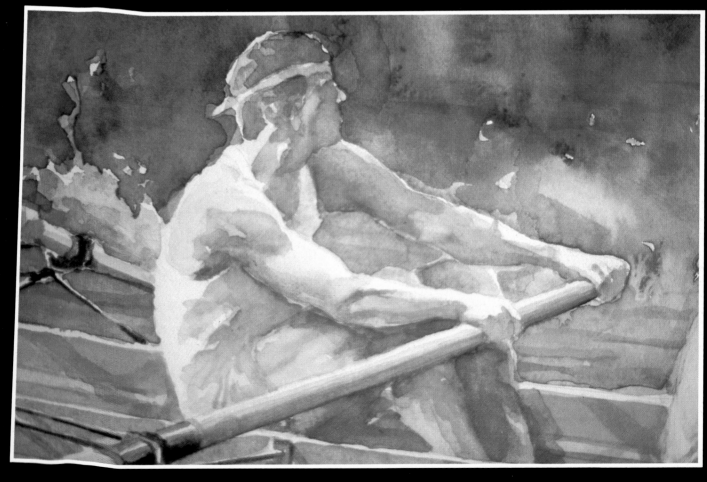

These three paintings show in each case a different approach to the medium. In *The Oarsman* (**above**), Marc Winer uses strong color contrasts and the quality of luminosity imparted by white paper to make a striking image. The nude studies by Stan Smith (**top right**) are on a ground tinted with gray and highlights were added with white. A gouache painting by Terence Dalley (**top left**) exploits the opacity of gouache in a detailed analysis of the scene.

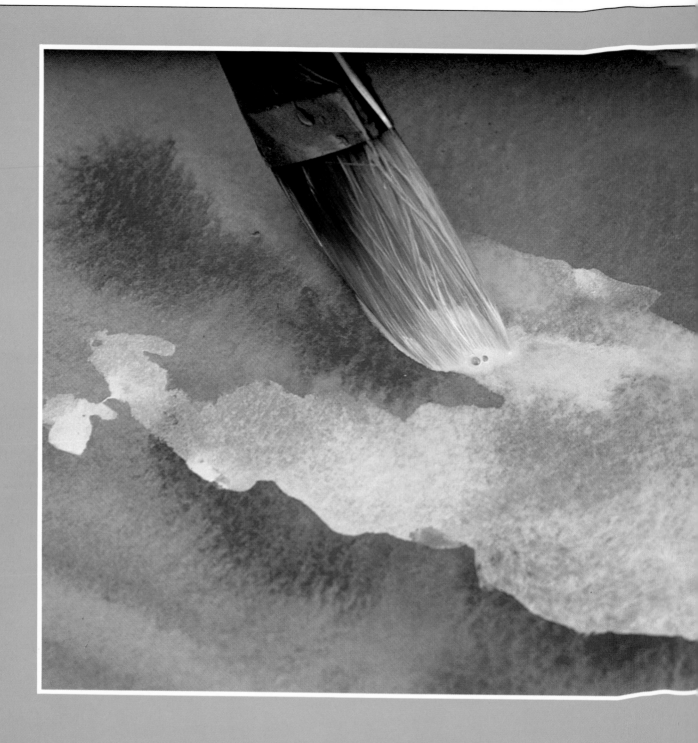

MATERIALS

THE THREE ESSENTIALS for painting in water-color are paint, brushes and paper. A bewildering range of paints is available; somewhere between 80 and 90 colors produced in a variety of forms. The artist of the past manufactured his own or bought his colors from one of the few specialist paintmakers.

All sorts of instruments have been used to manipulate color on the picture surface – rags, sponges, knives and fingers. But the most common way to apply color is with the brush. Traditionally these have been made with many different animal hairs but today synthetic fibres are available and are suitable for some purposes.

Paper is the surface used most frequently for making watercolors and it comes in a wide range of textures, sizes, thicknesses and tones. Colored papers are only really suitable for use with opaque paint, in other words for paintings in gouache; most watercolors, both from the past and by contemporary artists, are on white or light-toned paper.

Above: The requirements for watercolor painting are uncomplicated and readily available, but there is no limit to the range of effects you can achieve by combining these constituents in a variety of ways; no amount of experimentation can guarantee the same affect twice. Here two washes, green and blue, have been applied wet on wet so that they bleed then allowed to dry before the white is laid on top.

WATERCOLOR PAINTS

Watercolor is finely powdered pigment mixed with a little gum, usually gum arabic, until it is fully emulsified. Gouache, or designers' color, differs from watercolor in composition in that the basic color pigment has a mixture of precipitated chalk added to it before being bound with the usual solution of gum. These proportions differ from color to color. Postercolor and powder paints are cheaper forms of gouache but are of inferior quality to designers' colors and watercolors and therefore should be avoided. They lack the permanence and reliability required by artists and are mostly used by children in their classes at school.

Choosing paints

Designers' color is available in tube form, or gouache can be made by adding Chinese white to ordinary watercolor. The latter allows a greater range of transparency through to opacity than is possible with designers' color and produces softer, less chalky qualities. Pure watercolor is available in several forms; as dry cakes, in semi-moist pans or in tubes.

Bottled watercolors are concentrated and come complete with eye droppers so that they can easily be transferred to the palette. It is quicker to use this liquid color than dry cakes or semi-moist pans when a large area of wash is required.

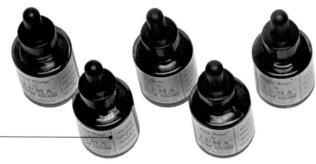

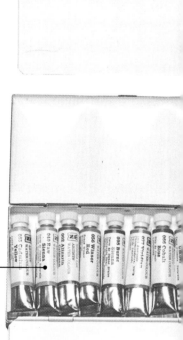

Dry cakes are the most traditional watercolors and contain the largest proportion of pure pigment. They have to be brushed with water in order to release the color, a fairly time consuming process which ensures that they are economical in use.

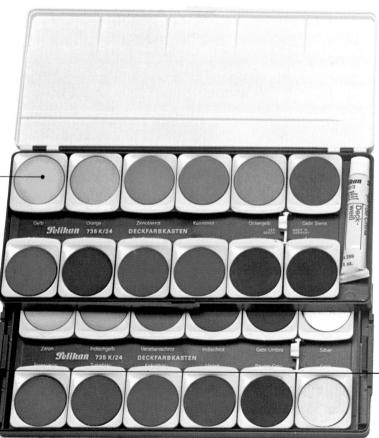

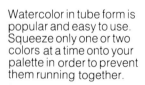

Watercolor in tube form is popular and easy to use. Squeeze only one or two colors at a time onto your palette in order to prevent them running together.

Dry cakes contain pigment in its most pure form, pans and tubes having glycerine or honey added to the mixture during the manufacturing process in order to keep the paint moist.

Selecting the most suitable kind of paint requires careful thought. Although the tendency is to find the type most convenient for your usual style and thereafter to use only that for all projects, it is a good idea to experiment with the difference between types. Pans and half pans of semi-moist paint, for instance are especially convenient for working

out of doors on a relatively small scale but will not necessarily prove ideal for an ambitious large scale work being developed in the studio. For the latter, tubed watercolor would be convenient for squeezing out in larger quantities.

Experiment with the entire range available, though in the long run you will probably feel at home with one type rather than the others. Above all, remember that the character of the painting will be affected by the paint used; dry cakes will need more water to release a strong stain of

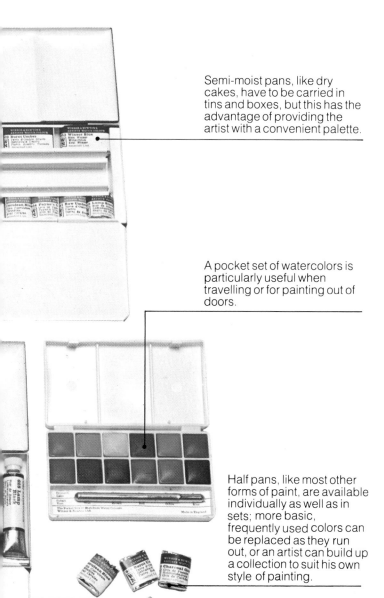

Semi-moist pans, like dry cakes, have to be carried in tins and boxes, but this has the advantage of providing the artist with a convenient palette.

A pocket set of watercolors is particularly useful when travelling or for painting out of doors.

Half pans, like most other forms of paint, are available individually as well as in sets; more basic, frequently used colors can be replaced as they run out, or an artist can build up a collection to suit his own style of painting.

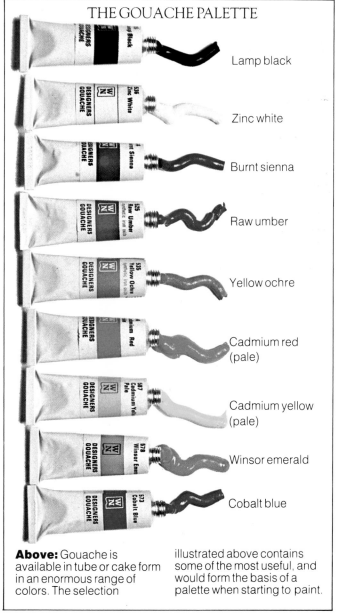

THE GOUACHE PALETTE

Lamp black

Zinc white

Burnt sienna

Raw umber

Yellow ochre

Cadmium red (pale)

Cadmium yellow (pale)

Winsor emerald

Cobalt blue

Above: Gouache is available in tube or cake form in an enormous range of colors. The selection illustrated above contains some of the most useful, and would form the basis of a palette when starting to paint.

GENERALLY AVAILABLE COLORS

Cadmium Red

Alizarin Crimson

Light Red

Rose Madder Alizarin

Venetian Red

Lemon Yellow

Cadmium Yellow

Permanent Yellow

Yellow Ocher

Viridian

Hooker's Green

Terre Verte

Cobalt Blue

Prussian Blue

Cerulean

Ultramarine

Cobalt Violet

Burnt Umber

Raw Umber

Raw Sienna

Burnt Sienna

Ivory Black

Payne's Gray

Chinese White

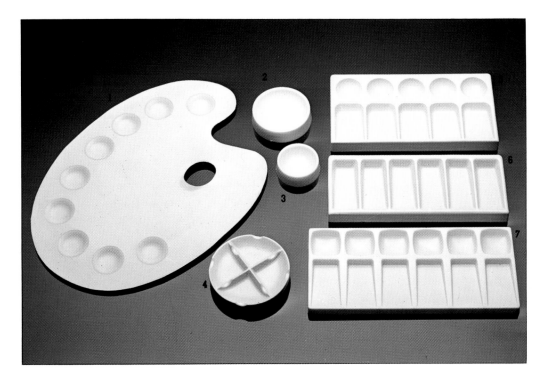

Left: Recessed or well palettes should always be used when mixing watercolor as they allow water to be added as required but prevent the colors running together. It does not matter what material the palettes are made of; ceramic, metal or plastic are all suitable. They can be bought in a variety of sizes and shapes; it is really a matter of personal preference which type is used. Small pots (**2,3**) can be used to mix each color or palettes with separate wells (**4,5,6,7**) are ideal for several colors; these are all particularly suitable for studio work. For painting outside, where flat surfaces may not be available, the traditional kidney-shaped palette with the thumb hole for easy handling (**1**) is particularly useful. Ordinary plates and saucers are perfectly all right to use as additional palettes.

pigment than will tubes and the semi-moist pans stand somewhere between these two.

Effects of climate

It is now almost universal practice to use only water as a vehicle, but certain other liquids have been used in the past and can be adopted under unusual conditions. A painter working under a very hot sun will find that his colors become almost insoluble and that color placed on the paper dries so rapidly that he cannot manipulate a wash. In this case he should add glycerine to the water (in the past calcium chloride, gum tragacinth and fig juice have been employed for this purpose). If the climate renders semi-moist pans too wet and makes them inconvenient to transport, substituting dry cakes of paint could possibly be the best solution. To accelerate drying, alcohol can be added to the water; in the 18th century it was quite usual to add a little brandy or gin!

Practical considerations

When using whole or half pans of paint it is essential to store them in a suitable container, preferably a metal box with slots to hold the pans in place. The boxes available in artists' materials stores are cunningly designed so that in addition to this function they also open out into a palette,

thus providing the surface upon which washes can be mixed, colors considered and various suspensions of paint in water tried. Tubed colors demand a different method of transport. Any bag or box will do but some form of palette is essential and it must be big enough to allow plenty of space between the fat worms of squeezed paint. This helps to avoid the irritation of the slightest tip causing colors to run together and form a rainbow.

As another precaution, limit the number of squeezes put out at any one time; since the wash technique tends to lay one color in all the appropriate areas before another is mixed, one color at a time may possibly be all that is required.

Price, permanence and quality

Variations in cost of watercolor paints are largely explained by the sources of pigment. A very wide range of colors is used and some of the traditional raw materials are surprising; cow excreta and burnt tar are typical examples. Today, with the benefit of modern techniques, most of the organic pigments are derivatives of coal tar and they tend in general to be rather more permanent than their predecessors.

Permanence is a quality much prized in watercolors and all reputable manufacturers grade their paints. Winsor and

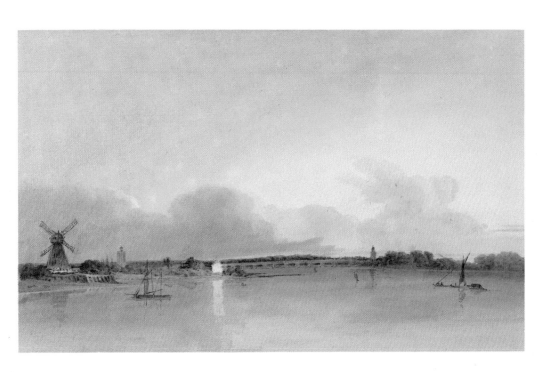

Right: The use of a limited palette provides good exercise in the assessment of tonal values and an opportunity to experiment in color-mixing. In this painting, The White House, Chelsea, by Thomas Girtin, the artist has succeeded in creating a rich variety of tone and color from a basic palette of Raw Sienna, Burnt umber and Prussian blue. The addition of, for example, Viridian to these three colors would considerably extend the range of tones available. By this type of self-imposed discipline, you will be able to discover your own preferences and learn to exploit color fully, even under such restricted circumstances. The extended palette (**far right**) will provide a comprehensive selection of hues.

Newton, Rowney and Grumbacher classify their artists watercolors in four degrees of permanence.

DEGREES OF PERMANENCE

Class AA	Extremely permanent (24 colors)
Class A	Durable (47 colors)
Class B	Moderately durable (10 colors)
Class C	Fugitive (6 colors)

The majority of colors fall into the second category; this presents the artist with a wide range and with reasonable care the colors are perfectly reliable. Fugitive colors, on the other hand, fade away in a short time.

Watercolors are sold in two standards – artists' and students'. Although students' colors are perfectly reliable, money buys quality and the strength and durability are not comparable with those of artists' colors. All watercolors will pale if exposed for too long to sunlight; advice on looking after your paintings is given in the final chapter.

Limiting your palette

The enormous range of pigments available today makes it increasingly difficult for the watercolorist to choose colors for his palette. Even in 1800 regrets were being expressed by professional artists that too many colors existed which were quite unnecessary and confusing for the student; a good basic palette for a beginner might consist of Raw Sienna, Light red, Cadmium red, Winsor blue, Alizarin crimson and Sepia. Artists such as Thomas Girtin (1775-1802) and David Cox (1783-1859) both used just such a limited palette. Here is David Cox's description of the palette he used for a twilight landscape.

'The grey tint in the sky is composed with indigo and Indian red, and the horizon is coloured with light ochre; the distant mountain with indigo, finished with the same, mixed with lake, and a little Venetian red on the light sides; the nearer mountains, indigo lake and Venetian red; the Castle with the same, the rocks and foreground, lake, ivory-black and burnt sienna; the greens, burnt sienna, gamboge and indigo; the trees, indigo and burnt sienna, heightened with spirited touches of vandyke brown.'

These, among others, were the colors which David Cox taught his pupils to use: while they account for the general subdued tertiary subtlety of his lines and color schemes, the enormous range of colorings displayed in the nature scenes he loved so well can only be accounted for by his consummate skill in controlling the mixtures of his comparatively few color ingredients. With inexperienced colorists the practice of limiting pigments may result either in crudity or monotony, but skillful control of a limited palette can produce a painting which is a highly successful example of delicate balance and color harmony.

SUGGESTED BEGINNERS' PALETTE

Cadmium Red

Alizarin Crimson

Cadmium Yellow

Yellow Ocher

Cobalt Blue

Prussian blue

Viridian

Burnt Umber

Payne's Gray

Ivory Black

Mixing greens To say simply that green can be mixed from yellow and blue gives little idea of the range of colors that can be achieved. Some examples are shown here, with details of the colors used to mix them; other colors, particularly red and blue, provide similar variety.

Cobalt Blue and Cadmium Yellow

Cobalt Blue and Yellow Ocher

Prussian blue and cadmium yellow

Prussian blue and yellow ocher

Payne's Gray and Yellow Ocher

Payne's Gray and Cadmium Yellow

Yellow Ocher and Black

PAPER

Paper is available in a wide variety of weights, sizes, qualities and colors. With the exception of the paler shades, toned papers are seldom suited to transparent watercolor whereas gouache covers the paper completely so that the tone of the paper need not be taken into consideration unless areas are to be left untouched in any way. More exotic types of paper include rice papers, of which Kozo, Mutsumata and Gambi are the most popular. The surfaces are delicate, fragile and highly absorbent and experimentation will produce a technique which will make full use of these characteristics.

Hand- or machine-made

The best paper for watercolor work is hand-made from pure linen rag. Because of the skill involved in making it and the cost of the raw material it is expensive, but the price of such paper is reflected in the quality. The very best is made from 100% rag; all impurities are filtered out and the paper is sized according to the needs of the watercolorist. These papers are easily recognised by the watermark which can be read by holding the paper up to light. Great care must be taken to use the right side of the paper; this can be detected by the surface texture which in hand-made paper is more irregular than the mechanical surface of a mold-made paper which will show itself to have a strong diagonal pattern under close inspection.

Mold- or machine-made paper is cheaper and paper mills often sell off seconds which are quite satisfactory for most purposes. It comes in three different finishes, hot-pressed, cold-pressed or rough. Hot-pressed paper has a smooth surface which is more suitable for drawing than for watercolor as the surface will not take the paint readily.

Right: Texture is one of the main characteristics that will concern an artist when choosing paper for watercolor painting. Three types are available – hot-pressed, cold-pressed or 'not' and rough. Hot-pressed is the smoothest surface and is possibly more useful for drawing than for watercolor, though it does suit some approaches. It takes washes of paint very easily so might be useful for quick work, and it is also suitable for a style which requires fine detail. It can, however, quickly become flooded with paint, so the transparency of the watercolor is lost. Cold-pressed paper is probably the most popular surface. Rough paper has a definite tooth to it and when a wash is laid over it some of the deep cavities are left unfilled, giving a sparkle to the paint, with clear white paper showing through. It is not perhaps the ideal surface for a beginner. Good quality papers have a right and a wrong side; the right side is coated with a size which is extremely receptive to watercolor. A simple way of determining the correct side of the paper is to look for the watermark (**right below**) which is visible if the paper is held up to the light.

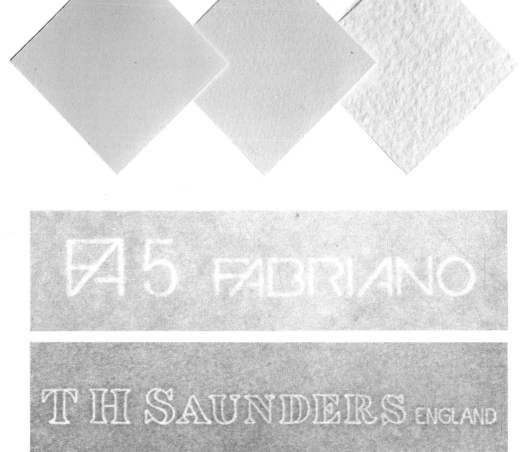

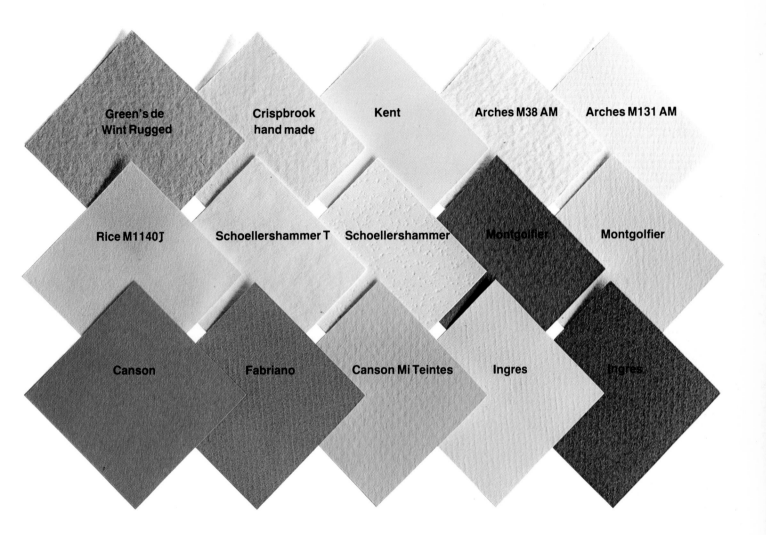

Green's de Wint Rugged

Crispbrook hand made

Kent

Arches M38 AM

Arches M131 AM

Rice M1140J

Schoellershammer T

Schoellershammer

Montgolfier

Montgolfier

Canson

Fabriano

Canson Mi Teintes

Ingres

Ingres

Above: The range of papers is vast and can be bewildering even for the practiced artist. In fact, choice is often narrowed considerably simply by the question of availability. If you are unsure about what paper will best suit your purpose, buy only a few sheets at a time; some specialist shops will provide you with samples.

As well as the matter of texture, discussed opposite, you will also have to consider what weight of paper to buy. Some of the heavier papers can absorb large amounts of water without buckling, so are particularly useful for outdoor work as they can be used without stretching. The heavier the paper, however, the more it costs. It is necessary to stretch lighter grades of paper before starting work.

Much watercolor painting is done on white paper, but toned papers are also available and can provide a good middle ground from which to work darks and lights; a good alternative to laying in a supply of toned paper is to lay a wash over your support before you start to paint, so that you have exactly the right tone for the painting you have in mind.

The established manufacturers make paper in a wide variety of weights, textures and tints some examples of which are shown above. There may be little to choose between, say, the medium weight 'not' made by one or another, or else you may find that one particular weight and type made by one particular manufacturer provides the ideal support for your style of painting. Whatever paper you buy, good quality will better withstand the use of very wet washes and correction and will be worth the money you have to spend.

Paper plays an important part in determining the effects you can achieve. Rough paper (**left**) is possibly the most interesting surface on which to work, but also the most unpredictable. A smoother paper (**below**) allows a more uniform wash to be laid but the effect will not have the same transparency and quality of reflected light as that caused by the white of the support showing through the paint-free bumps and crevices of a rough surface. Toned paper (**right**) provides the artist with a middle ground from which to work lights or darks and can either be bought as such in a wide variety of pale colors or produced at home by laying a wash over a white support. Many of the toned papers are fairly heavy and the prominent fibres provide additional texture.

Cold-pressed paper is usually known as not (in other words, not hot-pressed) and this together with rough paper is the most favoured of surfaces for watercolor painting. It is a textured semi-rough paper which is good both for large smooth washes and for fine detailing.

Rough paper, as its name suggests, has a much less smooth surface than not. When a wash is laid over its surface this rough texture causes some of the crevices in the paper to remain unfilled, presenting a speckled effect. While the aesthetic qualities of such a wash are pleasing and satisfying, the handling of such a surface is fairly daunting for an inexperienced artist as it is difficult to control. However practice and experimentation will reap rich rewards.

Grades and sizes

The grading of paper is by weight of the ream (usually 500 sheets). This varies from 40-44 lb (16.5-17 kg) for a lightweight paper to 400 lb (165 kg) for the heaviest paper. The weight is of great importance; the heavier the paper the more ready it is to accept water, and the lighter papers are in need of stretching before they will present a surface on which to paint (see page 45). Heavier grades of paper say upward of 140 lbs (65 kg) can be worked on without

stretching, but if the surface is to be awash with water at any time stretching might still be a wise precaution.

Cheaper papers such as cartridge are classified by the international A sizes; for the better quality hand-made and mould-made papers traditional sizes, listed below, are still used.

Antiquarian	31 x 53″ (787 x 1346mm)
Double Elephant	27 x 40″ (686 x 1016mm)
Elephant	23 x 28″ (584 x 711mm)
Imperial	30 x 22″ (762 x 559mm)
Half Imperial	15 x 22″ (381 x 559mm)
Royal	19½ x 24″ (490 x 610mm)

A good selection of hand- and mold-made papers is readily available from good art stores or direct from the manufacturers.

Apart from these more conventional papers, a variety of prepared boards are available as supports. These are simply ordinary watercolor papers mounted firmly onto stout card. Their advantages are mainly convenience, not only for transportation but also in that they dispense with the need for stretching paper. You can easily prepare your own boards by gluing paper onto a pasteboard, but be sure it sticks securely; if not, your paper will lift off the board as soon as it becomes damp.

BRUSHES

The best brushes are the most expensive, not only because of the type of hair used but also as a result of the need for secure construction. A typical watercolor brush has three main parts; the handle or shaft, the hairs and the ferrule or metal sleeve that attaches the hairs to the handle. In a good quality brush the ferrule secures the hair firmly. There should be no suspicion of individual hairs coming loose, indeed confidence that this will not happen is a prerequisite of peace of mind in watercolor painting. In general the cheaper the material used for the brush, the less strong will be its enclosure by the ferrule, resulting in hairs floating in the washes and irritation in executing detailed areas of the painting. As ease of man-

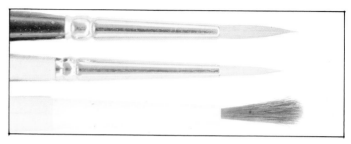

Above: There is a world of difference between the best and the worst type of brush. Best quality sable **(top)** is the most expensive and gives a much better point and lasts longer than a synthetic brush **(center).** No serious painter would attempt to use the type of cheap brush **(bottom)** sometimes found in watercolor sets.

Below: Round brushes are available in up to 13 sizes, but for most watercolor painters, four or five will be enough. The smallest size is usually designated 0, or 00 or 000, and the largest 8, 10 or 12 depending on the make.

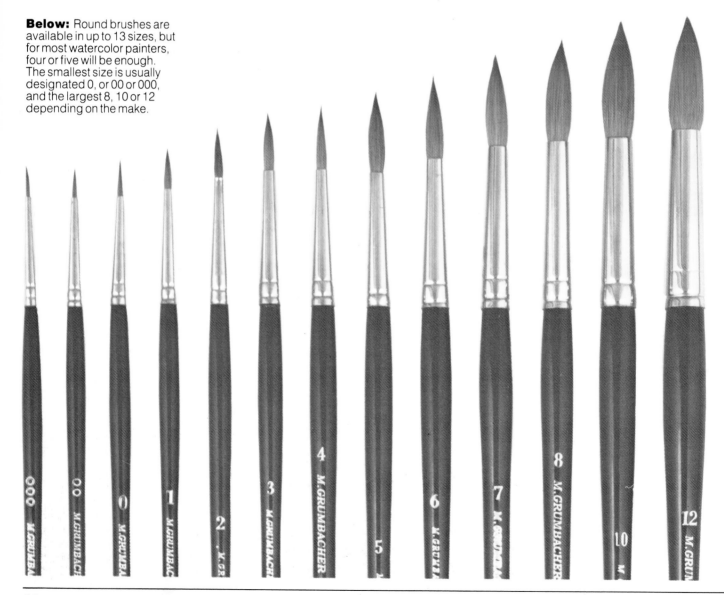

ipulation is essential, handles are always shorter than those of brushes used for oil painting.

Choosing your brushes

Only trial and error will show what size and shape of brush is most suited to your particular style. However, it is usual to keep a few larger brushes for laying on washes and a few smaller ones for putting in detail. Painters often use a particular set of brushes which then become shaped to their own hand. Peter de Wint (1784-1849) painted much of his work with only two brushes, one thick and stubby and the other finer which he squeezed between his thumb and finger to form a splayed end. After years of use these

brushes took on a particular character and would have been quite useless to anyone else. They would have been extremely good quality to have lasted such a time. The art of brush manufacture is exacting and the cost of skilled labor and rare materials means that good brushes can seem prohibitively expensive in comparison with cheaper versions. Nevertheless an expensive brush will last longer and looked after well will serve you better.

Maintenance

Never scrub hard with your brushes; if your technique demands that you do, use a strong or cheap brush which will either stand up to this treatment or not cost too much

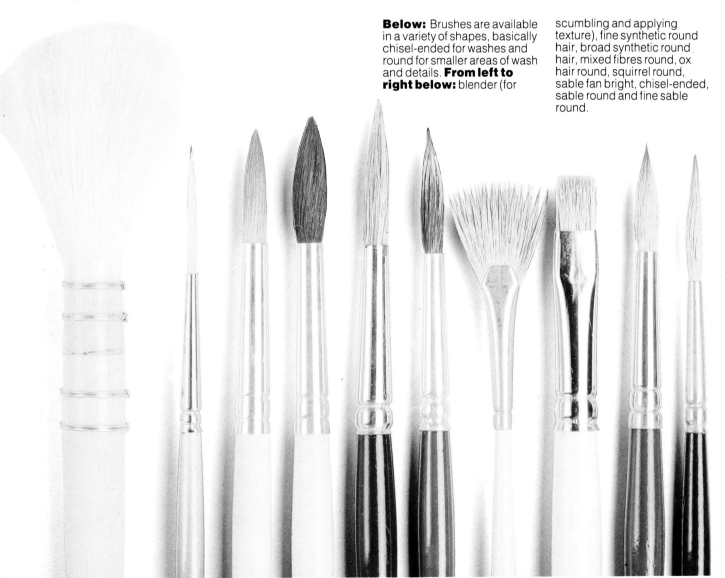

Below: Brushes are available in a variety of shapes, basically chisel-ended for washes and round for smaller areas of wash and details. **From left to right below:** blender (for scumbling and applying texture), fine synthetic round hair, broad synthetic round hair, mixed fibres round, ox hair round, squirrel round, sable fan bright, chisel-ended, sable round and fine sable round.

Left: Always keep your brush clean when not in use; leaving it dirty or with hairs downward in a glass of water are common mistakes. Rinse it out under running water to remove all paint. If the brush has become discolored or it still contains dried paint, a little soap should be used to clean it. The brush can then be shaped to a point either by putting between your lips or by gently shaking it. A good brush will easily regain its shape after being dipped in water and vigorously shaken.
Right: Make sure that all your brushes are thoroughly dry before storing them in a box or container as mildew can develop. If kept in a container – a japanned metal cylinder, a cardboard tube or a glass jar are all ideal – they should be kept upright.

to replace. Leaving brushes dirty when not in use is also a fairly common fault, as is leaving them hairs downward in a glass of water. Make sure they are thoroughly dry before putting them away in a box or container otherwise mildew will form. The traditional container for brushes is a japanned metal cylinder but a cardboard tube will do just as well. When cleaning your brush make sure that all the paint is removed. If the brush is discolored or the paint has dried into the hair then it may be more easily cleaned by using a little soap then rinsing out thoroughly under running water. Shape the brush naturally either between your lips or by shaking it gently to its point. A good brush will always come to a perfect point after being dipped in water and given one vigorous shake.

Types of brush
Watercolor brushes are made from many different materials. The kolinsky is a small rodent which is found on the borders of Russia and China and its tail provides the high quality hair, soft, springy and expensive, that is used in making red sable brushes. Only the extreme tip of the tail is used in the best brushes as the hairs feather off naturally to form a point. The hairs must all be pointing in the same direction and are graded and selected before being tied together in bunches, the longest hairs in the centre and the shorter ones ranged around it. The hairs are then glued to

the ferrule. Red sable itself is also used, together with oxhair taken from the ears of certain cattle. Oxhair on its own has more strength than sable and is more springy. It is therefore preferred by some artists, despite the fact that it does not produce such a fine point. Squirrel hair is used for relatively cheap brushes with neither the spring nor the fine point of red sable or oxhair. Other grades and mixtures are available, for example the cheaper camel-hair or synthetic brushes. Chinese and Japanese brushes are also obtainable, although not always suitable for a Western style of painting.

Brushes are graded according to size, ranging from 0, or even 00 and 000, to as large a size as 14. There are other shapes available, the most common being the chisel or square-ended. On a wet surface a flat brush comes into its own, carrying a large amount of pigment while the paper supplies the water.

Your collection of brushes should also include rags and sponges. Small sponges have an infinite variety of uses, for example in laying washes, or lightning an area which is too dark by lifting off the pigment. They can be used in conjunction with drier paint to create unusual textures and rags are also useful for applying irregular washes. With gouache, a palette knife can be used for pushing paint around, creating textures or scraping paint carefully off the surface.

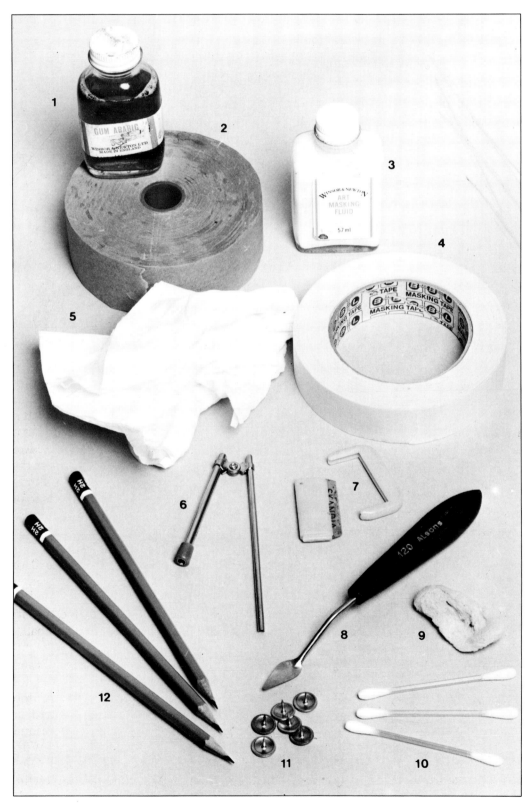

Brushes, paint and paper are not the only equipment needed for painting watercolors; the following articles can greatly help you in your painting and can create different and special effects.

1. Gum arabic; can be used to thicken paint and to create a rich texture.

2. Gummed paper tape; keeps your stretched paper in position on the board.

3. Masking fluid; design can be painted with this fluid, acting as a resist.

4. Masking tape; can be used for masking areas you want to leave free of paint.

5. Rags or tissues; are good for mopping up spills or controlling the paint if it is too wet.

6. Diffuser; a device which, when filled with paint and blown through creates a splattering effect similar to that achieved by running a knife through a paint filled toothbrush.

7. One-sided razor blade; handy for reducing layers of thick paint and perhaps making an unusual design.

8. Palette knife; a useful implement for spreading paint on paper.

9. Sponge; rich, rough textures and special effects can be achieved when watercolor paint is applied with a sponge.

10. Cotton buds; paint can be delicately applied or wiped off with a clean bud dampened in water.

11. Thumb tacks; help to keep stretched paper firmly attached to the board.

12. Pencils; required for initial sketching and drawing.

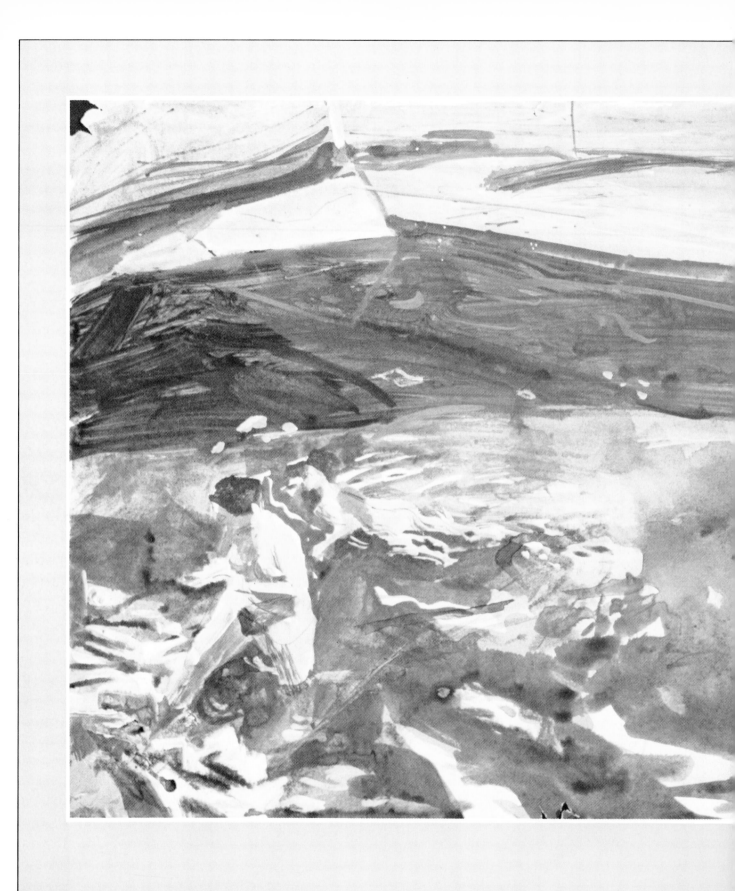

PREPARING
TO
PAINT

THE TECHNIQUES used in producing a watercolor or gouache demand a good deal of flexibility and it is essential to be able to move around as freely as possible. Try, for instance, to organize your work area so that it is easy to tilt your board to different angles and to work from all four sides if necessary. Though you can learn from the experience of others, this information will inevitably be adjusted in the light of your own endeavours; it is always necessary to solve your own problems.

Do not, however, be deceived into thinking that a flexible approach is the same thing as a haphazard one. Careful organization is essential, whether painting in the studio or out of doors, and it is precisely because you have set up a sensible and well ordered layout for your equipment and prepared your materials correctly that you will feel free to undertake any sort of experiment with confidence.

Above: Your sketchbook can be an invaluable source of material for watercolors. Here, the artist has captured the movement of the figures, quickly blocking in the background and recording the maximum amount of information in a short space of time.

INDOOR AND OUTDOOR EQUIPMENT

Watercolor painting requires little in the way of specialist equipment and certainly nothing need be elaborate or expensive. What is important is the way in which you make use of your materials, organizing them to suit your particular style and method of working.

Easels

An easel, though not essential, is useful for indoor painting. The table type is most suitable as it has been designed to allow for adjustment to angles other than horizontal yet is entirely stable. Security is of paramount importance, for to continually fear the collapse of your carefully contrived set-up is not merely irritating but likely to condition every mark made. When the board, with its stretched paper support or sheet of stiff watercolor board, has been firmly fixed into the slots provided and the butterfly screws on the easel have been properly locked in, the first essential of making a studio watercolor has been fulfilled.

Lacking an easel, a good alternative must be sought. The need to retain control over subtle variations in angle will necessitate either a table top as a foundation or a pair of trestles on which to suspend the support. Again, the prime concern is stability. Set the support at the desired angle. Take care to make use of the best available light, making sure if possible that the light comes over the left shoulder if you are a right-handed artist or the right if you are left-handed. This ensures that when making marks on the surface the light does not cast a shadow from the working hand, a factor which can be critical when making highly complicated detailed drawings, when an uninterrupted light source is essential.

Organize your materials

At a convenient distance place another table carrying materials to be used in making the drawing; the paints, brushes, water, sponges, knives and erasers. The location of each item should be considered with care; carrying the loaded brush across a longer distance than absolutely necessary risks spilling paint. Two water receptacles are necessary, one to use with the paint, the other for rinsing out the brushes and kept clean for emergencies such as the rapid douching and blotting off of random spillage or mistakes. The bases of the jars and pots selected for these purposes should be wide enough to guarantee that no slight knock will dislodge them. Similarly the top must be large enough to allow for easy insertion of your brush. Such considerations, although seemingly prosaic and obvious,

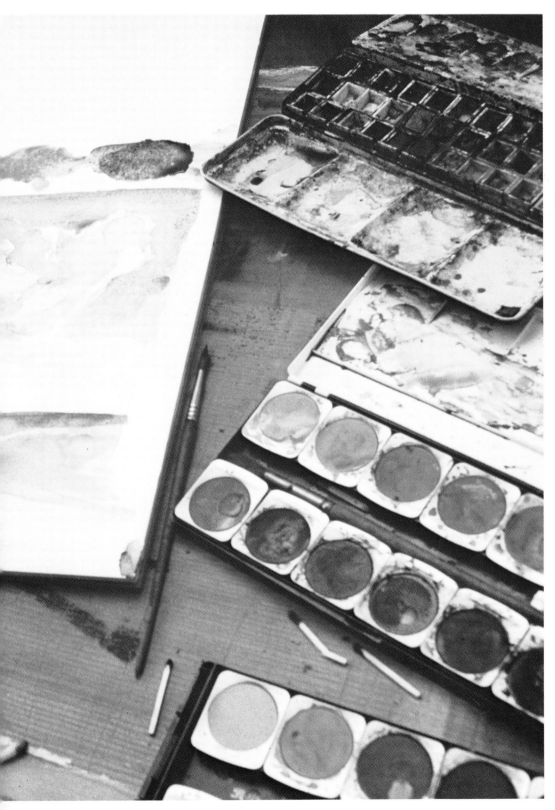

CHECK LIST
Indoor materials
Easel, desk or table
Paints
Brushes
Two containers for water
Sponges
Knives
Erasers
Palettes, pots or saucers
Pencils
Clean rag or tissues
Paper
One-sided razor blade
Prepared support
Gummed paper tape
Thumb tacks

Outdoor materials
Portable easel (if required)
Watercolor box containing
dry pans
Heavy duty paper in blocks
or single watercolor boards
Brushes (carried in
cardboard tube)
Sponge
Water in wide-bottomed jam
jar with tight lid

Clothes
Hat (in sunny weather)
Golfing or fishing
umbrella
Folding chair or
shooting stick
Waterproof sheet to sit on

Left: When beginning a painting ensure that the surface is at the right angle and that you have sufficient light by which to work. All your equipment should be close at hand. Two jars of water should be used: one for mixing paint and the other, kept clean, for rinsing out the brushes and rectifying mistakes.

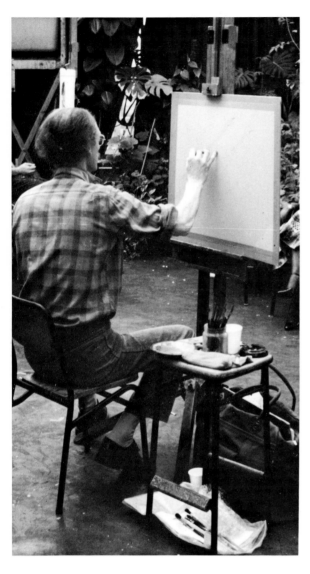

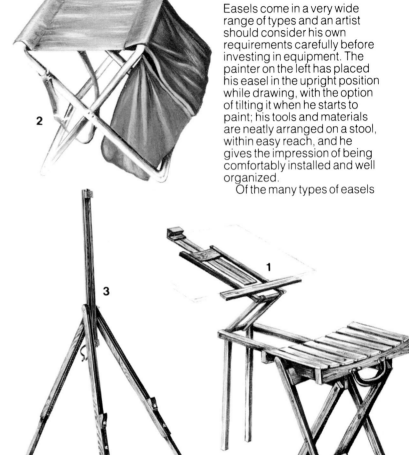

Easels come in a very wide range of types and an artist should consider his own requirements carefully before investing in equipment. The painter on the left has placed his easel in the upright position while drawing, with the option of tilting it when he starts to paint; his tools and materials are neatly arranged on a stool, within easy reach, and he gives the impression of being comfortably installed and well organized.

Of the many types of easels

cultivate good basic habits of organization essential for successful watercolor painting.

Painting out of doors

When working on location the preparations are of necessity different. The emphasis is strongly on compactness and portability, the obvious restrictions of weight and bulkiness placing less importance on the organization of the well set-up studio than on the careful plotting of the outdoor campaign. Does smaller inevitably mean lesser, or can these limitations aid a tighter focus, and narrowing of intensity? If employed properly the two methods, studio work from collected notes or ideas and the efforts of the itinerant topographer, complement each other.

Portable materials

Watercolor painting has long been thought of as an outdoor pursuit because the basic requirements are few and not too heavy. A watercolor box containing dry pans is lighter to carry than bottles or tubes and provides you with a mixing surface. Very few colors are necessary; a couple of carefully selected triads will prove adequate for most outdoor work. Heavy duty paper in blocks or single watercolor boards provide a much less cumbersome alternative to paper stretched on a board, though if travelling by car a board will provide a good surface on which to work. Paper can be stretched on both sides and should be covered by protective sheets.

Brushes hardly add weight or bulk to your load, but if you

available, one of the most useful for working out of doors is the combined sketching seat and easel (**1**), easily carried by the handle attached to the seat. Another useful piece of outdoor equipment is the combined satchel and stool (**2**). The sketching easel (**3**) can be fitted with spikes to anchor it firmly in the ground and is adjustable in height; the combination easel (**4**) can be used both as an easel and a drawing table, making it invaluable in small spaces.

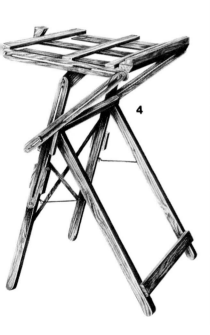

4

SETTING UP A STILL LIFE

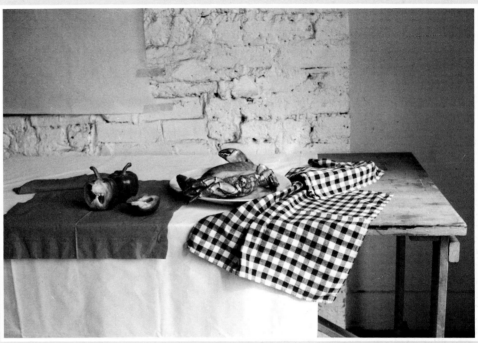

The way in which you arrange objects for a still life is an entirely personal matter and should be given a good deal of consideration before you start to put paint to paper.

Elaborate groups requiring a great deal of space are not the norm in still life painting, and a corner of your studio or work place will provide a suitable area in which to work. Even if you have to clear away your set-up between painting sessions, a reasonably simple arrangement can quickly be reassembled the next time you paint.

Simple groupings, indeed, often provide as much interest and variety as more complicated arrangements of objects. In the painting above, the 'props' are few and readily available, much of the interest being provided by the surroundings. The color, shape and texture of the cloths and the background wall draw the eye of the viewer into the center of the painting and add visual interest.

are really intent on paring things down to basics, one brush or sponge for laying washes and another medium brush with a good point will serve. Transport your brushes carefully to avoid damage, either in a shop-bought tube or in an ordinary cardboard tube with a piece of corrugated card rolled inside; the notches of the corrugated card will hold the brushes firmly. A wide-bottomed jam jar with a tightly fitting lid makes the most suitable type of water container.

Protective clothing
Discomfort from cold or excessive heat is one of the major hazards of painting out of doors. If the weather is sunny, remember a hat; in cold weather, the more clothes you can wear the better, although they might be too bulky for ease of working. A large golfing or fishing umbrella will protect you and your painting from showers, and it might be worth taking a folding chair or shooting stick, depending on how far you are willing to carry them and how anxious you are to be comfortable. Even in the driest of weather it is worth taking something waterproof to sit on; if a proper ground-sheet is too heavy, a piece of polythene or plastic will do.

These are just a few basic suggestions about what you might need on a painting expedition. Experience alone will guide you as to what is essential, and a lot will depend on whether you are travelling by car, by public transport or on foot, going far from home or simply sitting in your own back garden.

STRETCHING AND TONING

Before starting to paint a watercolor, preparations have to be made. It is important to carry out these preliminary steps with care in order to avoid spoiling the finished painting and wasting your efforts. Unless paper is extremely heavy, it should always be stretched; the quantity of water used in the painting of a watercolor causes unstretched paper to buckle. Most artists use a drawing board for this purpose, the only drawback being that they are heavy to carry any distance when painting out of doors.

The classical watercolorist often determined the mood of his landscape by giving his support an overall mid-tone out of which both lights and darks could be pulled. If the atmosphere of the landscape was dull or cool a thin, neutral blue-gray wash was used, barely tinting the white of the support. If the sun was out and the day warm and bright a thin, warm yellow such as Naples yellow was flooded over the paper.

Stretching

Paper is usually stretched onto a drawing board, although any surface of a suitable size which provides a good smooth base may also be used. Hardboard and cardboard should be avoided as they are likely to warp. On a drawing board, it is usual to stretch paper on either side, protecting the prepared supports with overlying sheets. It is important to distinguish between the right and wrong sides of the paper, the simplest method being to ensure that the watermark reads correctly.

Trim the paper so that it is slightly smaller all round than

TONING

1. When laying a ground color over your support the aim is to cover every inch of the paper with a uniform tone, so be certain to mix up enough paint before you start.

2. Test your mixed paint for consistency on a spare piece of paper in the same way as when laying a wash. In general, you will be aiming for a fairly light tone from which to work.

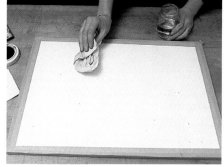

3. Dampening your stretched paper with a rag or sponge dipped in clean water helps to ensure an even covering of paint.

4. A sponge is probably more useful than a brush for covering a large area. Work backward and forward across the support in the same way as for laying a wash until the entire area is covered.

5. Make your toning as even as possible the first time round; you can, however, go over areas again if they seem patchy. Allow the toned paper to dry thoroughly before you start painting.

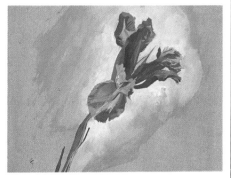

6. This sheet of toned paper has been used for a watercolor of an iris, making an ideal ground from which to work lights and darks and blending well with the color of the flower.

the board and put it to soak in water. It is perhaps easiest to soak paper in a photographic tray, but many artists use the bath, or simply hold the paper under a running tap, moving it backward and forward on both sides to ensure even soaking. This method is particularly useful if your paper is too big for your tray or bath.

Soaking time depends on the weight of your paper and how wet you intend your washes to be. Lightweight papers should probably not be soaked for more than a minute and there is a danger of them tearing if they become too wet. Heavier papers will absorb more water and can be left to soak for longer; only experience will enable you to discover the ideal length of time for the paper you use and the wetness of your washes.

Cut strips of gummed tape to the size of your board. Take your paper from the water and hold it by one corner, shaking it gently to allow excess water to run off. Lay it on your board using a rolling action and smoothing it out from the centre to make sure that as little air as possible is trapped underneath. This is difficult if there is any buckling, but as long as the gummed tape is stuck down flat, your paper should dry smooth. Press the gummed tape down firmly with both hands and finally insert a thumb tack in each corner so that the paper is firmly secured to the drawing board.

Lay the board flat until the paper has dried. It is best to allow it to dry as naturally as possible, however tempted you are to place it near a fire or heater to speed things up. Drying by artificial means causes the paper to shrink too much and too quickly with the result that it can easily split before or during use.

Toning

Painters in oils traditionally used middle toned grounds on their canvasses, developing the darks into shadows and the lighter tones into highlights in order to describe form. The paintings of the High Renaissance in Florence and Venice achieved differing temperatures according to the tone of the ground; the colorists of Venice used a hot, red ground for their figures while the Florentines tended to favor cool greens.

Toning should be carried out in much the same way as laying a flat wash, using a brush or sponge soaked in paint. A small painter's sponge is possibly slightly easier to use. Depending on your subject and the effect you want to achieve you might, alternatively, want to use a graded wash to tone your paper. There are no hard and fast rules which must be followed.

Stretching paper 1. Make sure that you use the right side of the paper. This can be done by holding it up to the light and checking that the watermark reads correctly.

2. Trim the paper to the appropriate size for the drawing board you are using. Leave an adequate margin of board so that there is room to affiix the gummed tape.

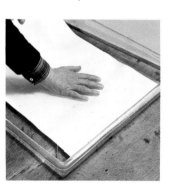

3. Soak the paper carefully in clean water, either by using a tray or by placing the paper in a sink. The amount of time needed varies with different types of paper.

4. Cut lengths of gummed paper tape to exactly match each side of the drawing board.

5. Drain the paper from the water. Put it flat on the board, watermark uppermost, and stick the dampened gummed tape on one side, then do the other sides.

6. To make sure the paper is firmly secured, insert a thumb tack into each corner of the board. The paper should be left to dry naturally or it may easily split.

SKETCHBOOK

One of the most interesting aspects of the work of any artist is to be found not perhaps as would be expected in the finished drawings or paintings but in the preliminary attempts and exploratory drawings, in the sketchbooks. Sometimes large, used to record in detail the world as seen and sometimes small, the right size to carry in the pocket and have with you in all situations, a sketchbook of some sort will provide the artist with the opportunity to record, reflect and reminisce.

If you prefer a small, pocket-sized sketchbook, the quality and type of paper should match your intentions. Color notes require a well sized, lightly textured paper while a smoother surface is more suitable if most of your notes are to be made in ballpoint pen. A good quality paper, however, should take any medium adequately and allow you a certain amount of choice.

Some materials are less well adapted to small scale work. Bamboo, pens and oil pastel, for instance, are fairly clumsy tools, ideal for certain tasks but not generally for making rapid notes. It is, as always, up to the individual artist to decide what best suits his purpose; whatever combination of materials is eventually chosen, starting with a ballpoint pen, an HB pencil and a small sketchbook will allow for a surprisingly wide range of possibilities.

Left: Sketchbooks are obtainable in all types and sizes. Those with a spiral binding are particularly useful, as is the type with tear-off perforated sheets; some come in book form so that it is possible to work right across the spread, or with a little ingenuity you can make a sketch book yourself, to your own specifications. Although a pocket size can be carried easily, not all sketching is done on a small scale.

The medium you choose to make your visual notes depends on personal preference. Color notes can be made with words and often an HB pencil and small notebook provide a practical solution. Ballpoint pens and pentels are permanent, requiring no fixing, whereas charcoal smudges easily; oil pastels and watercolor can be used to block in large areas at great speed. Only experience and practice will enable you to arrive at the ideal combination.

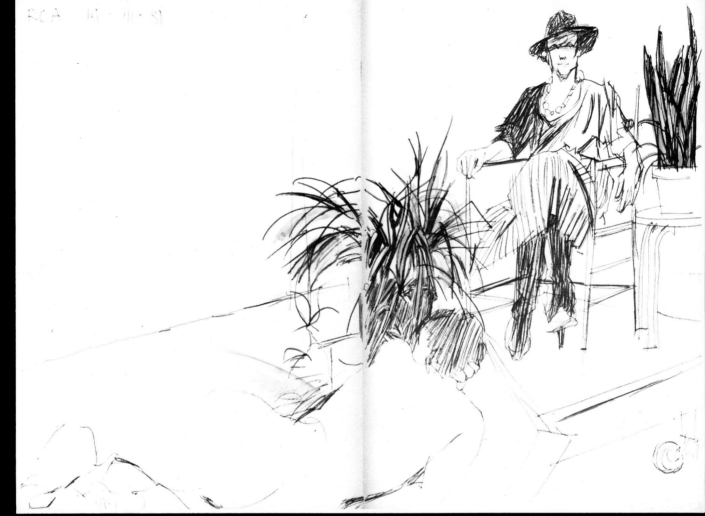

Above: Sketching plays as important a part in the making of a watercolor as in any other form of art and any aspiring painter should bear in mind its potential. Apart from the sheer pleasure of making rough drawings, sketching serves the purpose of making notes for future reference, particularly important where the light is changing rapidly or you wish to record moving figures or dramatic visual images.

Color can be added to a sketch as a means of enlivening and extending information and interest. Even black can be used to create a variety of effects. In the example above fine, linear drawing is used to describe the nude figure forms while hatching and stippling give a completely different quality to the seated, dressed figure. The artist has been concerned with the positions of the figures on the page, placing them so that the maximum contrast is pointed up between the horizontal and vertical poses.

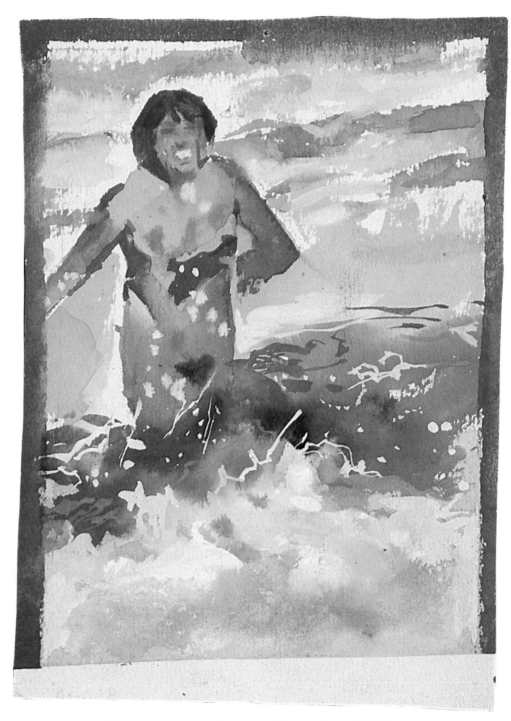

Sketches are especially valuable in providing information for large scale paintings when the subject involves a great deal of movement. The sketch (**above**) contains a summary of tone, color and detail, quickly built up with simple brushstrokes and easy, fluid movements of the hand.

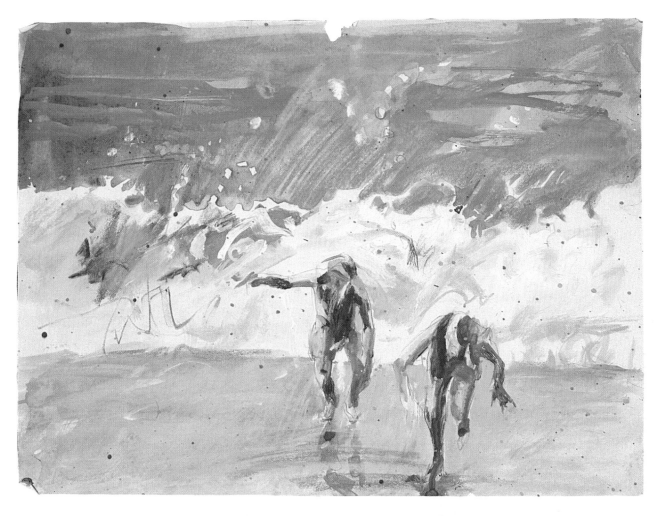

When sketching a subject characterized by vigorous movement and continual change, it is vital to record as much visual information as possible from fleeting impressions. The sketch (**above**) was roughed out in pencil, the artist's eyes scarcely leaving the subject. Broad areas of color are blocked in with watercolor and pastel, detail added with short brushstrokes and rapid gestures.

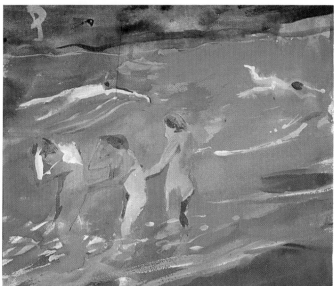

The scene on the (**left**), painted with watercolor and gouache, is more static, but again deftly describes the fluid rhythms of water and figures. Such work requires short bursts of intense concentration and dexterity, but is remarkably enjoyable.

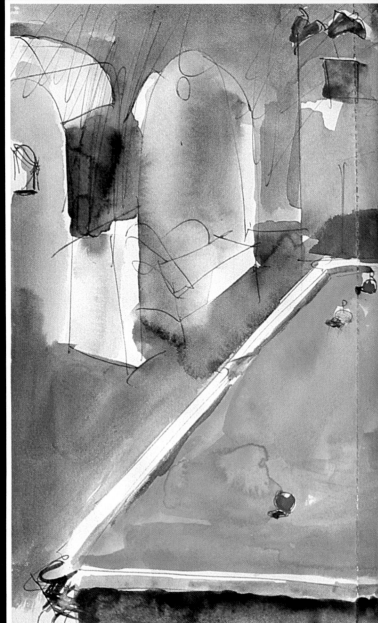

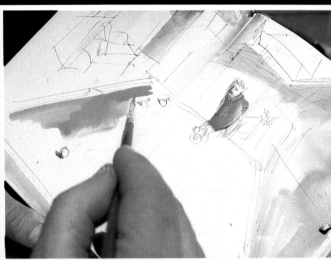

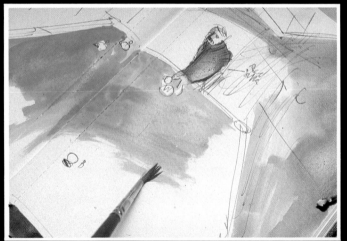

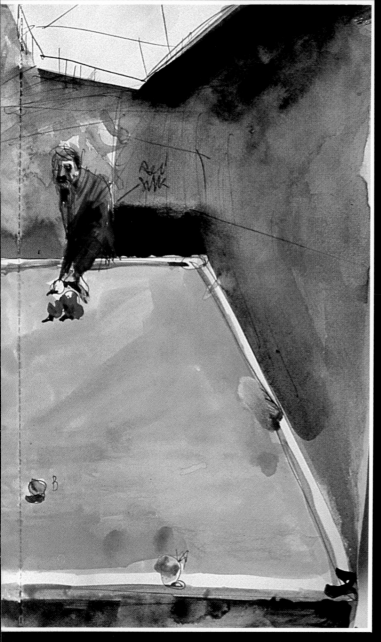

The sketch of a billiard player (**left**) is one of a series of studies made in preparation for a larger painting in a different medium. The sketches recorded notes for the artist on color, tone and form in the room as a whole and detail of different positions of figures around the table. It is wasteful to use good quality, heavy watercolor paper for such studies, but in sketchbook work the paper cannot be stretched and is bound to wrinkle slightly. This does not affect the usefulness of the material when the information is later used as reference. However, in order to minimize the wrinkling, the color should be applied as dry as is practically possible.

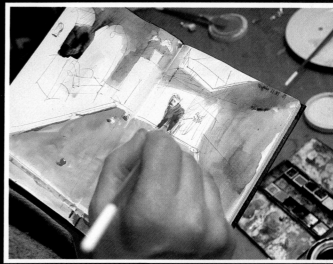

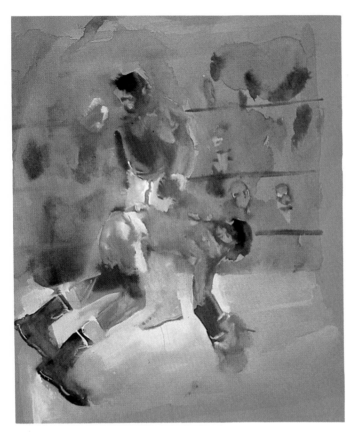

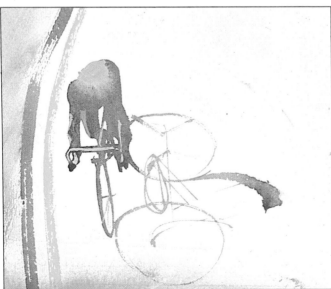

The fluid painting technique employed in this watercolor of boxers (**left**) enables the artist to capture the vigor of the subject. The paint is kept wet so that the colors flow freely together, creating an out-of-focus impression in which the movement of the figures is described by the active paint surface. This effect is enhanced by the occasional contrast with areas of heavy tone and hard-edged clarity, such as the boots of the figure in the foreground. The paint is applied to green paper which modifies the washes of blue in the background planes. Highlights splashed in with white paint create the floodlit floor of the boxing ring and draw attention to the figures. The watercolor sketch of a cyclist (**below left**) demonstrates an economical control of brushwork. The modified figure is presented basically as a silhouette, but touched with brighter color to indicate three-dimensional form. Speed is implied by the broken stripes of blue and yellow, applied with a dry brush technique. Cycling is a suitable subject for sketching practice as the actions, though rapid, are repeated over and over again. A watercolor and ink sketch of a park on a summer day (**right**) captures the serenity and charm of the subject, but also conveys a sense of immediacy in the lively and challenging paint surface. Bright light and deep shadow are given full tonal contrast while diminishing, intermediary tones create a feeling of distance Touches of pink and red enliven the heavy tones of green and blue.

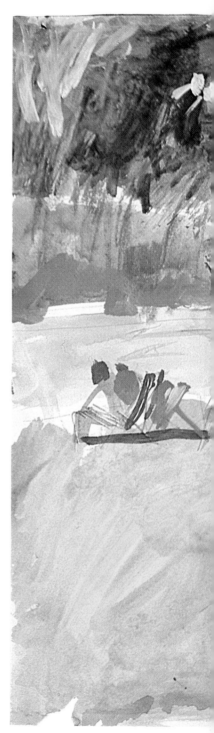

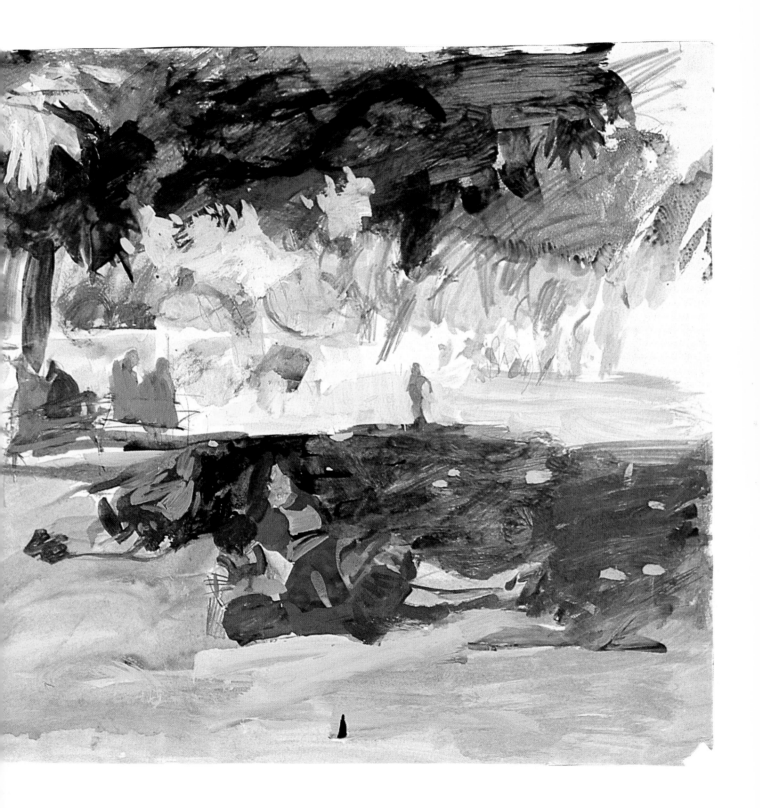

Basic Tenets AND Techniques

Above: Color is one of the topics which must be studied in detail by any aspiring artist. It is a complex subject, made more so by the difficulty of predicting how pigments will react when mixed. Only constant experimentation with different paints and papers and personal observation, making careful notes of the results you achieve, will enable you to develop your knowledge and skill.

THIS CHAPTER covers complex subjects in a way which will seem either daunting or insufficiently detailed, depending on how much practical work you have carried out already and how much, if any, further reading you have done. The theories of composition, perspective and color have been a lifetime's work for some artists, while others have been unaware of their existence yet have produced excellent work. It is probably true to say, however, that many of the great works of art that appear to ignore the theories are the result of a deliberate turning away from rather than ignorance of these complex topics.

Any aspiring artist is well advised to try to come to terms with as much theory as possible. By looking at reproductions in books and visiting galleries you will be able to compare the ways in which different artists have dealt with problems of composition, perspective and color. Perhaps the most useful method, however, of coming to terms with these subjects is through your own work. By setting yourself exercises and trying to complete them in the light of what you have read and observed you will gradually acquire greater understanding and be able to put this to practical use.

COMPOSITION

Before starting your painting you must consider how to devise a visually interesting picture and to arrange color, shape and lines on your support in a way that will best suit your purpose. This is the essence of composition. Different objects and parts of your picture must be related to each other; if your composition is poor you will fail to convey the meaning and thought behind your work. Theories have been evolved over the centuries, but the reading and understanding of these theories is no substitute for practice.

Many paintings are based on the arrangement of geometric shapes such as triangles, circles and squares. Some have strong linear compositions, both vertically and horizontally; vertical lines give a feeling of stability and

peace while horizontal lines tend to convey dignity. This is necessarily an oversimplified analysis and it is essential to try to analyze more complicated structures by looking at as many paintings as possible and understanding their design.

The mathematical approach

Mathematics has made a major contribution to the compositional theories of art. The Egyptians used it first and later the medieval master builders of cathedrals based their work on intricate mathematical theories. The Greeks devised several ideal standards, the most well known of which is the Golden Section. Evolved by Euclid, it was thought to divide the picture plane into a perfect proportion of natural balance and symmetry. Although it can be worked out mathematically, most people have an intuitive feeling for it and its harmony is a recurring concept.

Turner's *Norham Castle* is a fine example of the use of the Golden Section. Piero della Francesca (1410/20-92) is another artist who was deeply interested in mathematical structure, although his paintings have a quiet beauty and inner harmony which bely their complexity. More recently, Modigliani (1884-1920) was also concerned with the arrangement of geometrical forms.

Before you start

When about to embark on a painting, be certain that you have looked at it from every angle. The rearrangement of a still life, for instance, may make an enormous difference, and small thumbnail sketches will help you to remember any previous arrangements which you may have though more suitable. When considering a landscape, the placing of the horizon line is important. Consider the difference between a bird's eye view and that of a worm, and all the variations in between; thumbnail sketches are again very useful in helping you decide

Scale is another important factor, not only in giving clues about perspective and depth but also in determining the compositional impact of your painting. Difference in scale can heighten dramatic interest, a small, single figure conveying loneliness and isolation and a close-up view of a face giving a feeling either of intrusion or intimacy.

Some artists cut a hole in a thick piece of card of the same proportions as their support and use it as a viewfinder, as in a camera. It is possible to view a still life or landscape through this hole, considering a variety of proportions and viewpoints. Generally speaking, it is better not to place your main object of interest right in the center of your picture plane.

Above: To a certain extent, arriving at a successful composition is a matter of trial and error, it being necessary to try out a number of different groupings of objects and figures before you arrive at the best solution. Small thumbnail sketches are a useful aid, whether you are considering a still life, landscape or group of figures. The examples above show sketches of female nudes in various poses and against slightly differing backgrounds; they form the basis on which the artist will decide on the best composition for his finished painting.

LONG-STANDING THEORIES

Right: Piero della Francesca was a 15th century Italian artist as interested in mathematics as he was in painting pictures; the complicated compositional structures he used, however, do not detract from the beauty of the paintings. The triangle was the geometric base from which he worked (**center right**); following this principle, many other triangles can be discovered (**far right**).

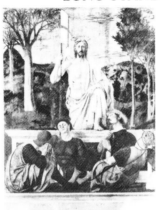
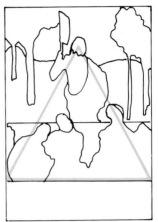
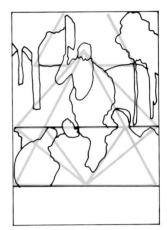

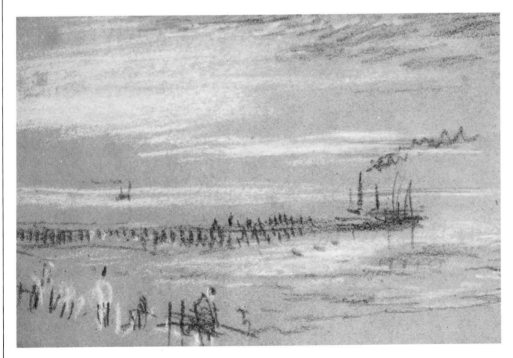

Left: The requirements of the Golden Section are fulfilled by this pastel sketch from the notebooks of J.M.W Turner. It was on this theory of the Golden Section that the Greeks based their definition of perfect proportion. By this mathematical formula a line is divided so that the smaller part is to the larger as the larger is to the whole (**see below**). The Golden Section was held to have a natural balance and symmetry; ever since its inception geometry has played an important part in painting and drawing. In Turner's sketch the horizontal line of the jetty and the verticals at its far end conform to the ideal positions described below.

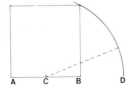

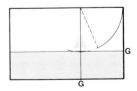

The Golden Section
Ascribed to Euclid, this rule was held by the Greeks to be the ideal division of a surface. To find the section, divide the line AB in half at C;

draw a radius from the top right hand corner of the cube to create D. In the drawing second right, lines have been drawn to create a rectangle, point BG forming

the vertical section. To find the horizontal section (**far right**) draw a line from the top of the vertical G to the bottom right hand corner and a radius from the top right

hand corner downward; the line and arc intersect at the level of the horizontal section.

PERSPECTIVE AND MEASURING

Most people draw what they know rather than what they see. It is important, therefore, to try and forget conventions and your preconceptions of the world and things in it and better to examine the subject you are concerned with, be it landscape, portrait or still life, and pretend you are faced with something new and strange which you have never seen before.

It is a mistake to try and paint from memory, spending more time concerned with your watercolor than with the subject itself. Spend as much if not more time looking at your subject and making mental notes of its relationship to other objects. Hold your brush or pencil at arm's length, shut one eye and examine what your eye told you to be horizontal or vertical lines. More often than not you will find that you have misinterpreted what you have seen; outlines of diminishing objects form subtle angles from the horizontal and vertical and need to be checked. In painting, you are attempting to transpose three dimensional objects onto a vertical two dimensional plane (your pic-

ture) in a realistic and convincing way. In order to able to do this you must understand some general rules.

The basic rules of perspective

The ground on which you stand is known as the ground plane. If the ground plane were completely flat, that is if you were standing on a beach and overlooking the sea or painting a Dutch landscape, you would be able to see where the sea or ground met the sky. The ground plane meets the sky where the curvature of the earth prevents us from seeing it stretching out before us. It often happens that hills, houses, trees or other obstructions prevent us from seeing this far.

The horizon line occurs at eye level. If you were standing on a flat plane you would be able to test this by holding a sheet of card or a ruler up to your eye level and finding that this matches up with the horizon line. The support on which you are drawing or painting is called the picture plane. By drawing in the horizon line you can establish

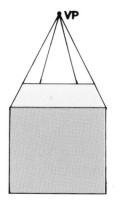

One-point perspective
Taking a cube as an example, in one-point perspective only two faces are visible, the top and one of the sides. There is only one vanishing point. A good example of a single vanishing point is provided by the photograph **above right**. The parallel lines of the sides of the road, receding into the distance, appear to converge at a point on the horizon.

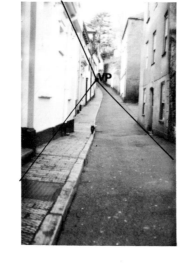

Two-point perspective
Here, three planes of the cube are visible, the top and two of the sides, so there are two sets of receding parallel lines and two vanishing points. The photograph of a street corner

(**bottom**) is a good example of two-point perspective, the two sets of lines from the tops of the buildings and the sidewalk converging at two vanishing points.

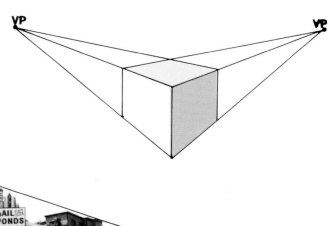

your vanishing points. These are imaginary points where parallel lines appear to meet. A straight road for example, or a railway line, will appear to converge into a dot on the horizon.

One-, two- and three-point perspective are three commonly used systems (see diagrams) and there are many more unusual systems such as cylindrical or spherical perspective. Other painters have adhered to totally different systems from those evolved by western European art. Egyptian art used scale to suggest distance, making distant objects smaller and placing them higher up the picture. Chinese, Persian and Indian art are also examples of widely differing systems used to convey distance and space. Within Western art the primitives have made pictures without following the conventions, either by showing parallel lines to be parallel or, frequently, by using systems very much akin to Egyptian or Chinese methods. Other artists have deliberately chosen to ignore these systems and contorted our perspective rules to change our ideas of space and shapes within that space.

Many artists have made drawing aids to help them understand perspective. Canaletto (1697-1768) used a camera obscura which projected his subject matter onto a sheet of paper or glass so that it could be traced off. Dürer (1471-1528) used a squared-up sheet of glass through which to view his subject and then translated this onto a squared-up sheet of paper. Try a similar method by tracing what you see onto a window, being careful not to change your viewpoint. By joining up your vanishing points you may find it easier to understand perspective, but these methods should really only be used as exercises. They have

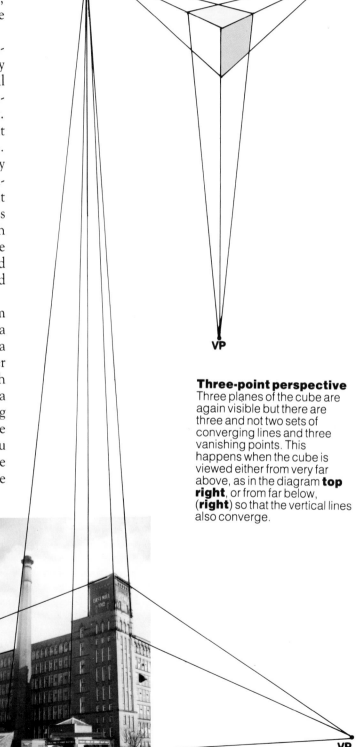

Below: In this photograph the highest points of the building are viewed from well below, creating a third vanishing point. In some cases, vanishing points will be obscured by buildings or other objects. It is nevertheless essential to know where they would have been in order to judge the correct angles of the lines.

Three-point perspective
Three planes of the cube are again visible but there are three and not two sets of converging lines and three vanishing points. This happens when the cube is viewed either from very far above, as in the diagram **top right**, or from far below, (**right**) so that the vertical lines also converge.

59

a tendency to go to the extreme of making one too aware of perspective and can give your picture a stilted appearance.

The importance of measuring

You should give yourself a very strict framework for measuring up your watercolor and relating the objects within it. Make sure that your viewpoint is always fixed; do not obscure your line of vision with your drawing board and be certain you are comfortable, seated or standing, so that you will not want to move after ten minutes. Do not attempt to draw your objects from too close a viewpoint or to cover too wide a range. Although we can see through an angle of 180° only a fraction of this, about 45°, is within our proper field of vision. Anything out of this field quickly becomes distorted and out of focus. You should never attempt to turn your head from side to side in order to see more as this will alter your central line of vision and your view will very quickly become confused. It is also necessary to shut one eye when measuring up distances. This is because our two eyes provide us with binocular vision, which gives us a moving viewpoint. Shutting your eyes alternately will show this to be so, particularly in the relationship of objects close to each other.

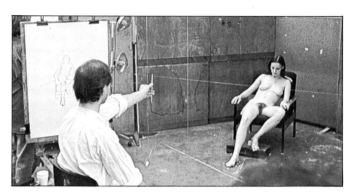

Above: Measured perspective drawing is a useful way of learning about perspective and developing accuracy. Use your pencil as a measuring device, holding it at arm's length and closing one eye so as to avoid double vision. By moving your thumb up and down the pencil (**left**) the proportions of the object you are drawing can be measured and this makes it possible to draw to scale.

CONVENTIONS OF PERSPECTIVE

Below: Over the centuries artists have used many different methods of perceiving and conveying space. In the Chinese painting below left the more important figures are larger, the king being largest of all and the unimportant demons and dogs at the opposite end of the scale. In Western art, painters have employed a variety of tricks to give an impression of three-dimensional perspective; in the painting **below right**, the dark shadow thrown by the figure gives a convincing depth despite the absence of any other surroundings to provide visual clues.

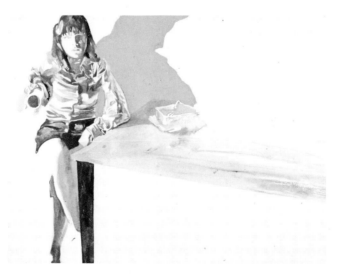

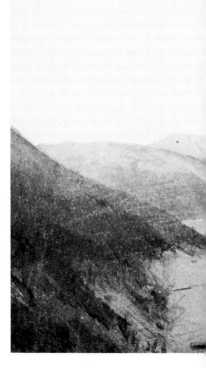

Continual measuring with one eye can be tiring at first, but practice and perseverance will soon make you more accustomed to it. Measure the relative sizes of objects and the distances between them by holding a pencil or brush at arm's length and by closing one eye; you can move your thumb up or down the brush or pencil and use it as a measuring stick. It is useful to keep one object as a constant – a tree trunk, say, or the side of a window frame – and continually to make reference to it and then cross-references with other objects. If you are using this method it is essential to check your measurements. Make sure your arm is always fully stretched and try to keep your head in the same position.

Atmospheric perspective

Apart from physical and mathematical ways of placing objects convincingly and solidly within a certain space, the illusion of depth can be increased by atmospheric or aerial perspective. This is mainly concerned with effects brought about by the atmospheric conditions which intervene between the observer and the subject. The unique problem of representing the atmospheric planes of nature and interpreting them on a flat surface is an essential and elemental factor in landscape pictorial art.

Objects which are close up will retain their full color and tonal values while being clearly defined. Objects seen from a distance will have their colors and tones modified by the atmosphere. In the 17th and 18th centuries fairly strict codes were often adhered to with regard to atmospheric perspective. The foreground would be brown, the middle distance green, the far distance often a pure blue. It is as well to bear such systems in mind when considering your landscape. Perspective should not be so important as to dominate your picture, unless carried out as an exercise, but atmospheric perspective is an aid to the illusion of depth and will be affected by weather conditions and the clearness of the day.

Other tricks will give your painting a convincing depth; overlapping objects in the foreground which partly obscure those in the middle distance or those directly behind them; more detail and texture to objects in the foreground; more focus on your subject and blurring and indistinctness of the far distance; colors becoming more neutral as objects diminish. These help to give clues for recognizing three dimensional space, but it is not necessary to include them all.

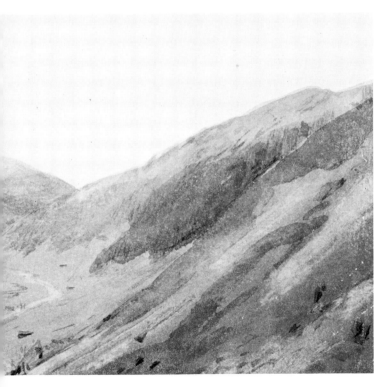

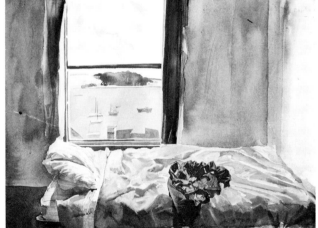

Left: A traditional landscape presents the painter with one of the most interesting problems when it comes to giving an illusion of depth and distance on a flat surface. By the conventions of atmospheric perspective, landscapes become increasingly blue and indistinct as they stretch away into the distance.

Above: The window in this painting acts as a device separating the clearly defined interior and the hazier tones of the sea and hills providing a frame through which to view the seascape beyond.

COLOR THEORY

The multiplication of pigments today has greatly intensified the problems of color schemes for the watercolorist. To make a successful painting it is important to understand the range and limitations of your palette and the color theories and effects involved in using a variety of colors in certain ways.

The importance of light

The scale and effects of color found in nature cannot be reproduced by the use of pigments on a flat surface; nor is it possible for the range of color to be produced with total realism. This is because what we see when we look at colored objects is not the objects themselves but the color reflected from them. Our seeing, therefore, is dependent entirely on light and an artist is faced with a complicated process when putting brush to paper; not only must he present a three dimensional space on a two dimensional plane but his pigments and brushwork must imitate a wide and varied color range which in reality is reflected light. These limitations and difficulties are forced upon the artist; others are self-imposed. It is in dealing with forced and self-imposed limitations that the skill of the water-colorist lies. They are, comparatively speaking, so great and the process of adaptation so intricate that they present scope for the exercise of a wide range of choice, selection, taste and the expression of personality. Here watercolor becomes an art and not a simple copying process.

Two sets of primaries – pigment and light

The color, or pigment, primaries are red, yellow and blue and by mixing them, red with yellow, red with blue and yellow with blue respectively, orange, purple and green are obtained. These are secondary colors. The mixture of secondary colors will produce what are called tertiary colors, which tend toward a scale of grays and reflect more closely the range of the natural colors which surround us than do the brightness of the pure primaries and secondaries. These brighter colors are more reflected in man-made objects and must be used with discretion in natural landscapes and still lifes. A bright color will seem all the brighter for shining out of a field of modified hues rather than being used in a range of colors of equal intensity and brightness.

Primary light colors, red, green and blue-violet, are different from primary pigment colors and the effect of mixing light is very different. A mixture of two pigments will result in a darker color, the three primary pigments together resulting in black, but the mixture of light will

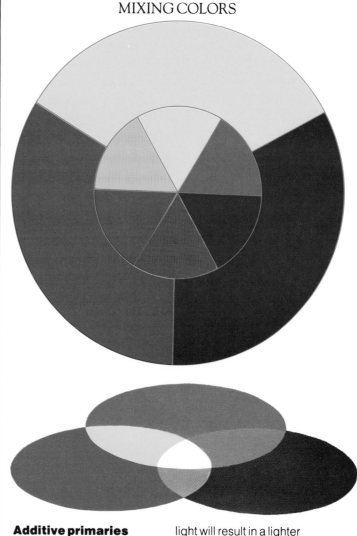

MIXING COLORS

Additive primaries
These are the light primaries, red, green and blue-violet. Just as absence of light produces darkness, mixing

light will result in a lighter color, and mixing the three light primaries produces white.

result in a lighter color. This mixing of light is called an additive process and although initially it might seem confusing (this being the opposite to what we experience when mixing paints) it does make good sense. Absence of light produces, naturally, black and the more light used in mixing, the lighter the color produced. Therefore a mixture of red and green will produce yellow, red and blue-violet will produce magenta, blue-violet and green will produce blue-green, or cyan, and a mixture of all these primaries, red, green and blue-violet, will produce white.

green and blue-violet) only the green and the blue-violet would work strongly. You would see, therefore, not just a white surface but the after-image mixture of a green-blue – or cyan – ball.

Complementaries

Cyan is the light complementary of red. Complementary colors, as opposed to light complementaries, are those pairs which are at opposite sides of the color sphere, with the same degree of intensity; red and green, blue and orange or yellow and purple. It can be seen that each of the primary colors – red, blue and yellow – has as its complementary the color formed by the mixture of the other two. When two complementary colors are seen together the same degree of intensity sets off the same degree of reaction in the rods on the back of the retina; at the same time their intensity and brightness are not reduced or modified, as is the case with other colors. Rather they are enhanced and can set up the sort of dazzle which we often associate with the close proximity of bright colors and which was a characteristic of op-art.

Influential theorists

In the past artists have made various attempts to formalize color theories and to create aesthetic laws and principles on the use of color for other artists to follow. In Paris, Chevreul (1786-1889) was the first to combine his knowledge as a color physicist and his interest in art to publish a treatise on color in which he described harmonies of similar colors and harmonies of contrasts and devised tables of induced color effects. Some believed that it was possible to equate the laws of musical harmony with those of color in order to obtain an aesthetic code.

Seurat (1859-91) used Chevreul's theories in most of his paintings. He covered his canvasses with tiny dots of color which merge when viewed at a distance. His method of painting, known as the *pointilliste* technique, closely resembles the way in which color pictures are reproduced by modern printing methods. A close view of an advertisement hoarding or a scrutiny of a picture reproduced in any book will reveal a myriad of dots printed in the three colors cyan, yellow and magenta. The overprinting of these three colors reproduces the whole range of color and the varying density of dots over the surface changes color and tone. Viewed from a distance these dots merge to produce the exactness of the photographic image to which we have become accustomed. In the same way a close examination of Seurat's work will show that he often used red, yellow or

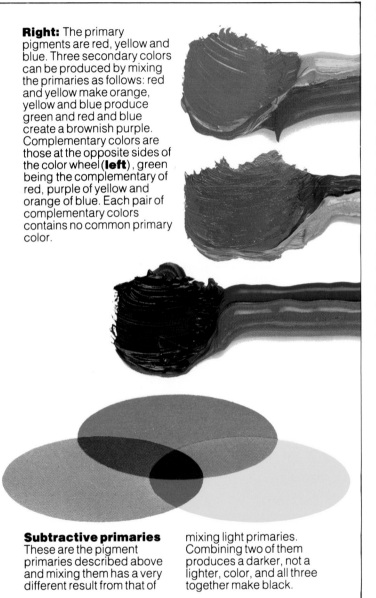

Right: The primary pigments are red, yellow and blue. Three secondary colors can be produced by mixing the primaries as follows: red and yellow make orange, yellow and blue produce green and red and blue create a brownish purple. Complementary colors are those at the opposite sides of the color wheel (**left**), green being the complementary of red, purple of yellow and orange of blue. Each pair of complementary colors contains no common primary color.

Subtractive primaries These are the pigment primaries described above and mixing them has a very different result from that of mixing light primaries. Combining two of them produces a darker, not a lighter, color, and all three together make black.

How the eye sees color

The retina at the back of the eye is made up of rods and cones which are sensitive to light and color. The cones react to blue-violets, greens and reds, the light primaries, and are dispersed on the retina in these three groups. They react strongly or slightly to colors seen and between them are able to mix up the entire range of colors. If you stare for any length of time at a red ball, the red-sensitive cones will over-react and become tired out; if you were to turn immediately to a white surface (which consists of red,

JUXTAPOSITION OF COLORS

Perception of color is affected by the context in which it is seen. Complementary colors are at opposite ends of the color sphere and have the same degree of intensity; blue and orange, yellow and purple or red and green (**below left**). When complementary pairs are seen together their intensity is enhanced, setting up the sort of dazzle evident in the painting **below.** This phenomenon apart, colors will tend to be reduced and modified by their surroundings. In the examples shown **below right** circles of light gray, dark gray and pale green are seen against different colored backgrounds. Although each of the pairs of colors is exactly the same, they appear to vary in tone because of their different surroundings.

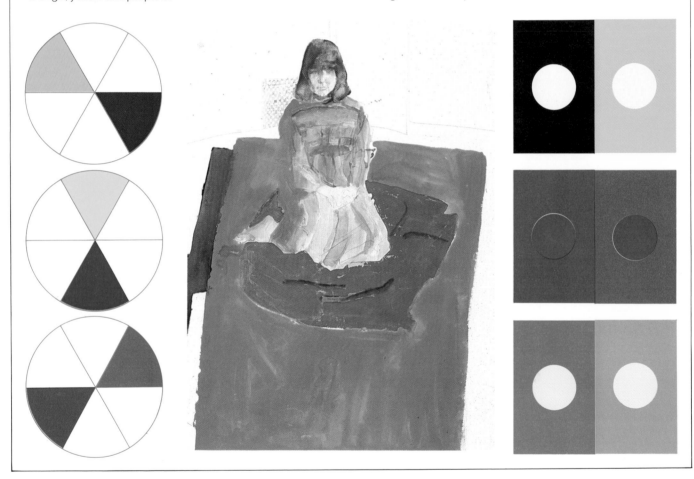

blue straight from the tube. Distance blends them together to produce broken or tertiary colors.

Theory into practice

Two ways in which color can be differentiated are in terms of tone and hue. Hue describes the color itself, while tone is the darkness or lightness of the color. A whole range of tone can be present in a single-colored object and a good exercise would be to paint a single-colored object lit only from one side. This would produce a whole range of tones of one hue in the object, ranging from highlights to deep shadows. Tone is often very difficult to assess and many artists find themselves squinting. This has the advantage of reducing detail and giving a view of the object or landscape as a whole, thus allowing the judgment and assessment of tones to be made more easily.

In terms of landscape most of your picture will be made up of a variety of greens. How can you make these greens more interesting as color. Are they warm, cool, brilliant, dull, acid? What evidence of other colors do they show? A red flag on a golf course will bring out the contrast of the greens more sharply. Experimentation in mixing up a

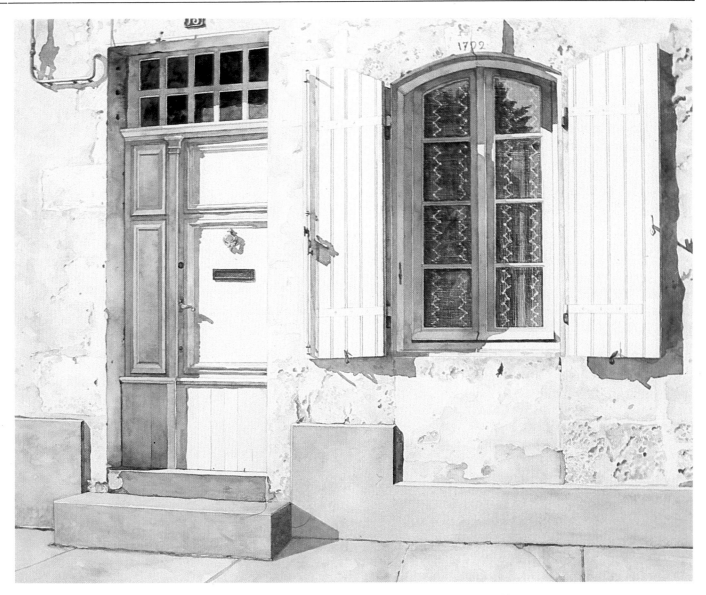

When dealing with a scene which is predominantly white it is crucial to be alive to any small changes of tone and texture and odd flashes of color. These can be drawn out, even with a limited palette, to ensure that the surface of the painting is interesting and varied. The cool tone of the deep shadows contrasts with the warm yellow in the stonework and accentuates the brilliant white light. Pattern and texture in the wall and windows are used to break up the broad planes. A confident handling of perspective adds three-dimensional reality.

variety of greens will show how wide your choice can be; by stretching your blues and yellows to the furthest edge of your color spectrum and by making your greens as warm and cool as possible by adding more blue or red hues you will see how exciting a range is obtainable.

A selection of seemingly white papers will show that white will vary from off-white to cream to gray-white. In the same way your whites, when painting, should always be qualified and never used straight from the tube. Consider which color your white tends toward; pure white is rarely either seen or used except perhaps on the highlights of a

shiny surface. In the same way a shadow or a changing surface is not necessarily merely a darker tone of the same color. The tone of the shadow may tend toward warm or cool gray, in some cases it may be purple or, for example with a green object, it may be its complementary red. These areas need to be examined very carefully and a true and selective eye is needed to record colors seen and not colors as they are thought to be seen. A good exercise for practicing this vision is to paint a still life entirely composed of white objects. You will find you use the whole range of your palette – not simply white, black and gray.

WATERCOLOR TECHNIQUES

Washes are the very substance of which watercolors are made, whether they are thin skeins of paint over a sky stretching across a huge expanse of paper or cover only a tiny area of the support. A perfect pure wash will lie flat with no visible edges or ripples. It must be executed while the paint is still wet, so the whole operation must be carried out quickly, with plenty of paint and a full brush. The water used must be perfectly clean in order to preserve the purity of the pigment.

An example of a pure, well laid wash can be seen on page 68 and its flatness and translucency is in keeping with the general style of this particular watercolor. This approach, however, may be at odds with the effect you are trying to achieve, and it can be seen from many other paintings reproduced in this book that pure washes have not always been used; one of the delights of watercolor painting is the 'happy accident' which can give unexpected results. If your wash does not lie flat, do not despair! Perhaps you have created a more interesting and unusual effect.

Some historic examples show that the flatness of the wash was crucial to style and execution, but many artists have broken away from this approach. Topographers in the 18th century used a thin wash to add a tint to their underlying drawing. Once it was dry, a second wash was added to give another tone, while leaving some of the original wash to show through. Girtin (1775-1802) and De Wint (1784-1849) added fresh color to their first washes while still wet to break them up and give variety. Many artists have preferred to do this by starting on a damp paper and continuing with a sort of wet mosaic of running washes. Using this method, the end result is never predictable; it is impossible to tell what will happen until your washes have dried out.

Another variation on the pure wash approach can be seen in the work of David Cox (1783-1859). Much of it was done entirely with separate brush strokes, almost in the manner of the oil painters of the Impressionist school. In the middle of the 19th century the stipple technique became popular with such artists as William Hunt (1827-1910) and Birket Foster (1825-99). By this method areas

Right: The watercolor artist has at his disposal techniques ranging from the orthodoxy of the perfectly laid wash to the less traditional use of materials and implements other than paint and brushes. Do not feel compelled to use quite so many effects in such a small space!

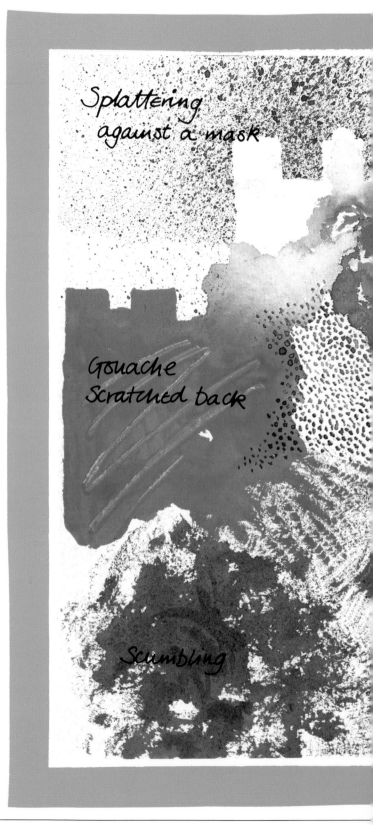

Splattering against a mask

Gouache Scratched back

Scumbling

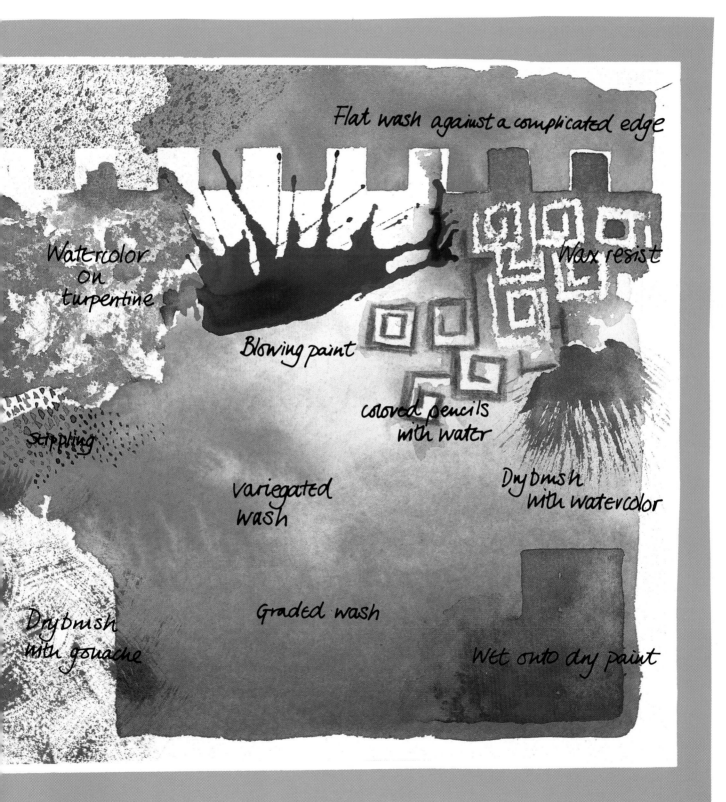

Flat wash against a complicated edge

Watercolor
on
turpentine

Wax resist

Blowing paint

colored pencils
with water

stippling

Drybrush
with watercolor

variegated
wash

Graded wash

Drybrush
with gouache

Wet onto dry paint

Laying a flat wash with a brush
1. The object is to lay flat color over an area too large to be covered by a single brush stroke. The larger the area to be covered, the more paint you will need to mix — probably more than you think you will need.

2. Use a good quality brush to lay the color. When covering large areas, as here, a large size is useful, but a smaller brush will sometimes be easier to manage.

3. Continue to work backward and forward horizontally in broad strips of color until the entire area is covered, then leave your completed wash to dry.

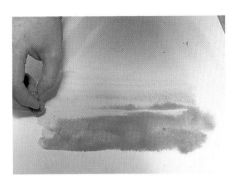

Laying a flat wash with a sponge
1. The object is the same as when using a brush, and a brush is still useful in the preparatory stages for mixing the paint and testing its consistency.

2. It is possible to control quite accurately the amount of paint you lay at each stroke. By allowing the sponge to absorb plenty of color a fairly dense covering can be achieved, or else it can be squeezed gently until almost dry.

3. If a paler effect is required (as shown below) it is possible to rinse out your sponge in clean water and take off some of the color already laid.

were gradually covered with very fine filaments of brush strokes so that the naked eye saw them as solid color.

Flat wash

A good flat wash should have no variations in tone and in order to achieve this it is necessary to dampen your paper before you start; this enables the pigment to spread out so that as one brush stroke is laid against another the paint dissolves on the paper without leaving a hard edge. Mix up plenty of paint – more than you think you will need – and

have to hand a jar of clean water and a large, good quality brush.

Fill your brush from your palette of ready-mixed paint and lay a strip of color across the top of the area to be covered. The board should be tilted slightly to allow the paint to gather along the bottom of the strip so that it can be incorporated into the next brush stroke. Working in the opposite direction, refill the brush and repeat the process, continuing until the entire area is covered. If any blots or drips of paint remain, pick them up with an empty brush,

Laying a graded wash 1. If covering a large area, be sure to mix up enough paint, using a clean palette or white saucer. Once mixed, test for consistency on a piece of scrap paper. If a thinner covering is required, more water should be added.

2. Use a rag, brush or sponge and clean water to dampen your support. Make sure that it is thoroughly damp but not so wet that it buckles violently and makes for a bumpy brush action. A sponge can be used to mop up as well as to add water.

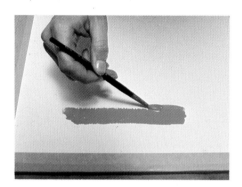

3. Load a brush with the mixed paint and lay a line of color at full strength right across the top of the paper, taking care not to lift the brush half way across and tilting the board slightly so that the color runs downward.

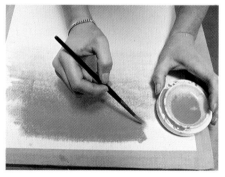

4. In order to achieve a graded effect water is added in increasing quantities to the mixed paint. Make sure that it is absolutely clean; any trace of white or other colors will spoil the transparency and evenness of the finished wash.

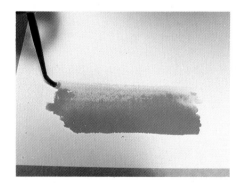

5. Once the paint has been diluted slightly lay a second line of lighter color directly under the first. Repeat with increasingly diluted tones, allowing the lines of paint to blend into each other.

6. The wash may not be as evenly graded as you would like and it is possible to go carefully over areas for a second time before the paint dries, adding pigment to increase density of color or water to make it lighter.

being very careful not to disturb the rest of the color. A wash will often appear uneven until it has dried properly; if you do have to fill in an area, turn the support around so that you can work from the irregular edge toward the area to be filled rather than having paint running into the part of the wash which is already sufficiently dark.

Graded wash

A graded wash covers the paper with the same color of paint but shows a variation of tonal intensity. Lay the first strip of the wash in the same way as for a flat wash, but make the succeeding strips lighter or darker in tone either by adding more water or pigment to your ready mixed paint.

Variegated wash

In variegated washes, it is the colors themselves rather than the tones of a single color that are different. Dampen your support and mix colors in the usual way, then lay the different colored washes side by side so that they melt into one another. Only experience will tell you how much or how little of each color you will need, and no matter how much practice you have had the end result will always be unpredictable. If the wash does not turn out as you had hoped it would, on no account try to change it before the color has dried; only then can colors be lifted off by sponging out or added to by overlaying other washes.

Special effects

Although there exist specific and recognized techniques for obtaining special effects, the possibilities are endless. It requires some ingenuity to discover the methods and materials best suited to your work and the subject in hand; the examples shown here should serve simply to whet your appetite for experimentation.

Keep all your painting materials close at hand so that they are immediately available. It is worth collecting a variety of papers and fabrics for possible use; blotting and tissue paper and materials for collage need not be specially bought but can be accumulated from everyday sources, as can unusual supports on which to work. Paintings done on these unorthodox surfaces will tend either to dramatic success or failure and will teach you a great deal about the potential of techniques and materials.

Left: A completed wash should be left to dry flat; if the paper has been properly stretched any buckling should disappear completely. An entire sheet of paper may be covered with a wash only to practice technique, but quite an extensive area of wash is often required to provide the underpainting for skies, seas or fields.

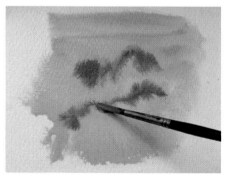

Laying a variegated wash
1. Dampen the paper with a sponge and lay a thin wash in one color, in this case blue.

2. With the original wash still damp, flood in a second color with the tip of the sponge and allow the colors to run together.

3. Finally, prepare a stronger mixture of paint and use a brush to draw it across the support. A fourth color can be added or the wash allowed to dry.

Left and right: The variegated washes shown give but a small idea of the infinite number of effects that can be achieved by the watercolor artist. Variegated washes are controllable only to a degree and provide an example of the unpredictability which is one of the characteristics of watercolor as a medium. It is never possible to repeat the same effect exactly, no matter how practiced the artist

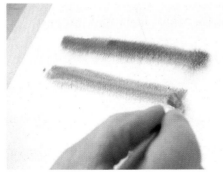

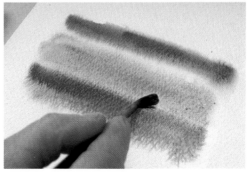

Blending colors 1. This is a more controllable technique than that of laying a variegated wash. Lay two parallel strips of color on dampened paper and allow to dry.

2. A middle strip of color is laid and the edges blended into the existing strips of paint with gentle brush strokes.

Special effects: Watercolor is an extremely versatile medium and can be used either on its own or with other media, materials or resists to produce random, controlled or sometimes dramatic results.

Water on oil: Paint white spirit over the surface of the paper and allow to dry slightly. Lay a wash of watercolor over the top; the paint will separate on the oil creating a marbled effect.

Dry brush technique: Load the brush with paint and wipe off excess moisture before starting to make marks on your paper. A fairly stiff brush is sometimes suitable for this technique.

Scumbling: Load your brush with paint but keep it fairly dry. Rest your working hand on the other hand as a support and work over the surface of the paper with a circular motion.

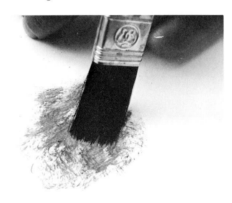

Gum arabic: Painting this substance over your color adds a rich texture to the quality of the paint and, because it acts as a form of varnish, keeps it very bright.

Sponging: Soak a sponge in paint but keep it reasonably dry. Dab the color onto the surface of the paper to achieve a textured effect.

Spattering 1. Dip an old toothbrush into paint until it is well coated and hold it over the surface of your paper. Gently run a knife through the bristles to create a spray of paint.

2. Masking tape can be combined with the spattering technique to create more regular patterns. Here a second color is being applied to give a more complex effect.

3. Be certain to allow the paint to dry thoroughly before attempting to remove the masking tape. There is no limit to the number and complexity of effects you can achieve by this method.

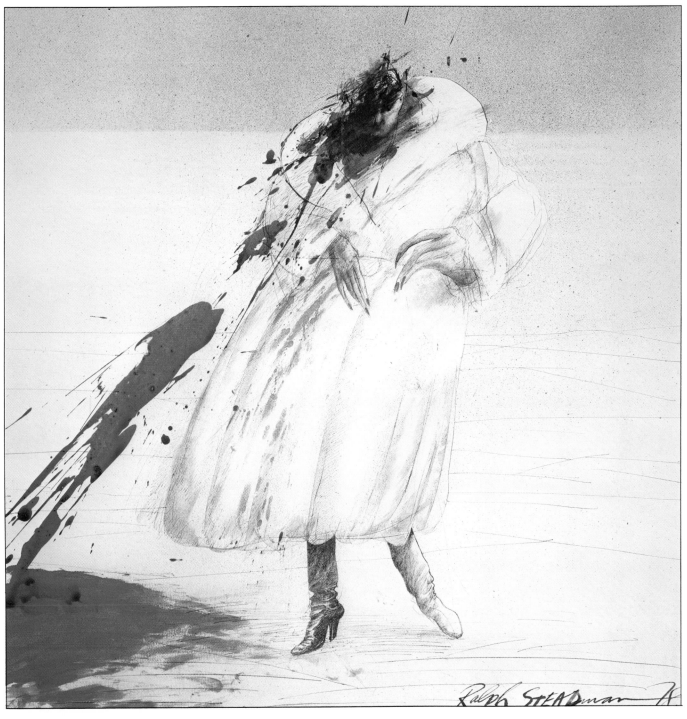

Above: This painting by Ralph Steadman shows an interesting combination of various techniques, including a drawn penline. Much of the blue on the figure and background has been sprayed on with a toothbrush or diffuser, while the energetic splatter of red has been hand thrown with a loaded brush.

Special effects with gouache:

Gouache, or gouache used in conjunction with watercolor, is perhaps the most suitable medium for experimenting to achieve unusual effects. Make a collection of implements other than brushes or sponges that might prove useful and keep them near at hand while you are painting.

Blending two colors: Lay an area of wash in a solid color. While wet, work towards it with a second color until the two merge together.

Comb texture: Mix paint with gum arabic and apply to your support in a thick layer. Use a comb to work the paint in different directions.

Variegated wash: Gouache is more easily controllable than watercolor and if applied fairly thickly, will almost hold its own, with only slight bleeding.

Scratching lines: Lay an area of thick paint over a color that has already dried. While this second layer is still wet, scratch into it with the wood end of the brush.

Scumbling: As with watercolor, work in a circular motion, having loaded the brush with paint, wiped off the excess and fanned out the bristles.

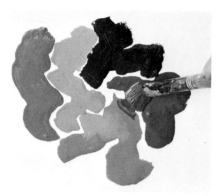

Transferring a design: Use very thick, wet paint to make a design on a sheet of smooth paper, allowing it to bleed in places.

2. Place the painted side of the paper face down on a second sheet and press firmly with your hands to transfer the paint.

3. Remove the top sheet, peeling it back gently. The design will have been transferred to the bottom sheet, the colors spreading slightly.

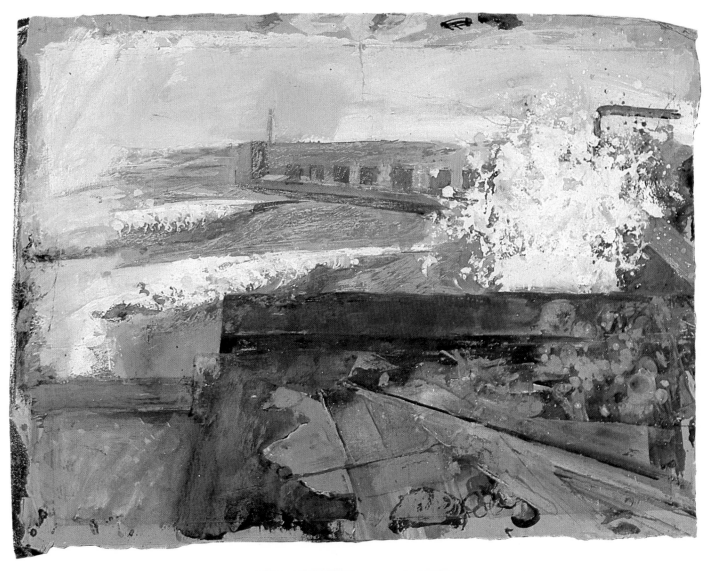

Above: This painting provides a good example of some of the effects that can be achieved using thick paint. The sea spray has been painted by applying the paint directly from the tube onto the brush and the energy used to disperse it onto the paper well reflects the force of the sea. Exuberance in execution and delight in the quality of the paint are benefits to be reaped from the use of gouache.

Drawing with a painting knife
1. Gouache can be applied thickly to the support and spread with a knife to achieve a variety of interesting textures.

2. One method of moving the paint is to place or rest the heel of the knife on the support and make a deft circular movement with the wrist.

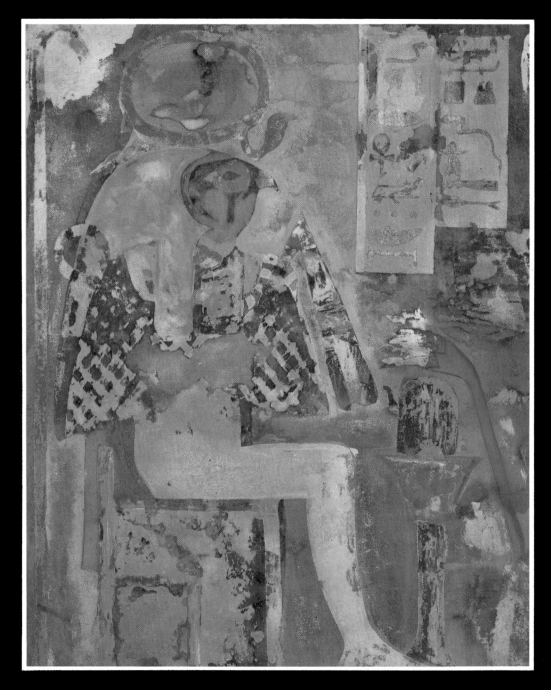

Above: The technique of washing off, as described opposite, is extremely unpredictable and can create an enormous variety of effects. Here, areas of the support were left untouched and brown and orange inks flooded over; this is common in wash off, spaces being left for inks to make a permanent impression in some places while being washed off elsewhere.

Wash off 1. Different colors of gouache are applied thickly to the support and allowed to dry thoroughly.

2. Waterproof ink of any color is then flooded over the support and paint and allowed to cover the rest of the support. This is also left to dry thoroughly.

3. Water is flooded over the support (warm water works more quickly) so that the ink is washed away in places revealing the paint underneath.

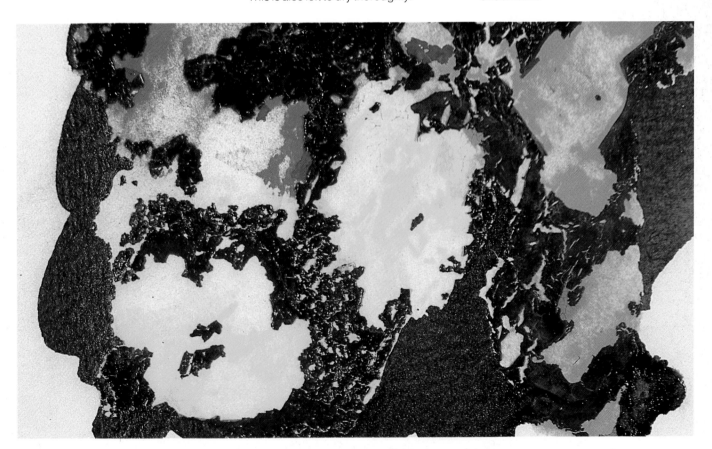

Above: The operation of washing off inks is best carried out over a sink or basin. The results are always unpredictable and it is essential to proceed slowly and carefully. A damp sponge can be used to lift off more difficult areas; whatever the method used, the final result will depend on how thickly the original gouache was painted, how thick a layer of ink was used and the temperature of the water used for washing.

Blotting with tissue: When using a lot of water to blend colors together and to move paint around on the support, tissue is useful for removing paint or for wiping areas that have become too wet.

Laying a wash against a complicated edge: Draw outline and dampen paper up to line. Work paint into damp area, allowing it to spread slowly into required shape.

Stippling: Use the point of the brush to make dots of paint, varying the brush size as required. This technique creates texture and gives a light and bright feeling to an area of color.

Wiping out with a cotton bud: For small areas of correction, dampen a cotton bud in clean water and use it to absorb paint from the support or to move colors around.

Straight edge with ruler: It is quite possible to use a ruler as a guide with a brush, but necessary to work carefully and keep the ruler well away from the wet paint to avoid smudging.

Blotting: Blotting paper is as useful as tissue paper for controlling the flow of paint if the color is too strong or too wet. Press it gently over the area to be dried.

Masking fluid: Paint a design on your support using masking fluid and allow to dry before laying a wash over the top. When the paint is completely dry, use a soft putty rubber to remove the fluid.

Oil pastel resist: Draw a design on your support with a neutral colored oil pastel then lay a wash over this; the areas covered by the oil pastel will form a resist and remain free of paint.

Masking tape: Apply tape to the areas you want to remain white and lay a wash over the support. When completely dry, lift the masking tape carefully to reveal the design.

MAKING CORRECTIONS

Scraping off: Use a one-sided razor blade to scrape off the surface paint to lighten an area. Keep the edge of the blade flat on the paper to prevent corners digging in.

Blotting paper: This can be used to pick up surplus paint and water and is thicker and therefore more absorbent than tissue paper.

Sponging: A wet sponge will reduce some of the intensity of color, although the success of this correction technique depends to a certain extent on the staining power of the pigment.

Right: Small splashes can be removed by soaking up the paint with the corner of a twisted piece of tissue paper. Once the paper is thoroughly dry, a razor can be used to gently scrape away any remaining stain (**above**). Rubbing the area gently with a soft rubber will help to smooth down the surface before you start to paint again.

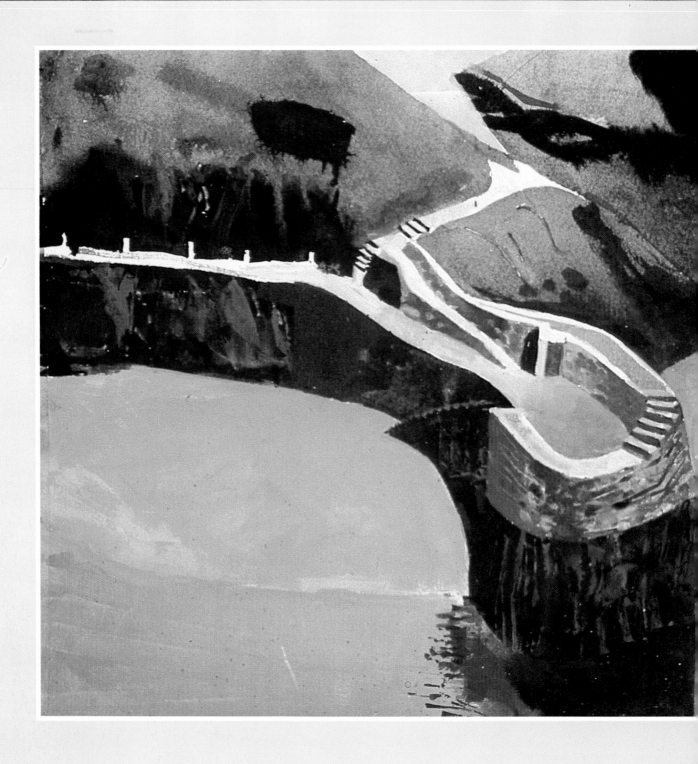

Above: In many seascapes the interest lies not so much in the painting of vast areas of water but in the way in which the water is intersected by the shoreline – by the juxtaposition of sea and land. Here, the emphasis is on the shape of the pier and the jutting of rocks, resulting in a slightly unusual perspective.

LANDSCAPE AND SEASCAPE

MANY WATERCOLORISTS will not consider that they have begun to explore the possibilities of their chosen medium until they have made some progress in the painting of landscapes. It was not, however, until the 17th century that landscape painting became an art in its own right, the narrative element formerly being much more important and the surroundings thought of merely as a backdrop against which figures were to be placed.

There are as many subjects to choose from as there are watercolorists to paint them. Look for something which interests you particularly and excites you visually. Do not feel that you have to search out an idyllic vista of fields and hills; many interesting paintings have been made from much more unlikely urban scenes, or from the tamer versions of nature to be found in your own garden or local park.

If you do venture forth, go well prepared. Decide in advance just how little you can manage with in the way of materials, but do not forget the few creature comforts that will make all the difference between an expedition that is merely bearable and one that is positively enjoyable.

LANDSCAPE

Much of the tradition and history of watercolor painting is based on the painting of landscapes and today mention of the amateur watercolorist still conjures up visions of the dedicated artist facing the elements, armed with brushes and portable easel. Practical considerations should certainly be pondered before setting out to paint a landscape. You will have to contend with the weather, sometimes wet, windy or far too hot, and with the idle comments of curious passers by. But it is well worth the effort of making excursions to paint out of doors.

Start close to home. Your garden or local park may provide just as stimulating a view as acres of rolling countryside, with the added advantage that if you have forgotten a vital piece of equipment, it is easy to return home to collect it. Use these early excursions to discover if

you prefer paper stretched on a board and supported on your knees, heavy duty paper that will not buckle under wet washes, or a small portable easel.

We appreciate the countryside or townscape that forms our environment not merely through our eyes but also through our senses. Changes in the weather, the seasons and between light and dark are all part of this experience and will color our approach to painting a landscape. The colors used and the quality of tone will have a direct effect on the light and atmosphere you create in your painting.

The very English landscape on pages 86 and 87 is a good example of this. The white of the paper shines through the wetness of the loose washes to give a light and clarity; the horizontal lines give a sense of tranquility; a high viewpoint shows the overall scene. The sky is light in tone and

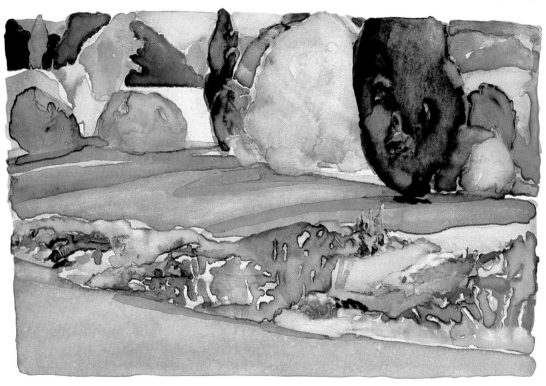

GARDEN WITH FLOWER BORDER
10 x 8 in (25 x 20 cm)

Broad areas of color are laid in with well-diluted paint to establish the basic forms in this landscape. As the pools of wet color dry out, a line of concentrated color forms around the shape. Descriptive detail is added in the same way, by gradually breaking down the large masses with small areas of local color. This technique allows you to visualize the overall scheme of the painting at every stage, so the impression of detail emerges through the careful placing of successive washes, rather than by intricate brushwork.

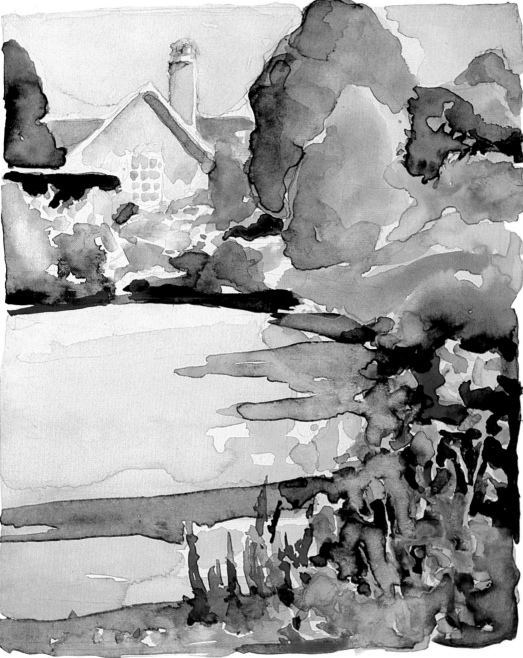

BACK GARDEN VIEW
10 x 12 in (25 x 30 cm)

The visual charm of your own home surroundings may be overlooked because everything seems so familiar. If you spend some time examining different viewpoints in terms of your interest as a painter – the light, colors, tones, pattern and texture – you will soon find an unexpected angle which can form the basis of a satisfying composition.

Above: Brief pencil guidelines help to establish the scale and position of each element of the landscape. Although much of the painting has been built up with washes, some linear and color detail is best defined at an early stage, by drawing in paint with the point of the brush.

Right: Sometimes the nature of a painting demands an even spread of color in the wash areas, but interesting surface effects are gained by allowing the paint to flow freely and dropping extra color into the damp wash to emphasize the hues. However, this must be carefully controlled, especially if the detail depends upon the calculated use of white paper to provide the highlights. Although some paint can be lifted, the brilliance of the white is lost if too much of the paper is flooded accidentally.

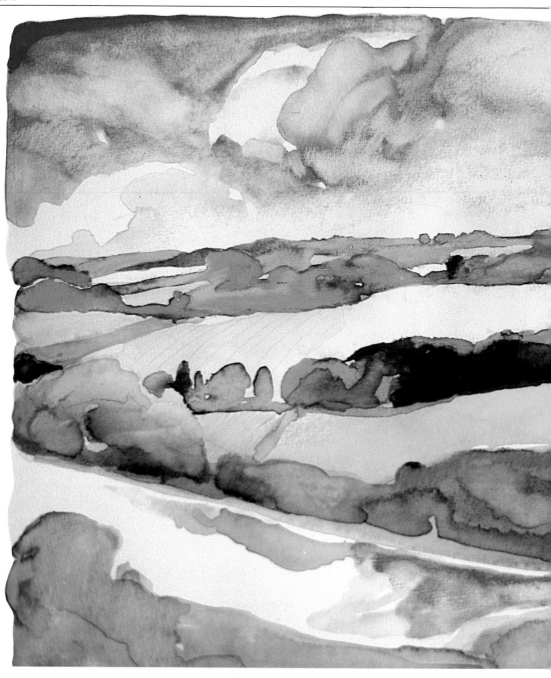

Above: Many different colors are used in painting the sky (**top**) – Magenta, Deep cobalt, Cerulean and just a touch of Yellow ocher predominate They are laid in very wet washes over one another, so that they bleed together, but it is important to leave white spaces as shape, particularly as background to set off the stronger foreground clouds. Leaving the edges darker than the centre gives a three-dimensional effect. Wiping out color with a cotton bud is another important technique (**center**). If this is done while the support is still wet the paper is softer and more inclined to break and color floods in quickly again. When the paper is dry, more paint can be lifted off. Cotton buds can also be used to blend colors or to lay a thin layer of color over a light surface (**bottom**).

Right: The different greens of the fields and trees are also laid in washes, starting in an investigative way with the paler tones then putting in the darks of the trees and hedges, again using plenty of water to blend colors.

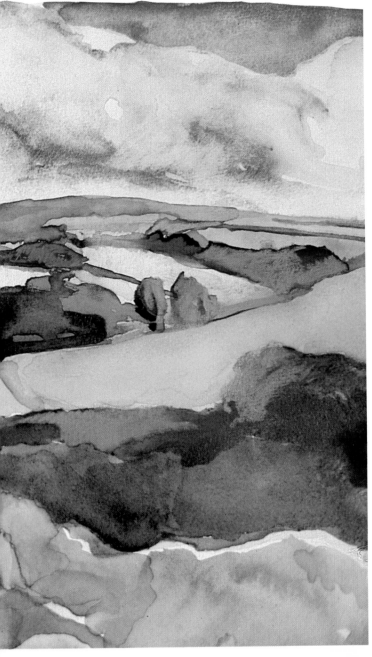

therefore all parallel surfaces – fields, rivers, lakes – will tend to be light also to reflect this. Under these circumstances, objects standing against the sky such as trees, banks and distant hills will tend to be dark. Conversely, if the sky is dark and ominous this will be reflected in the other flat surfaces.

With a low evening sun, buildings and trees will catch the light; wind causes movement and bends trees, people and blades away from its direction; rain brings in its wake fresh visual excitement; late evening sun shines red through low cloud and causes long shadows and warm lights; snow or mist transform a familiar landscape. These points may all seem obvious, but you will find it helpful to bear them in mind when looking at a landscape.

Aerial perspective

Also known as atmospheric perspective, this is a subject which is of particular concern to the landscape artist. *River Landscape* shows how diminishing tones and distant blue mountains give a depth to the work which is totally believable; we see it not as a hillside and mountains painted on a vertical picture plane but as a landscape stretching away from us.

Objects in the foreground are stronger in tone and have stronger tonal contrasts within themselves than objects in the middle distance, and these in turn are stronger than objects in the far distance. This difference in tone is the result of haziness caused by dust particles and mist and other effects of weather. As tones lessen in strength, they take on an increasing blueness; as in the case of *River Landscape*, a far distant range of hills is likely to be seen almost entirely as a limited scale of light blues and blue-grays. Middle distance fields will tend to be seen as greenish

RIVER LANDSCAPE
18 x 12 in (45 x 30 cm)

A landscape such as this is notable for the fact that it relies for its impact and dramatic effect on purely natural features. An artist will often include a distant group of buildings, an architectural feature such as a church spire or a figure to provide interest. In this case, however, there is plenty of variety in the combination of rolling hills, widely differentiated colors of fields, shadows from the trees and, most importantly, the river with its reflections of the dramatic sky.

Left: Very fine sandpaper can sometimes be used to make small corrections, leaving the watercolor until it is dry then rubbing the surface gently. In this case, sandpaper is used to lighten the color of the entire surface of the largest field. Anything other than the most gentle pressure will cause holes in the support.

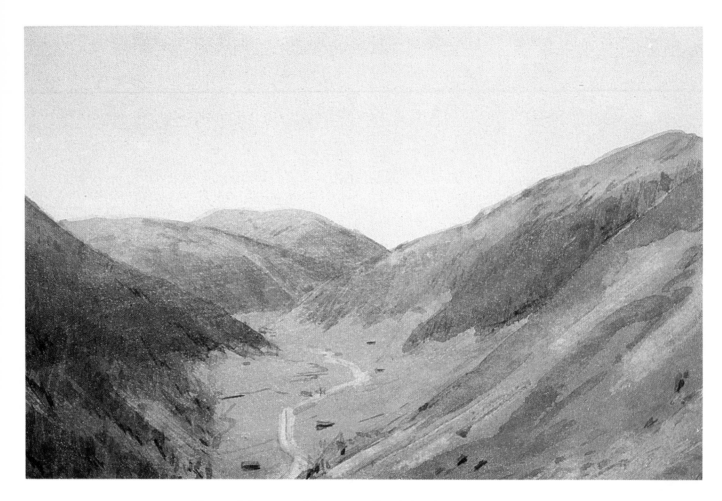

blue and foreground features will exhibit the whole range of color and tone.

Another method of establishing depth is by the scale of forms in the foreground. *Standing Stones* on page 89, for instance, uses a deliberate contrast of scale, while *White Horse* on page 113 sees the distant hills through a lacework of fence and trees. The inclusion of monuments, buildings, figures and other features adds interest and can create drama. It can often be the visual focus point in the composition as seen here, or the main subject of the painting, with the surrounding landscape providing atmosphere and setting the stage. A building in a landscape can provide an interesting change of tone and form – a basic rectangular shape within softer, more natural forms.

Green is the most dominant color in landscape. It is easily made thin and acid and it takes real sensitivity to achieve vibrant foliage or a good grass green. No one green will be adequate to depict the range of color seen in nature.

VIEW THROUGH THE VALLEY
10 x 7 in (25 x 18 cm)

This landscape illustrates the use of a classical watercolor technique. The palette is limited and the tones and hues derive from the overlaid washes, with the white paper providing the highest tone and giving luminosity to the color washes. The control and subtlety exercised here indicate the considerable technical skill of the artist and a good eye for tonal assessment. Full use has been made of atmospheric perspective as the magnificent slopes in the foreground give way to the hazy blue tinge of the distant mountains.

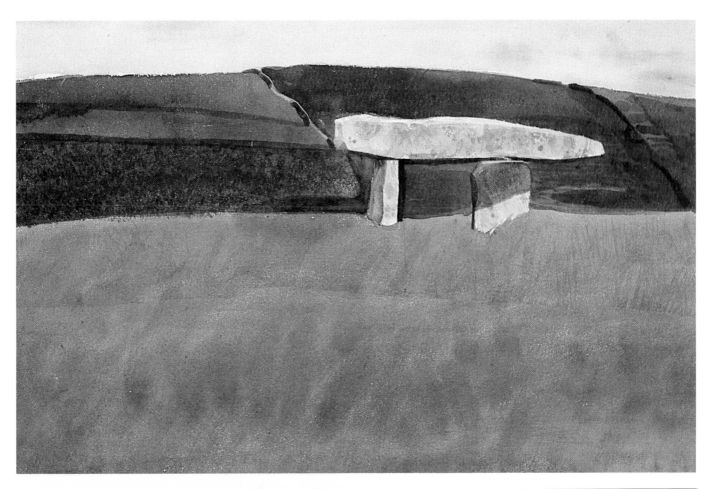

LANYON QUOIT
20 x 14 in (50 x 35 cm)

Natural conditions are not always kind to artists working from life. This watercolor (**above**) was made out of doors in extremely cold temperatures. This is an occupational hazard which need not be a handicap. The energy, enthusiasm and commitment which enable an artist to persist in working in such unfavourable circumstances are often reflected in the quality of painting. The horizontal emphasis of this composition is reinforced by the broad tonal divisions of the planes. The large area of wash in the foreground is enlivened by a varied density of color and the addition of fine brush strokes to create texture.

STANDING STONES
10 x 7 in (25 x 18 cm)

In the second example (**left**) the foreground colors, and the purple of the cabbage field behind, are the result of several overlaid washes, each qualifying the color of its predecessor. This allowed the artist to lay in warm tones and then overlay cooler colors, to correspond directly to his analysis of the tonal balance. The complex depth of the colors thus created is one of the advantages of watercolor over other mediums.

The same trees and fields will change from season to season; yellow-green spring shoots change to blue-green summer leaves to the purple, yellow and orange of autumn.

It is important to vary the basic constituents of the greens you use; blue and yellow mixed give the most common result but Black, Umber and Yellow ocher are frequently added, and mixtures of Prussian blue and Raw Sienna or Raw umber contrast well with the brighter hue of Viridian. The general rule is to make sure that more than one green is used in any painting.

The effects of light

Light will play an important part in determining the atmosphere of your painting, and watercolor, with its characteristics of fluidity and transparency, is a particularly suitable medium for capturing its effects. As well as creating the general mood of a picture, light can also be responsible for dramatic effects, with strong light giving rise to deep, dark shadows or an unusual quality in the light being responsible for a weird and unnerving glow.

Geographical location is one of the major factors affecting the quality of light. *Roadside Cafe*, *River Steamboat* and *Townscape with Tower* were all painted abroad and show evidence of the hot intensity of southern light which is in marked contrast with the light coolness which emanates from pictures painted under a northern sky. The time of day is also important. The qualities of thin, early morning light, of midday sun high in the sky or of a rich, warm

1. Make a fairly accurate drawing, positioning horizon carefully. Lay sky color first as everything else will be darker, using a variety of blues and Naples yellow to cut intensity.

2. Add plenty of water to building color to give effect of age. Block in greens, cutting intensity with complementary colors – Yellow ocher, Siennese red and Cadmium yellow.

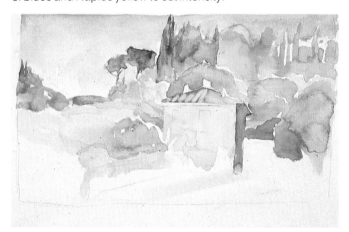

3. Put in red roof of building; shade side with Sienna red, Naples yellow, a touch of Emerald green and Cobalt violet deep. The small group of Italian umbrella pines provides a focal point; use plenty of water and do not line them up too regularly.

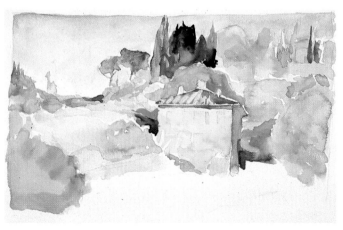

4. Use Sienna red cut with Emerald to put shadow under roof; deepen texture on roof and face of building with subtle, warm earth tones. Redraw the church in background. Place darks all round the picture, inserting foreground color.

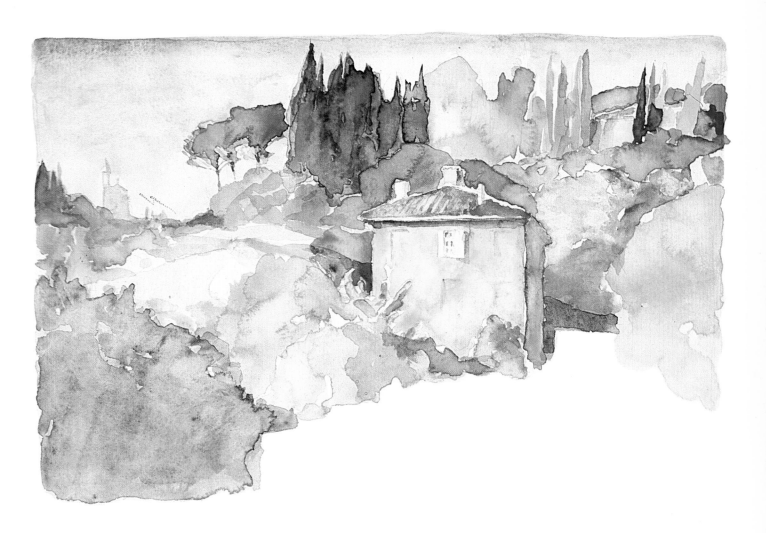

HOUSE AMONG TREES
15 x 9 in (37 x 22 cm)

When making your preliminary drawing for a landscape, do not be afraid to alter small details of composition, in this case, for instance, the position of groups of trees or distances between windows or chimneys on the house. This painting does not employ the traditional method of working from light to dark, some small areas of darker color being put in in the early stages. The real darks, however, are not inserted until the end.

Above: Make furrows of tiles on roof by extracting, using a clean cotton bud. Work gently or paper will rip.

Above: The tops of the trees provide interest on the skyline and should be delicately painted. In order to make a good point, pull the brush upwards and lift.

evening light can totally alter the scene you are painting. A midday sun produces short shadows with objects lit from above whereas a sinking or a rising sun will produce long shadows with warm or cool tones.

General weather conditions will of course affect the quality of light, a cloudy overcast sky, for instance, giving a dull thin light, and dramatic clouds producing strong shafts of light piercing through. Dramatic weather conditions do not appear to order, and certainly not if you are anxiously waiting for a thunder storm or a thick fog. It is advisable, therefore, always to be prepared, perhaps carrying a sketchbook and small box of paints if you are travelling by car. Even an ordinary notebook is extremely useful; weather conditions can be quickly recorded and copious notes made so that a finished watercolor can later be painted in the studio.

ROADSIDE CAFE
18 x 12 in (40 x 30 cm)

This roadside cafe (**below**) formed an attractive subject for a painting because of the crazy paving patterning of the advertising signs and the variety of letter forms. A careful preliminary drawing was made, requiring much discipline and patience on the part of the artist. A knowledge of perspective was needed and the drawing had to be precise and brought to a detailed state before the watercolor was added. The painting technique is quite simple, but there are many complicated outlines and an artist must be skilled in controlling flat washes of color if this technique is to produce a result worth the effort applied to the drawing.

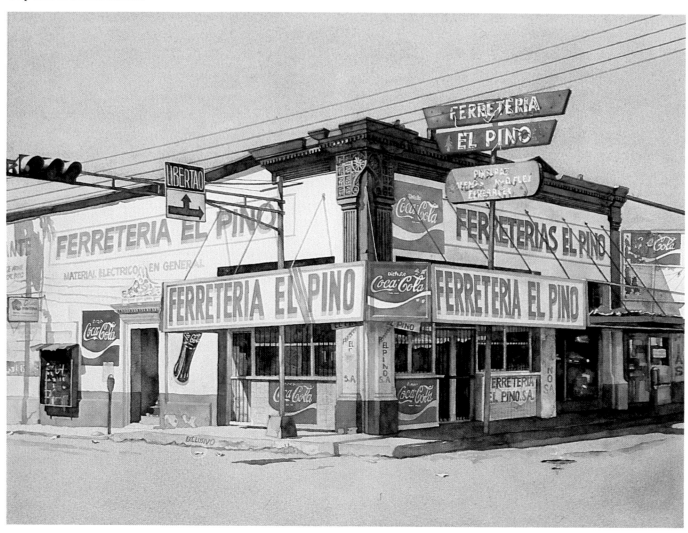

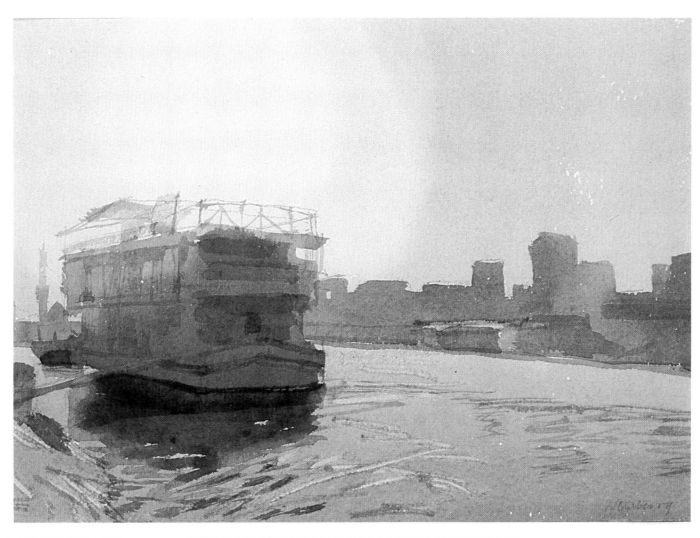

RIVER STEAMBOAT
10 x 7 in (25 x 18 cm)

Tonal variations within a limited color range are skilfully used to create the form and space in this river scene (**above**). Simple devices such as the streaks of light tone in the foreground and the reflected color of the boat effectively convey the rippling water surface. The background shapes are blocked in briefly but the subtly changing tones of gray demonstrate the artist's careful observation and interpretation of the receding view.

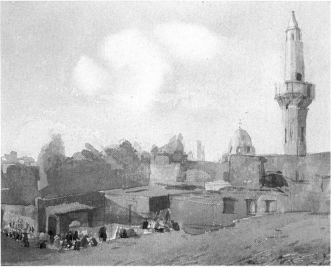

TOWNSCAPE WITH TOWER
12 x 8 in (30 x 20 cm)

The accurate assessment of tonal relationships in the painting of this townscape (**left**) is another method of conveying an impression of complexity. The chatter of bright color representing the crowd of people contrasts well with the neutral colors of the architectural shapes.

STONES AT AVEBURY
22 x 14 in (55 x 35 cm)

The artist chose the viewpoint for this painting with great care, wishing to impart a sense of the grandeur and timelessness of an ancient monument. This is achieved by placing the dominant form of the large stone directly in the foreground to fill the picture plane from top to bottom. The cool tones of washed-in color express both the clarity of daylight and a sense of spaciousness which echoes the perspective provided by the stones. The texture of the stone is detailed with a limited range of color and contrasts well with the flat washes corresponding to the broad expanse of grass.

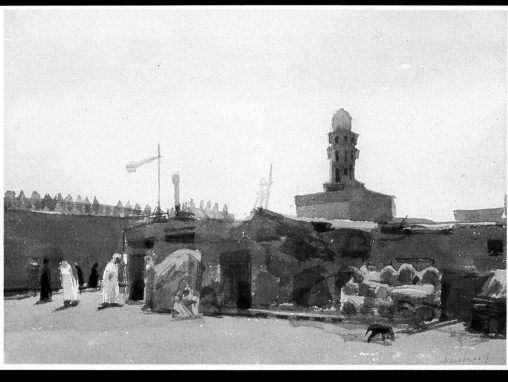

FOREIGN TOWNSCAPE
12 x 8 in (30 x 20 cm)

The use of the subtle tonal capacities of watercolor to portray the quality of light is again seen to advantage here. The highlights on the figures are the only areas to show white from the paper support. The buildings are described as blocks of tone with the shadows gradually darkened in successive washes. The limited palette lends an overall harmony to the color values. The sky is laid in with a simple wash of blue, gaining luminosity from the white paper beneath. A holiday abroad is an ideal opportunity to study unfamiliar light effects.

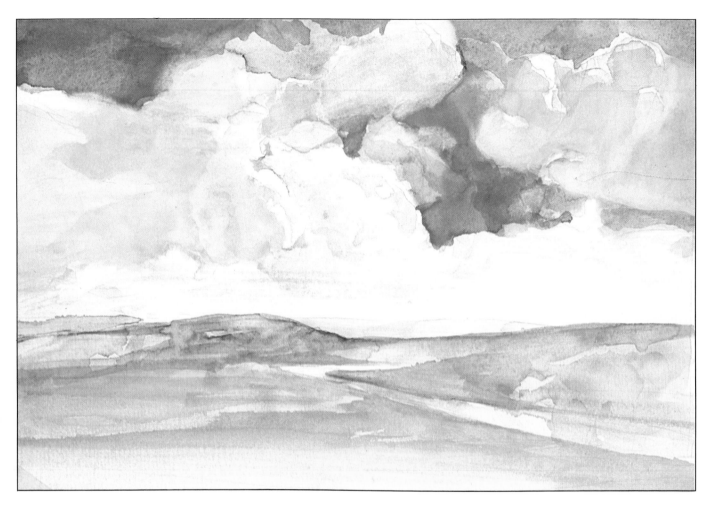

1. There are two general methods of drawing clouds; either from a photograph, extremely accurately, or by sketching to get the general effect – the rhythm of the clouds and the shapes between. Start painting in the clouds, working horizontally then drawing the brush around the shape to pull it into the picture.

2. Block out the land lightly. The distant hills are darker than the foreground but will be overlapped so are put in first. Keep the middle ground fairly light – Olive green, with Burnt Sienna to cut intensity. Pick out some darker shapes in clouds; a tiny bit of pink indicates light from the land.

Even under normal conditions, light can change very quickly and it may be necessary to work extremely fast. On a summer's evening, for instance, fast lengthening shadows and the sinking of the sun will make it necessary to pace your work accordingly and not attempt too detailed an interpretation of your landscape. As far as choosing a palette is concerned, only practice and experience will tell you which range of colors is best suited to certain effects.

Painting skies

Large expansive skies have played a prominent part in the history and tradition of watercolor. They can feature as a backdrop to your painting or else play an integral part, frequently lending drama or indicating vastness. Because the source of light is generally in the sky itself, it follows that this will be the area lightest in tone in the landscape; it is necessary, however, to integrate it with the overall tonal scheme and you may find yourself adjusting either the sky or the land accordingly.

The fact that watercolorists have had such a propensity for painting skies is due to quite a large extent to the nature of watercolor itself. It lends itself very well to this subject, the unpredictability of wet into wet washes, the transparency of the medium and the possibility of coming up with a happy accident all contributing to the range of effects that can be achieved. It is possible to create a sky by means of a single flat wash but much more likely that it will be the result of many overlaid washes and exploratory workings.

LOW HORIZON WITH CLOUDS
14 x 10 in (35 x 25 cm)

The perfect landscape doesn't exist; it's what you do with your material that counts. Make preliminary notes and sketches to decide on the best composition. Here the sky is the most interesting feature so the horizon is in the lower third of the picture.
Above: Mid-tones like Payne's gray help counteract one-dimensional effect.
Right: A cotton bud softens edges of clouds.

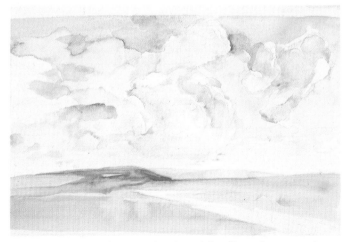

3. Put middle tones into the clouds, adding Payne's gray and other colors to make them more three-dimensional. Deepen tone in area of horizon; some small clouds here will help the overall perspective.

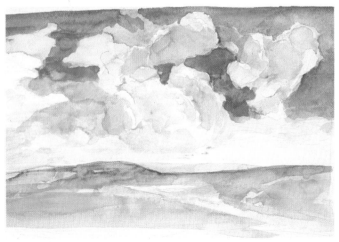

4. These are storm clouds, so make them more dramatic. Drop some dark clouds into the foreground and stripe the land with shadows. Unify some of the cloud shapes by making them bigger and less fragmented. Emphasize the contrast between small, sharp-edged clouds and more diffuse edges of larger shapes.

Various basic techniques of watercolor painting are useful in simulating the effects of patchy white clouds in the sky. A thin wash of white over dry washes in tones of blue (**below**) suggests a heavy, fleecy cloud. The tone is modulated by the washes beneath so the shape does not look too solid. Gouache over dry watercolor is well suited to this practice. A more vaporous, atmospheric effect is gained from dropping wet paint into a wet wash of color. The paint spreads of its own accord and the edge diffuses gently. Too much moisture will cause colors to mix on the support and become dull. If there is excess paint, sponge out unwanted areas as they dry. Repeated applications of color to modify the tone are unlikely to be successful.

THE LIGHTHOUSE
20 x 27 in (50 x 68 cm)

This painting is on tinted paper and the light blue and white washes of gouache across the area of sky are qualified by the tone underneath. This enhances the brilliant white of the buildings, which gain strength and solidity from the use of pure, opaque white gouache. A hint of pink on the horizon line suggests evening, as do the long, deep shadows on the buildings. The simplest possible statement of the broad expanse of green clifftop grass in the foreground is an obvious foil to the detail and clarity of color in the forms above.

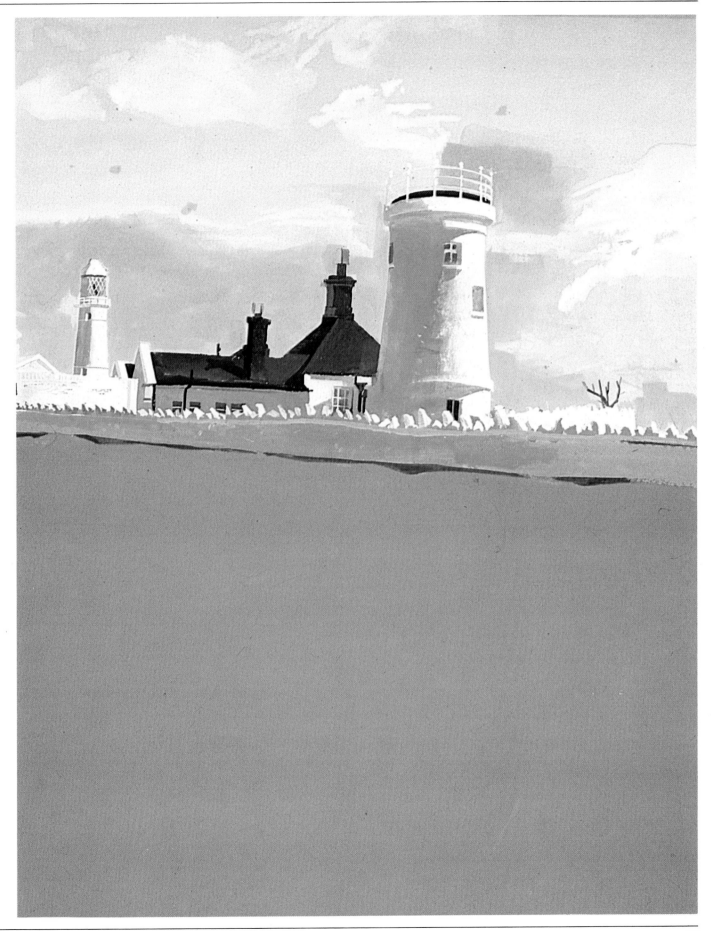

ARCHITECTURE

BALCONY IN FRANCE
8 x 8 in (20 x 20 cm)

The organic form of the tall palms contrasts well with the regular shapes of the buildings in this courtyard scene. Fresh colors are further enlivened by the splashes of intense red and blue in the flowers lining the balcony. A subtle use of shadow gives the image depth and solidity without dulling the colors. A careful pencil drawing was made to establish a sound interpretation of spatial relationships before color was applied.

When painting urban landscapes or buildings in general it is essential to have a fairly thorough knowledge of perspective. Rectangular, man-made forms require a believeable and more solid realism than softer, less easily defined features of a landscape.

In the painting *Roman Facade* the initial drawing has been carried out accurately. The shapes and forms are closely related and although there is freedom within the work every window, column and carving has been judiciously considered and placed. The perspective used here, however, is fairly simple, the trees and pavement giving the initial clues to the three-dimensional element.

A roof-top view would require greater knowledge of perspective. Even drawing from an upstairs window will be

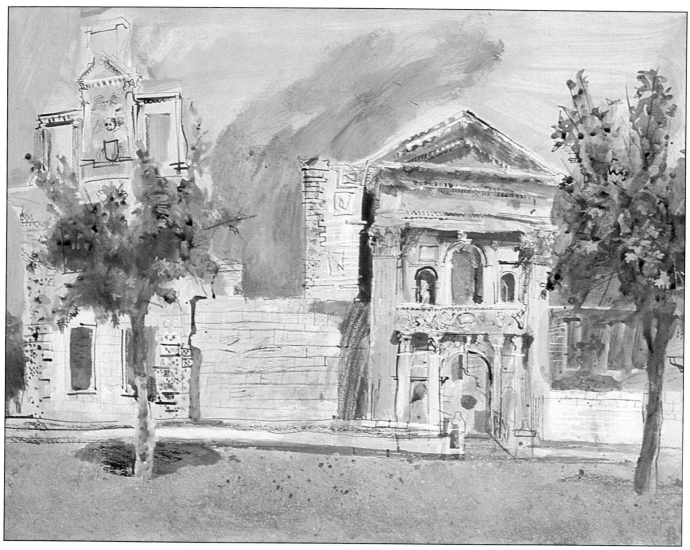

ROMAN FACADE
30 x 22 in (75 x 55 cm)

A combination of painting and drawing techniques is the key to this exuberant rendering of a classical structure. The balance of horizontal and vertical stresses was carefully considered in planning out the composition. The trees relieve the central division of the picture plane by cutting through the height of the walls. The linear detail which etches in the character of the old building is laid in with sepia ink, applied with a dip pen (**left**) over the watercolor washes. Pastel drawing in the curves and hollows of the building (**far left**) adds depth to the tones and textures of the stonework.

DOORWAY
12 x 20 in (30 x 50 cm)

To achieve the crisp detail of form and decoration in this painting (**opposite**) a pencil drawing was made to form the basis for the addition of color. All the lines, shapes and proportions were carefully considered and realized in the drawing before the initial washes were laid. To maintain this standard of precision, each area of wash was allowed to dry before more color was added. This can be a time consuming process, so when you approach a subject requiring a similar technique, arrange to work from all sides of the drawing, turning the board to fill in a section opposite a newly laid wash. Take great care not to let your hand rest on paint which is still damp as it is difficult to disguise smudging and unintentional variations in tone in work of this accuracy.

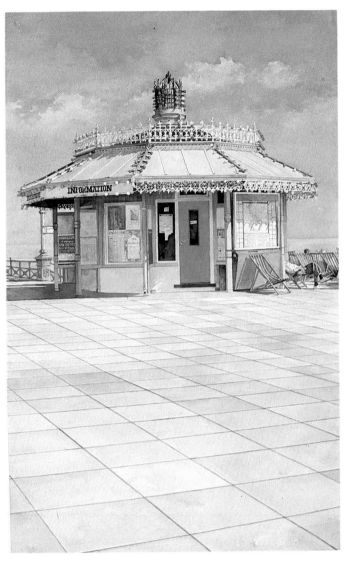

SEASIDE PAVILION
12 x 20 in (30 x 50 cm)

The regulation and delicate tones of the pink and blue paving stones (**left**) here offer a pleasing contrast to the detailed treatment of the intricate ironwork and jumble of notices on the little seaside pagoda. The light and shade are cleverly handled and complement the accurate drawing so that the pagoda stands out clearly in three dimensions against the sky. The summery blue of the sky and suggestions of passing clouds are built up in a series of washes of the same color, some allowed to dry with clearly defined edges, others melting hazily together. The considered treatment of each area of the painting, including the generous foreground, makes this an attractive, cohesive image.

more difficult than working from ground level; the establishment of your eye level is important. The handling of the Roman building, however, is more akin to that used for natural forms; the freedom of splatter, pastel and pen and ink work is not immediately recognized as being suitable for such a classic, restrained subject.

The color of a townscape can be infinitely subtle and stimulating, with varying grays, brick reds and the white of stonework providing a harmony. Try to capture also the bustling pace of a town and the movement of people and cars. The light of townscapes is very different from that of the country. Instead of light being flooded over a whole area with the sun being diffused only by the atmosphere or by clouds, buildings act as obstacles and create interesting and even dramatic lighting effects. On the brightest of days tall buildings can trap shafts of sunlight so that one side of the street can be in sunshine, the other deep in shade.

The intimacy of narrow, winding streets and passageways can provide the focus for your painting; ancient buildings and modern skyscrapers can throw up strange and interesting contrasts in scale, architecture, social comment and juxtaposition of shapes. Within your local town, search out areas of interest for painting; a church, the market place, a riverside and docks or wharves.

One problem you may encounter is the practical one of setting yourself up. A crowded street is no place for a portable easel and in most urban locations you will have to make do with a sketch book.

SEASCAPE

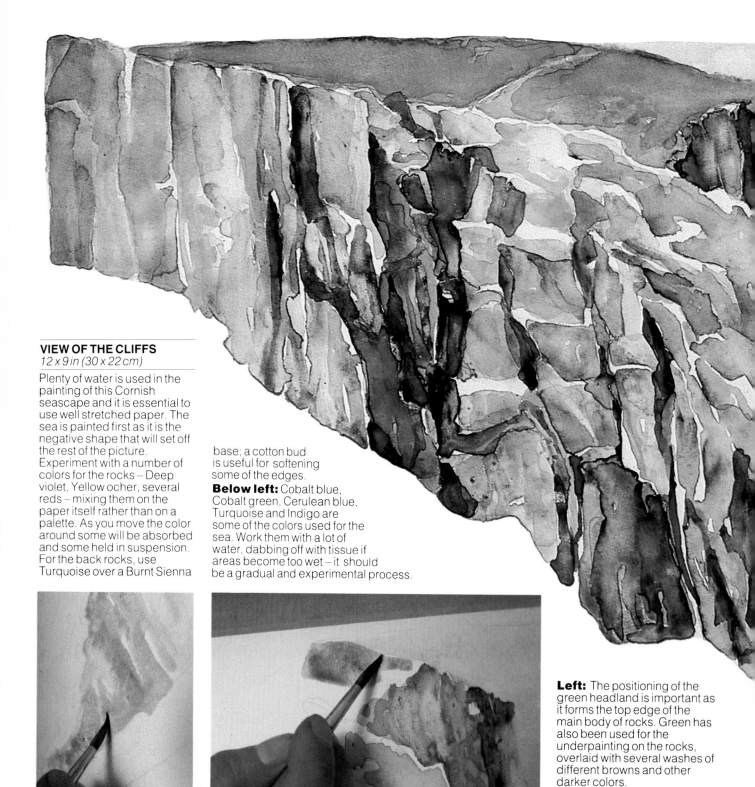

VIEW OF THE CLIFFS
12 x 9 in (30 x 22 cm)

Plenty of water is used in the painting of this Cornish seascape and it is essential to use well stretched paper. The sea is painted first as it is the negative shape that will set off the rest of the picture. Experiment with a number of colors for the rocks – Deep violet, Yellow ocher, several reds – mixing them on the paper itself rather than on a palette. As you move the color around some will be absorbed and some held in suspension. For the back rocks, use Turquoise over a Burnt Sienna base; a cotton bud is useful for softening some of the edges.

Below left: Cobalt blue, Cobalt green, Cerulean blue, Turquoise and Indigo are some of the colors used for the sea. Work them with a lot of water, dabbing off with tissue if areas become too wet – it should be a gradual and experimental process.

Left: The positioning of the green headland is important as it forms the top edge of the main body of rocks. Green has also been used for the underpainting on the rocks, overlaid with several washes of different browns and other darker colors.

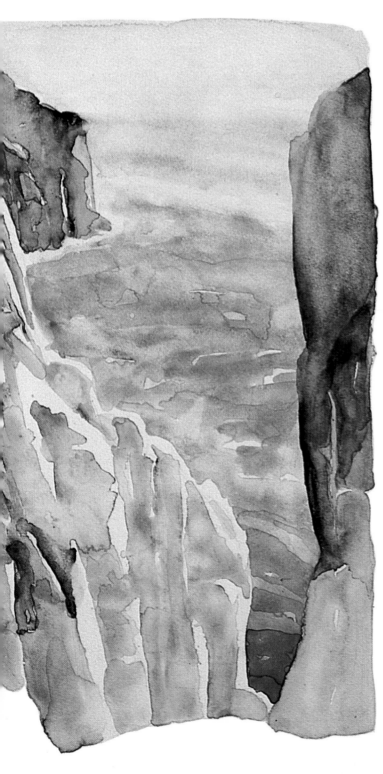

The various moods of the sea provide the artist with a very different challenge from that of painting a landscape. The changing seasons bring tremendous fluctuations between wild threatening waves and strong winds and the balmy airs of a warm summer's day.

Selecting a subject

As well as trying to capture the moods of the sea, the watercolorist may choose to depict figures, either bathers at a resort or fishermen, or items such as the Victorian amusement piers which still exist in some of the more popular seaside towns. The cosy harbor walls of a Cornish fishing village, the clifftop lighthouse or seaside changing cabins can all contribute to atmosphere. The landscape near to the coastline also offers plenty of scope – towering cliffs, sandy coves, rocky bays and flat sand dunes.

When selecting your subject, think of what it is that attracts you to a particular theme and consider the best way of recording your reaction and the materials most suitable for depicting your chosen topic. *View of the Cliffs* is a striking view of the coastline and the composition was chosen to emphasize the magnificence and majesty of the cliffs as they meet the sea. The thin, light washes provide evidence of the way in which the transparency of water-color as a medium can convey the impression of light.

Techniques

A variety of techniques is appropriate for seascapes, as can be seen in the thick, impasto-technique use of gouache in the painting on page 77 and the dry brushwork of *The Cob at Lyme Regis*, but a wet technique is naturally more appropriate and easier to handle as it reflects the character of the water and allows for the freedom and fluidity for which you

Right: The rocks at the right-hand side of the painting are put in in two steps; first a light ground of Payne's gray and Yellow ocher then a darker wash of Payne's gray and Deep violet. The edge is created with the point of the brush. At the bottom there is a swopping over of tones, with the rocks becoming lighter than the sea.

HARBOR WALL, BOSCASTLE
14 x 22 in (35 x 55 cm)

A visually rich combination of color and texture is given elaborate treatment here to describe the quaint appearance of a twisting harbor wall (**right**). Earth colors and a glowing green form the basic palette.

Above: The surface of a flat wash comes alive when the tonal detail is provided in a carefully judged combination of warm and cool tones. Small areas of color are applied to broadly washed in tones with the point of the brush (**top**). Soft fusions of tones are made by laying more paint into a still damp wash.

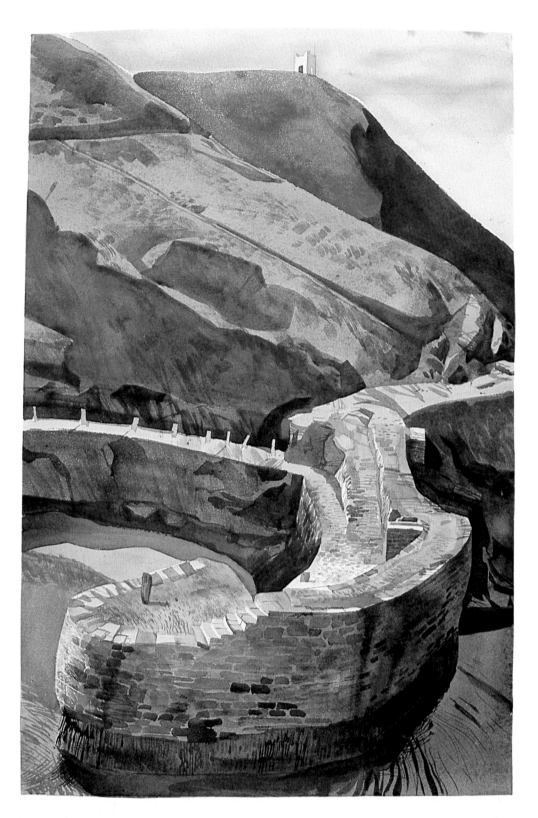

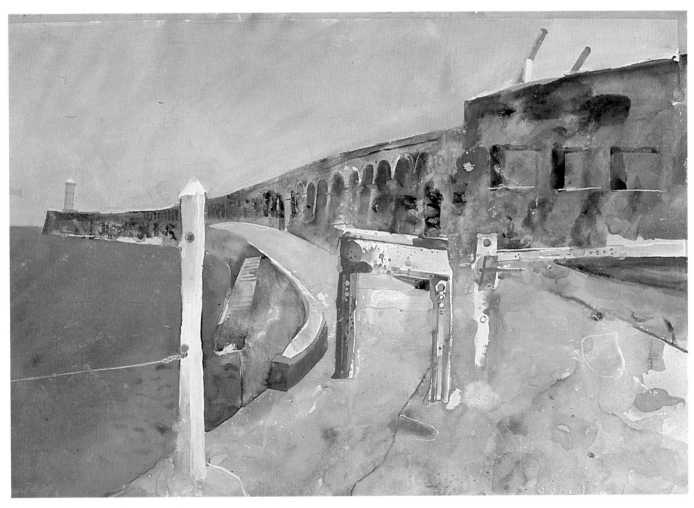

may be searching. Be careful, however, not to be carried away by the beauty of your wet washes. Too much color added too quickly can result in a muddy nondescript wash; sometimes it is better to allow washes to dry before adding any additional color.

Piers and buildings

Harbor Wall, Boscastle and *Newhaven Pier* show a keener interest in the architecture related to seascape than in the sea itself. They adopt differing viewpoints, one looking down across the harbor inlet and the other looking up the pier from a seated position. Both are compositionally strong, using the sweep of the pier to lead the eye through the picture. It is certainly true that the land can often provide more visually interesting aspects than the sea, which is often indicated only by a simple wash in the background.

NEWHAVEN PIER
20 x 14 in (50 x 35 cm)

The same subject, but in a different location, prompts a wholly different mood in the artist's approach. The paint is applied freely with loose areas of bright color melting together. Even a relatively inactive area like the sky, where only one color was applied, is treated vigorously with broad, sweeping brush strokes. To create an interesting focal point, the rusting metal structure in the harbor wall is brought forward and emphasized with clarity in form and color. It may often be necessary to select from a natural view and alter the relationships of the components slightly, even abandoning those aspects which interfere with the development of a satisfactory composition. However interesting the subject, painting is not just a matter of slavishly copying, but rather of allowing the demands of the medium and your own skill to modify and interpret the information.

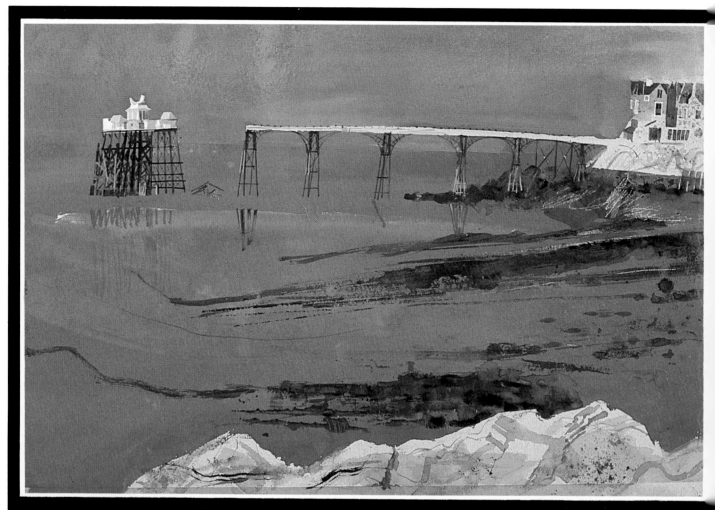

This painting is made on tinted paper so the ground has a warm cast initially. Highlights must be added with opaque white paint (**far right**) and in this case they were put in at an early stage to give the artist the range of the tonal scale. To obtain the heavy quality of the blue and mauve washes they were laid over an initial application of dark tone. The right mixture of colors was achieved by building up the washes, rather than by mixing the color first in the palette. For this to work effectively the paint must be allowed to dry between each successive stage.

THE PIER AT CLEVEDON 1
22 x 14 in (55 x 35 cm)

This is the first of two studies of an early Victorian pier (**left**), a fascinating structure which collapsed while being tested. The strange mood created by the stranded effect of the broken pier was considered important and the heavy, purplish tinge of the gouache wash describing the sea was intended to convey a sense of mystery. A dry brush technique was used in the rocks and houses to allow the paper to show through, creating the bright tones. Extra detail was added as small areas of wash. Broad areas of color over the whole paper surface were washed in with a large, rounded brush and allowed to dry before the details were developed with a good quality, finely pointed sable. Broad and tapering brush strokes in the foreground are the result of deft handling of a chisel-shaped brush.

Reflections

When painting a watercolor, the main difference between a landscape and a seascape is that water reflects the sky above, which means that the normal tonal values will be reversed. A large expanse of water will often be lighter in tone than the sky because of reflected light, and the sea will reflect the character of the sky and vice versa, so that a gusty sky with racing clouds will be matched by whipped up waves and a clear, calm sky by an equally calm sea. Reflections play an important part in explaining what is happening to the surface of the sea, although they are difficult to capture in precise detail. Try and read their general direction and tone in relation to the surface of the sea and the object or area reflected.

Weather conditions vary enormously and will have an important effect on your seascape. Many artists have mainly been concerned with such changes in the weather and have made numerous sketches, notes or even quick watercolors, either for future reference for works to be completed in the studio or as a means of getting to know their subject.

Varying styles

The two watercolors of *The Pier at Clevedon* use very different compositions and viewpoints to record the atmosphere of the sea. They provide good examples of an

THE PIER AT CLEVEDON 2
22 x 14 in (55 x 35 cm)

The second study of the same pier (**below**) has a completely different atmosphere. For both paintings the artist used David Cox paper and in this case the washes of paint have been laid quite thinly, so that the colors have a luminosity gained from the bright tone of the paper beneath. The pier is even more isolated in this view and the lack of peripheral detail emphasizes the strange sense of loneliness which the artist found so characteristic of the subject. Seen by itself, the picture gives no indication of the relationship of the pier to the shore and the composition is formally quite stark, with the bleak expanse of sea and sky barely disrupted by the broken diagonal.

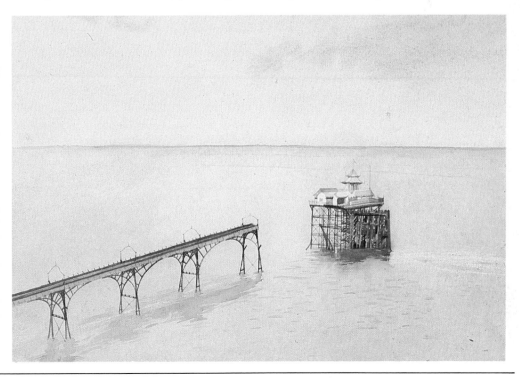

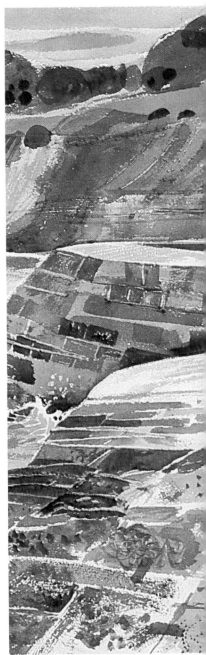

CORNISH HARBOR
9 x 7 in (22 x 18 cm)

In this small painting the shapes are emphasized and the colors heightened to stress the twisting, deeply cut structure of the harbor. The use of intense blues strengthens the outline of interlocking shapes. The colors are projected from natural colors observed in the scene, but nowhere is the treatment of the image intended to be realistic. Washes of gouache are overlaid with dots and spattering to create areas of texture which add character to the image and at the same time provide an additional abstract sense.

artist having considered his subject thoroughly before starting work. A long walk to the other side of the pier, harbor or bay may be worth the effort. The depth of your painting will depend upon accurate judgement of tone, and aerial or atmospheric perspective can be as useful or necessary as in the painting of landscapes.

Cornish Harbor and *The Cob at Lyme Regis* also show contrasting views of a harbor pier, the former more traditional in flavor, with dry brushwork imitating the texture of the stone and the latter in mixed media, abandoning normal perspective in favor of shape and abstract arrangement.

Practical considerations
All the examples of seascapes shown here were painted in places reasonably accessible by car but often you will find that walking is the only way of reaching your destination. Clifftop walks encumbered by easel and materials can lead to accidents; make sure that you carry the minimum on your expeditions. Be prepared in particular for gusting winds and make certain that you weigh or pin down any loose paper or precious sketches.

THE COB AT LYME REGIS
22 x 14 in (55 x 35 cm)

Extensive use is made here of the true tradition of watercolor. The areas of light tone in the foreground are bare paper, as are linear and textural details throughout. The complex pattern of stonework on the Cob is made with patches of wash, small brushstrokes and dots, and broken color laid with the drybrush technique. A broad wash of gray across the background sets the tone for the cliff rising from the bay.

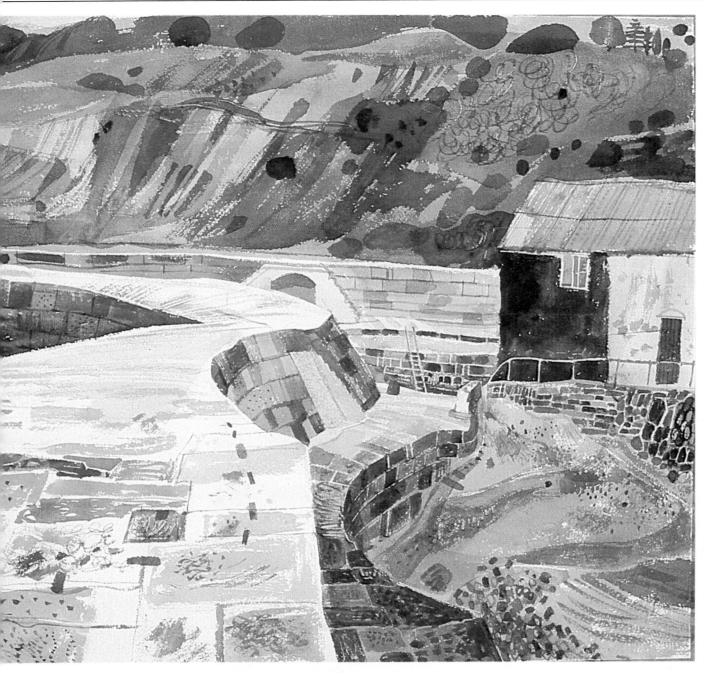

Only two brush sizes were used to make this painting, but the ingenious techniques put to work gave the artist a broad range of marks with which to translate the various textures in the subject. Small shapes and well defined lines of dark tone were selectively applied using the point of the brush (**far left**). This same brush, loaded with well-diluted paint, was also used in applying the broader areas of wash. Ragged marks and broken color were achieved by working with the bristles spread between thumb and finger (**left**).

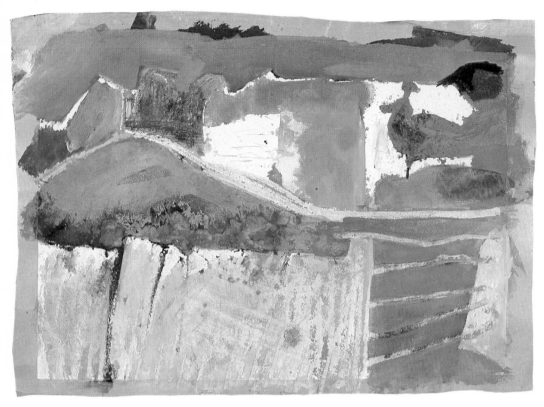

LANDSCAPE WITH BARRED GATE
20 x 14 in (50 x 35 cm)

Small areas of wash, overlaid one on another, drybrush technique and delicate drawing with the point of a sable brush are combined in this painting on board to produce the richly textured effect. The tracing of white lines is in some cases due to the support being left bare, but the artist has also gently scratched into the surface with a knife blade. Masking fluid is an effective way to protect narrow lines from being flooded with paint and does not damage the paper surface, as may happen if a blade is used. The richness of the dark tones is due to washes of purple under the greens and browns.

VIEW ACROSS THE CLIFF
21 x 15 in (52 x 37 cm)

Individual forms in this landscape have been reduced to the barest essentials of color and texture. The composition has an abstract quality which is nevertheless evocative of the scene because the basic spatial relationships have not been altered. Wax resist and masking fluid have been freely used to draw rich texture into the washes of color and break up the broad surface areas.

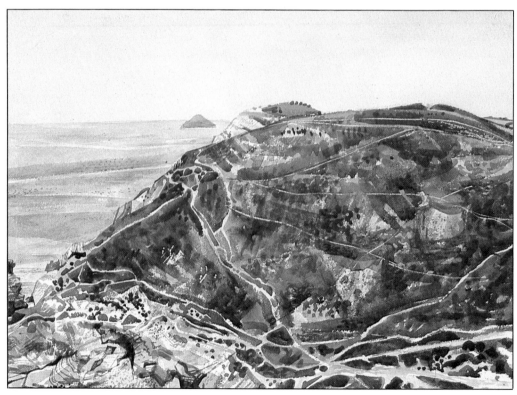

WHITE HORSE
22 x 13 in (55 x 32 cm)

A sense of distance is created here, despite the use of strong color throughout the picture, by the placing of the heavy tree in the foreground, spreading across the image (**right**). Fine strokes of light colored gouache streaked across the foreground give texture to the overlaid washes, while the detail diminishes as the field recedes toward the hill on which the stylized shape of the White Horse is just visible.

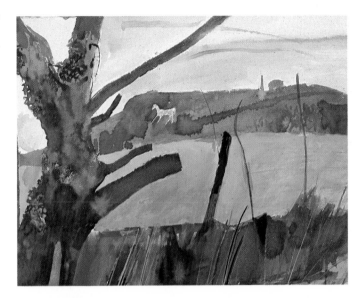

BREAKWATER AT LYME REGIS
21 x 13 in (52 x 32 cm)

The vivid blue line of the railings running horizontally across the picture (**below**) balances the sharp diagonal thrust of the breakwater. Color is handled very subtly to evoke the stony beach and graying water and extra depth is drawn from an underlay of warm brown which forms the basis of the other washes. The converging lines of the breakwater itself connveniently depict the distance from front to back of the picture area.

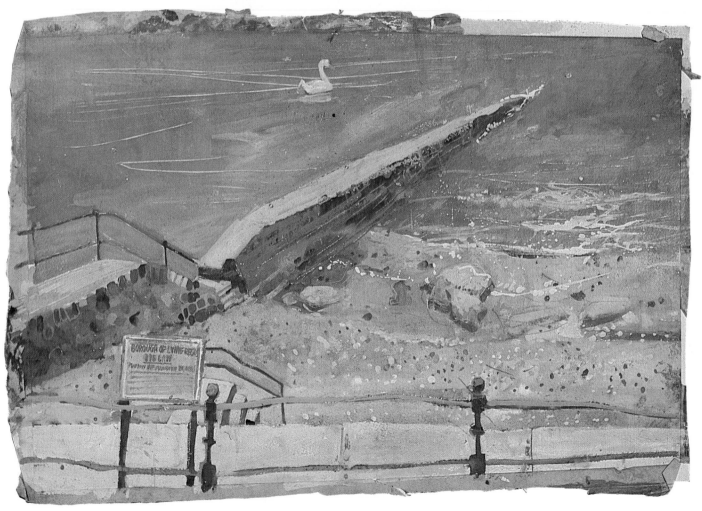

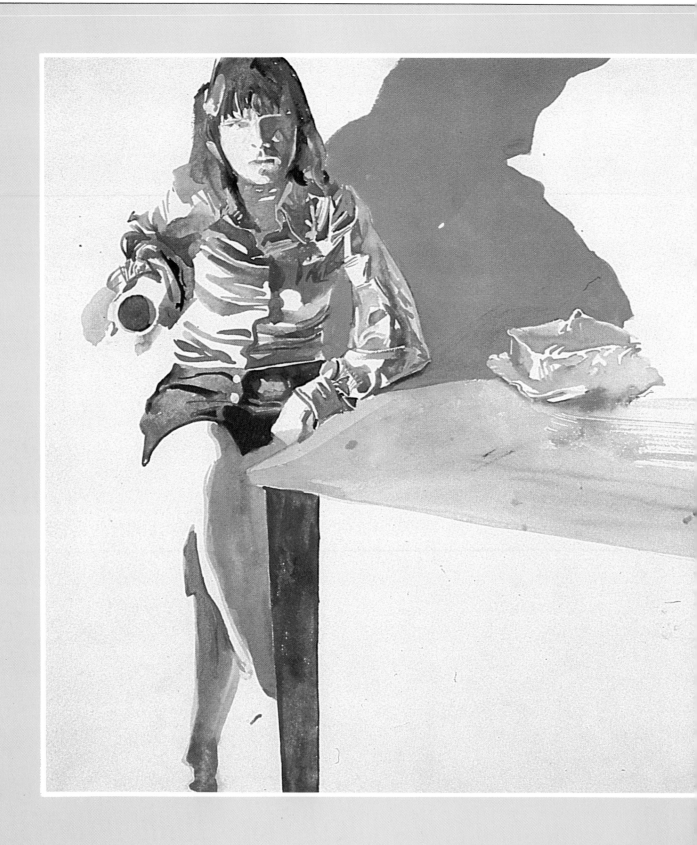

PAINTING
THE
FIGURE

THERE CAN be few more satisfying achievements than that of making a successful painting of a figure, expressing its individuality, character and style and using the qualities of your chosen medium to best effect. Watercolor is particularly suitable for depicting the translucent quality of human flesh and can be worked quickly, in well-judged washes, to achieve a subtle and effective result.

It is not necessary to organize proper sittings of professional models in order to practice figure painting. Members of your family or friends will often be willing, even flattered, to be invited to pose for you. Quite often, day to day events and situations will present opportunities for making sketches, or even finished paintings if you work quickly enough and do not aim for too detailed an effect.

Some knowledge of anatomy will obviously be helpful but it is not essential to learn in great detail about the make-up of muscles and joints and the way in which the body is put together. To begin with, all that is necessary is the ability to distinguish between the characteristic features of men, women and children, and a willingness to observe keenly and to practice as much as you can until your drawing improves.

Above: The most commonplace domestic poses can provide material for paintings. The shape of the figure on the page is emphasized and made more unusual by the solid shadow, which also gives the feeling of three-dimensional space.

FEMALE FIGURE

Much good figure painting in watercolor is fresh, simple and vigorous. Whereas, with oils or acrylics, figures may be carefully worked up and refined over a long period of time, a watercolor is often done quickly, on the spur of the moment when a suitable opportunity presents itself, avoiding the stiffness that can result when a great deal of thought is given to presenting a person in static pose. By working quickly, the character of the figure is summarized, relying as much on good judgement of tone and color and a confident approach as on perfectly drawn accuracy.

Do not worry too much about your ability to depict problem areas. Hands and feet are traditionally difficult subjects, and there is no point trying to hide them because the eye of the viewer will seek them out automatically. It is much better to make an honest attempt at painting every-

thing, not only because through practice you will eventually improve but because details treated with care and sensitivity and, above all, with confidence, will improve any work.

Selecting a pose

Many watercolors of figures are not 'posed' at all but are painted simply when the opportunity arises and the subject happens to be standing or sitting in a suitable position. *Kate in Corfu* is just such an example. If, on the other hand, as in the case of *Pregnant Woman,* you set out deliberately to draw a particular person, take some time to observe your subject and see if any characteristically personal poses recur. In this case the artist was anxious to record the shape and form of a swelling belly so a side view was chosen. An unpracticed model may find it difficult to hold a pose for

KATE IN CORFU
15 x 22 in (37 x 55 cm)

This painting of a girl on a balcony is a fine example of a captured pose, informal and unplanned, which nevertheless uses a classic method of leading the eye toward the subject. The interior is the key to the composition; although the shutters and walls are not drawn in detail their tone and surface are accurately summarized in a way which focusses attention on the figure. Outside on the balcony the girl is bathed in sun, with the light coming from behind, and the artist has left paper white to capture highlights and describe the figure form. Neutral washes are laid over most of the support, the main contrast in tone being provided by the deep blue of the dress.

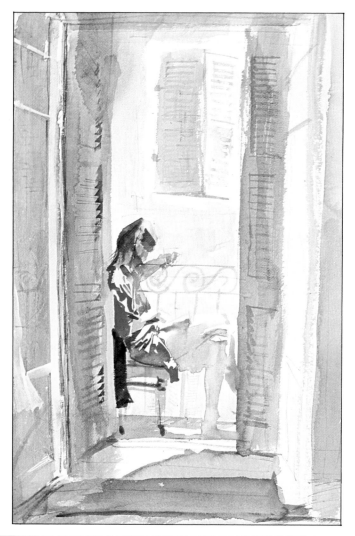

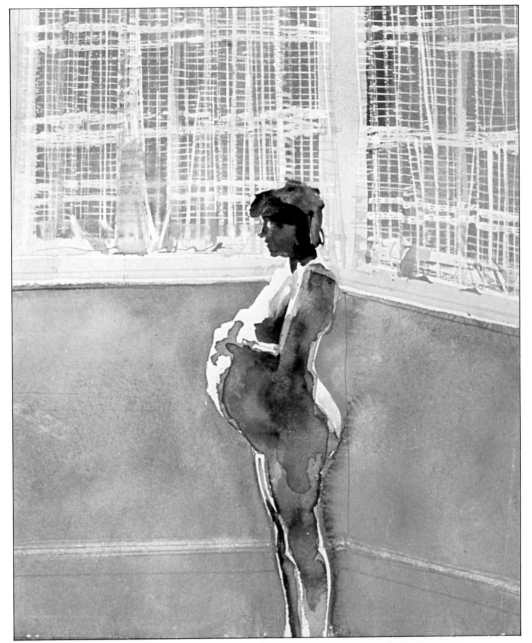

PREGNANT WOMAN
14 x 18 in (35 x 45 cm)

The interior again plays an important part in the composition of this painting, the delicacy of the curtains providing an interesting backdrop and the light again coming from behind. Although the curtain appears complex, the effect can be achieved simply, by the method described below. A wash of Payne's gray covers the wall area and the underpainting on the figure itself (below) leaves white paper to indicate highlights.

Above: Masking fluid is brushed in to make the fine vertical and horizontal lines of the curtain which will appear as white in the finished painting. When the fluid is dry, a gray wash is applied over the top to provide the tone of the sky behind. **Left:** When the sky wash is dry, gently rub off the masking fluid with a putty rubber or other soft eraser. The folds at the bottom of the curtain can be put in by adding small areas of a pale blue wash.

Above: The skirting board provides an example of another method of allowing white paper to appear as highlights. Rather than leaving the area white in the first place, as on the figure, a scalpel is used to scratch away the gray paint to reveal the paper.

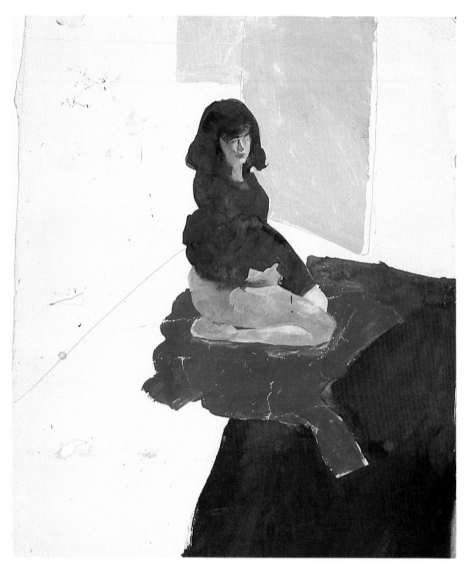

GIRL ON RED RUG 1, 2 & 3
14 x 18 in (35 x 45 cm)
These three gouache studies show a varied approach to technique. The paint has been used both in areas of solid color and as transparent washes. Pencil used to scratch through the paint or add detail in localized areas alters the texture of blocks of color and around the standing figure (**right**) some collage has been added to describe the floor space. Abstract shapes dominate each composition and these are strikingly emphasized by the vivid complementary colors.

any length of time so care must be taken to ensure that the chosen stance or action is a fairly natural one. In the paintings on these two pages the poses were suggested by the model herself. They are relatively quick and unstudied pieces which serve as documentation but are also interesting in their own right.

Female figures generally have a softer, rounder feeling to their forms which shows both on the surface, when drawing nudes, and through clothing. Before starting to paint, examine the interplay of the parts of the body. It is important to note the way in which the head sits on the neck form and how the breasts affect the balance of the pose; the tilt of the hips influences the angle of the shoulders and the general stance. In a standing pose, look

for the centre of gravity; this will help to establish the figure firmly on the ground.

The 'classical' shape for the female figure is of a triangle, wider at the base to accommodate the hips and narrowing towards the shoulders; this is a useful guideline. The proportions of the head and face differ from those of men or children; the forehead will be gently rounded, the mouth smaller and the eyes larger than those of the male, who will be more likely to have a protruding jaw, deep-set eyes and a harder line to the forehead.

Lighting

This is an important factor as it will help determine where the shadows fall and give form to the figure. In *Pregnant*

Far left: This painting depends absolutely upon impeccable drawing and to establish the verticals without distortion a ruler can be used to guide the hand holding the brush. The ruler is held at a slight angle to the paper surface. It is never advisable to draw the brush tip directly along a flat ruler as the paint bleeds underneath, smudging the line. The green wash behind the figure has a strong yellow underlay (**left**) to give a quality of brightness.

FIGURE BY THE WINDOW
14 x 16 in (35 x 40 cm)

This composition is carefully structured, with a fine balance between the horizontal and vertical stresses. The wide green strip running diagonally behind the upright figure offsets the static dignity of the pose. In keeping with the atmosphere of the scene, washes of color are delicately overlaid and the detail in every area of the work has been carefully observed. Such a painting may provide useful reference for a larger work in oil paint at a later stage, but is also complete in itself and worth attention.

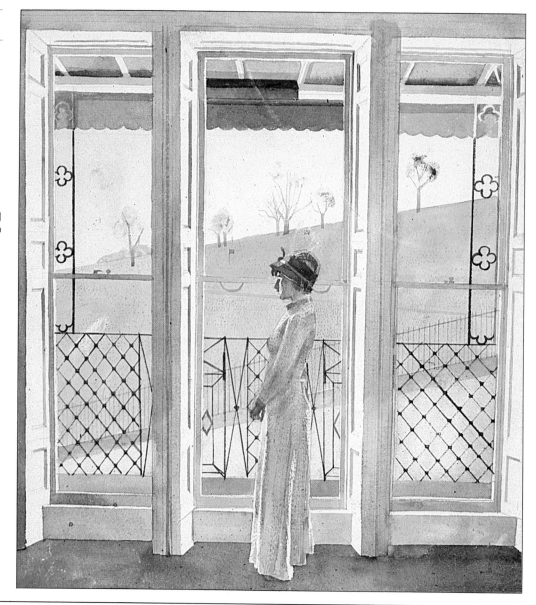

Woman the figure is almost reduced to a silhouette, but in other examples where the light is more diffused, shadows and tones will be interpreted in thin, flat or flattish washes in the early stages of the painting. In such cases it is essential to half close the eyes and squint in order to decide on the edges of these shapes and their related tones.

Lighting can also be an aid to creating atmosphere, whether a general mood or a more dramatic effect. The two paintings on this page use backlighting to describe the figure but create completely different effects; *Figure by the Window* uses diffused light to describe softer-edged tones, contrasting with the effect created in *Nude in Landscape* which is more stark and dramatic, with a harder edge between tonal variations.

Two very different techniques have been used, one employing soft gentle color washes and the other a greater freedom of brushstroke with a harder surface and edge. In this second painting, the figure is depicted by the use of two main tones and the variations within these tones. The ability to do this so successfully requires a practiced eye in summing up the figure form; apparent simplification belies the knowledge and experience at the disposal of the artist.

Perspective

One of the main problems encountered in figure painting is the foreshortening that occurs in certain poses. It is necessary to relate the size, shape and scale of fore-shortened limbs to points outside the pose (furniture, walls, windows); constant measurement and reassessment will help to make certain that your drawing is accurate. Do not hesitate in rubbing out, overpainting or redrawing what you have already committed to paper as you will never improve your technique if you continue to ignore faults and badly seen poses.

Environment

The surroundings in which your figure is placed can play a prominent part in the effect you are trying to achieve. Sometimes the decision on how much or how little of an interior should be included is a compositional one. In *Figure by the Window* the setting was the starting point for the painting.

Any 'props' in the form of plants, furniture or other accoutrements must be as carefully observed as the figure itself; they must add to rather than detract from the credibility of your work. In all the examples shown in this chapter the figure is closely related to its environment.

Sometimes a vital piece of furniture or equipment will be

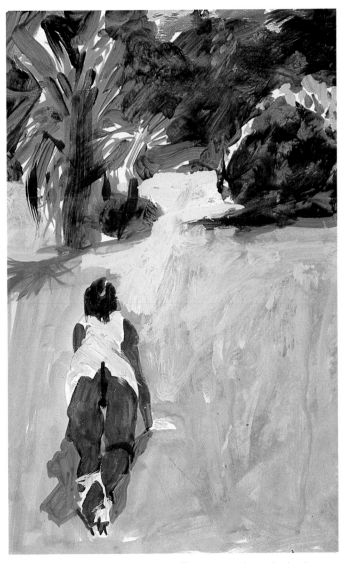

NUDE IN LANDSCAPE
14 x 22 in (35 x 55 cm)

This study of a model posed in a garden setting is characterized by strong sunlight and this is expressed in the artist's vigorous handling of color. Areas of intense light and heavy shade describing the form of the model are not diffused by the use of blended color or intermediate tones. Complicated organic forms are summed up in a mass of simple brushstrokes, but despite the vitality of the technique, a real sense of the figurative reality is retained.

The watercolor paint is given a greater richness and plasticity by the addition of gum arabic.

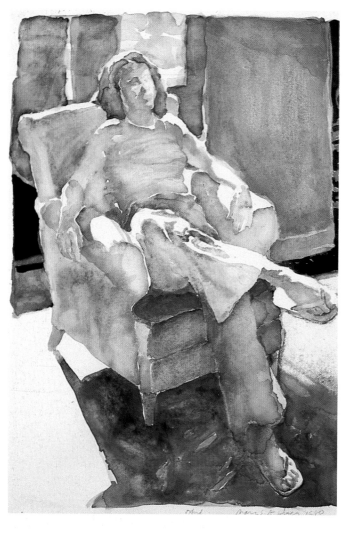

GIRL IN ARMCHAIR
8 x 10 in (20 x 25 cm)

A friend, relative or neighbor may be persuaded to sit for a watercolor figure painting if the pose is quite relaxed and comfortable. If the work is likely to take a long time, take care to arrange the pose so that it is easy to hold. Even the attitude shown here could be trying for the model, although she is seated in a soft chair, because tension can quickly build in the legs when one is supported on the other. To ensure that all the forms were well seen and related correctly the figure was roughed in with a pencil before the washes of wet color were flooded in.

hidden, for example in the paintings *Girl with Striped Socks* and *Gypsy Lady* where the chairs on which the figures are sitting are omitted or obscured. Here it is essential that the figure's centre of gravity is firmly fixed so that she looks secure, with both feet planted firmly on the ground plane. When drawing a more complicated pose it may be helpful to walk around the figure so that you can see what happens to parts of arms and legs not visible from your viewpoint. Understanding how the complete pose is formed will help you make a more accurate reading and a better representation.

Models

Working from a nude will help you to understand the construction of the figure and the way in which the muscles and limbs work in relation to each other. A clothed figure

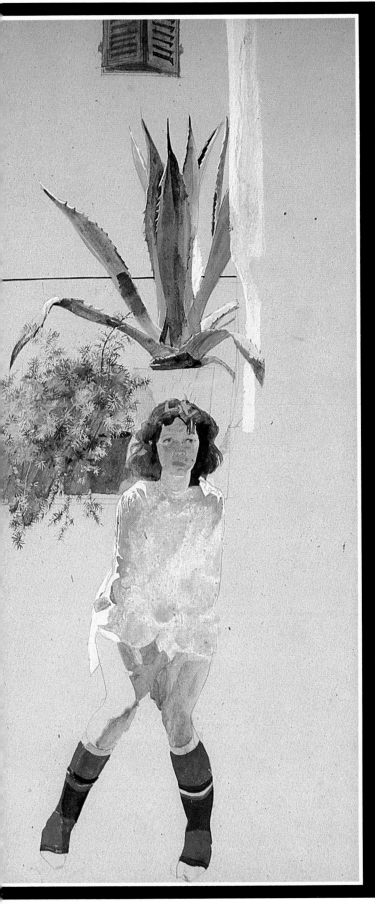

GIRL WITH STRIPED SOCKS
22 x 30 in (55 x 85 cm)

The warm tone of the paper is used in various ways here; as an overall background tone, to qualify the thin washes of color in the painting and as an indication of local color. This is cleverly exploited, for example, where the artist has defined one leg with a simple pencil line so the flesh tone is the same as the background, but the form can be clearly identified. The composition is neatly arranged within the rectangle forming an unusual study of the plants and figure. The striped socks add a touch of vitality and humor.

Above: This detail of the flesh tones shows the combination of washes and opaque paint to create tonal variety. A light tone achieved by mixing colors, including white, is laid over a transparent wash of flesh color. The different shades of green in the bushy plant (**top**) are blended gently by dropping in new washes while the underlayer is still wet so the colors slowly merge.

GYPSY LADY
14 x 22 in (35 x 55 cm)

This painting shows the full extent of the inventiveness which can be applied to studying the figure clothed. The rich color and intricate patterning of the dress is an enormous task for the artist, but one in which there is a continual challenge to perceptiveness and skill. The details (**below**) show how the artist has summarized the wealth of information and developed a mixture of techniques to cope with the problem. Each pattern is built up from a complex network of overlaid washes, strokes of opaque paint and lines of broken color. The elements of the form and surface detail must be carefully identified and translated so the image has an overall order and solidity

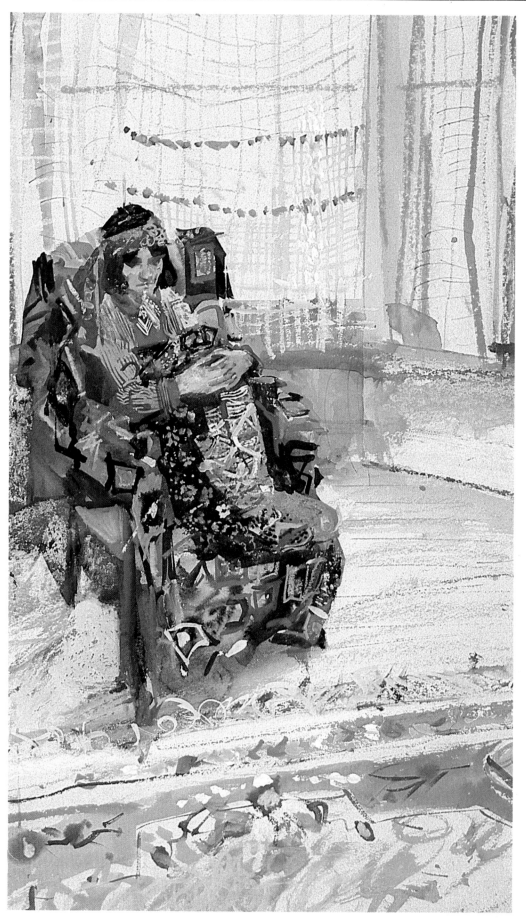

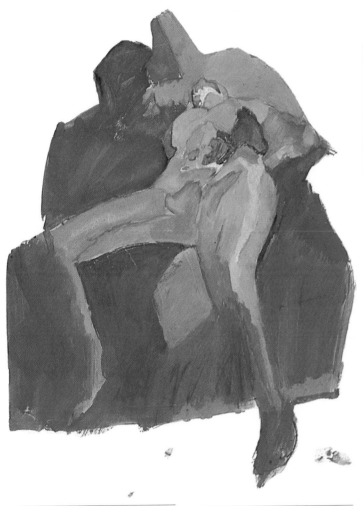

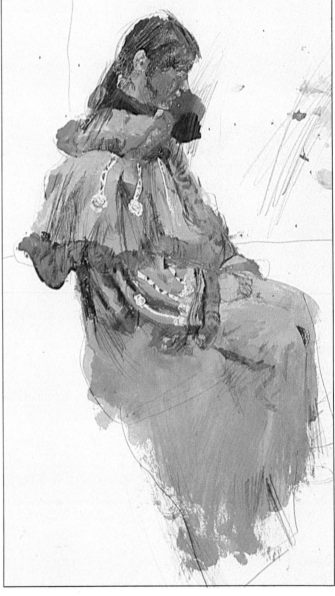

NUDE ON BED
14 x 16 in (35 x 40 cm)

The unusual perspective of this figure and the painting technique of patching in areas of thick color combine to present an almost abstract image. The shape of the composition is compact and self-sufficient.

GIRL IN FUR CAPE
12 x 15 in (30 x 37 cm)

The luxurious cape is the focal point of this painting, so the artist has elected a simple pose which shows it to the best advantage. The figure appears isolated and there is nothing to distract attention.

provides just as much of a challenge, even though it may appear that the material would hide complicated anatomical details. No matter how loose the clothing, it will reveal the form underneath.

Whether working from a nude or clothed model, try to establish lines which characterize the pose, whether they be angular or fluid, and consider how this might be reflected in or contrasted with other effects. In the painting *Nude on Bed*, the figure and background are seen very much as a unit – a complete image in which knowledge of figure forms is carried toward the abstract level. By com-parison, the clothing in *Girl in Fur Cape* is rich and sumptuous enough to carry a simple pose in semi-profile without the need for any additional interest.

Clothing is a contributory factor to the overall character of the paintings *Girl in Armchair* and *Gypsy Lady*. Both place the figure in informal poses in interiors but use different treatments. The former captures a relaxed pose, with the sitter informally dressed; the latter is more styl-ized, the artist more concerned with pattern, texture and tonal relationships than with the character of the sitter and the domestic nature of the surroundings.

MALE FIGURE

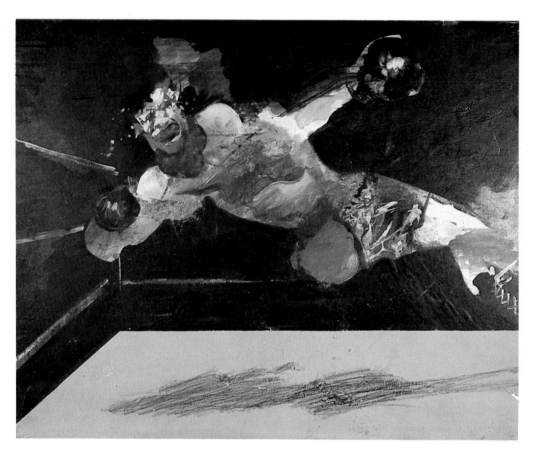

When drawing men, many of the factors to be considered are the same as when drawing the female figure. There are, however, obvious anatomical and character differences which will be reflected both in the physical form of the pose and the environment. Here, men are shown engaged in typically male pursuits.

Physical features

In general, a man's body is more muscular than that of a woman, with the classic triangular shape of the woman being inverted so that the shoulders are wider than the hips. Such a generalized summary is of course denied by the existence of men where fat hides the shape of the skeleton or, for instance, by the sort of frame where slim hips are parallel with small shoulders.

The classically handsome man has a strong jawline, wide mouth and angular, sloping forehead which will identify him as being characteristically male. The fact that many of the men you paint do not conform to the ideal should not prevent you from making use of this generally useful guideline.

FALLING BOXER
20 x 15 in (50 x 37 cm)

This painting was executed on a ground of a very positive color. Wet gouache was flooded on to the green paper and brushed around to allow the image to emerge. As the form developed, changes were made by overpainting where a modification was suggested by the moving paint. The work was done in the studio following a series of sketches and photographs taken from life. The energy of the boxing ring and the violent movement of the falling figure are emphasized by the free, almost abstract style of painting.

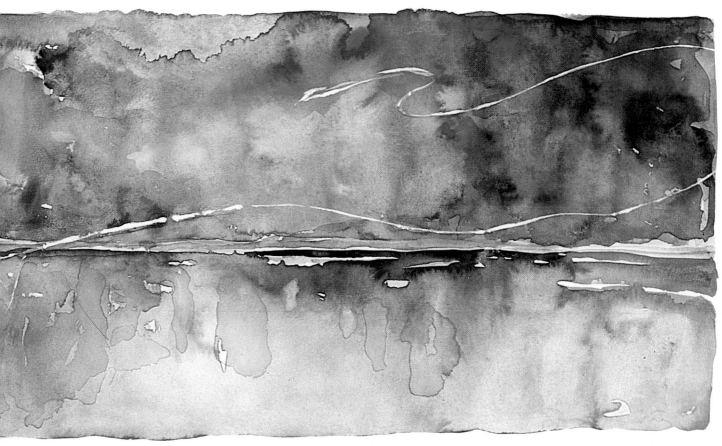

FISHERMAN
18 x 8 in (45 x 20 cm)

The rich backdrop for this solitary fisherman was created by applying wet pools of color and allowing them to flow together. Smaller areas of wash were laid into the paint when partially dry. Jagged shapes suggesting foliage occur naturally by an intense concentration of color at the edge of a drying wash. It provides a dense ground over which the looping fishing line provides a flicker of movement. This was painted with Chinese white gouache, using a fine brush and a confident movement of hand and wrist. An alternative technique would be to paint in the line with masking fluid before applying the washes. A finished painting of this type is best carried out in the studio using information from sketches.

Above: A heavy, dark horizontal line was applied to imply depth and differentiate between the horizontal and vertical planes.
Above right: The shape of the figure was roughly defined in pencil before the background washes were laid, so that local color could be used in small areas of wash to build up the form. Dark tones can be intensified with successive layers of paint or by using gouache which is more dense than watercolor.

OARSMEN
18 x 12 in (45 x 30 cm)

This painting is a fine example of complex problems skilfully solved. The greatest difficulty in drawing or painting any active sport lies in capturing the movement. Watercolor can be a quickly executed medium and it is sometimes possible to paint from life if the same actions are repeated frequently enough, and close enough for accurate observation. Often, however, it is necessary to resort to good photographs. This method enables a careful drawing to be made, really a necessary preliminary when trying to capture complex muscle shapes. Traditionally these pencil marks have been left in watercolors, but if a very light effect is required it is sometimes necessary to rub them out carefully. Leave details such as hands and features until the very end.

The other difficulty tackled is that of painting water and reflections. Again, it is important to know what to leave until last – reflections have to take their cue from solid forms and in this case the reflections of the figures cannot be put in until the oarsmen themselves have been painted.

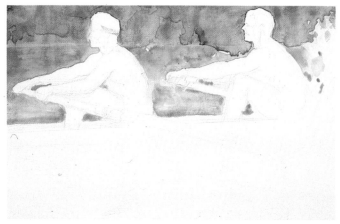

1. Draw the figures carefully and around them lay the first wash of Cobalt blue, well diluted, for sky and general background toning. Use Prussian green, Cadmium orange, Burnt Sienna and Cobalt violet deep for the trees and their reflections; some tree shapes can be put in when the paper is about 80% dry.

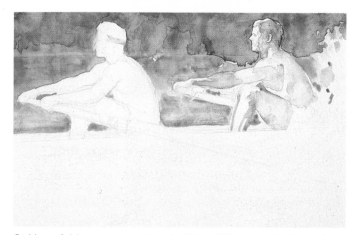

2. Use a fairly transparent wash of Burnt Sienna, with a little blue to take away any orange effect, to start building up flesh tones; add more washes, experimenting with Raw umber, Cobalt blue, Cadmium orange. Cotton buds can be used to blot out paint and make muscles.

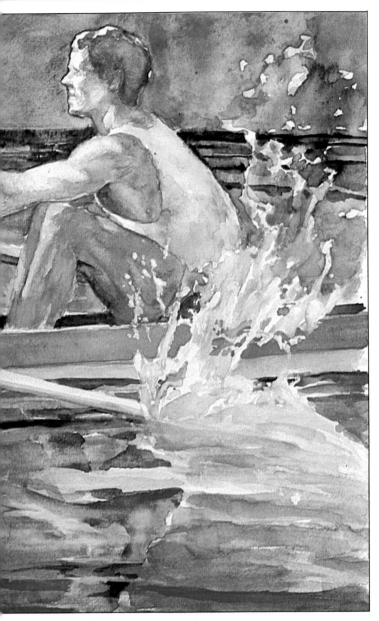

Above: A hairdryer is a useful piece of equipment for drying areas of your painting when laying successive washes.
Left: Payne's gray is used at the bottom of the painting to emphasize the foreground. This subtle gradation of tones is evident elsewhere: the color of the boat has been deepened, making it warmer so that it stands out against the skin tones, and the value of the reflection has also been made deeper so that it sets off the boat.

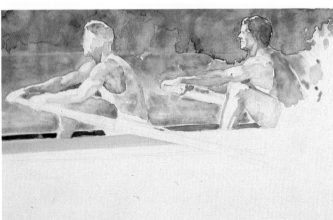

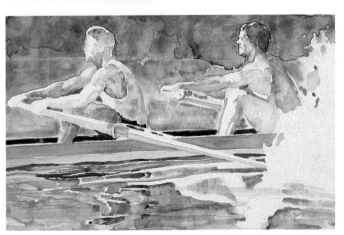

3. The underpainting for the inside of the boat is crimson, to make the eventual black richer; use Yellow ocher for the outside shell. As the splashes are made entirely out of negative shapes it is important to leave this area white at this stage.

4. Draw in the reflection of figures and boat. Experiment with Ultramarine, Cobalt or Burnt umber, using plenty of water and playing with the paint while it is still wet until you get the right effect. While the paint is drying use a cotton bud to make horizontal streaks and a brush for vertical lines.

GROUPS

Paintings of more than one figure, either in pairs or groups, present problems for any artist whether a formal or a more relaxed pose is selected. It is important to establish the depth and space in which the figures are placed, both in your mind and on the picture plane. Walking around a pose can show you the possible variations in the relationships between the figures.

The juxtaposition of figures can add to the narrative element of your picture; by positioning or capturing figures in certain positions – looking at each other, back to back, hands touching – you are saying something about the models and the situation. They are always linked together, whether by a spatial relationship or a physical object.

In *Two Figures* and *Mother and Child* the figures are portrayed in different surroundings. The first is the more formalized pose of the art school, the study of figure forms being the main concern; the second is a more relaxed painting of a pose captured in a domestic setting. A crowded restaurant, park bench, bus queue or market stall may provide you with ideas for more ambitious groups. You will need to make both separate studies and sketches of the overall scene before embarking on such a complex piece of finished work; a quick sketch is often sufficient basis, backed up by a repeat visit to the scene to note architectural details and the use of friends or relatives to reproduce poses.

TWO FIGURES
21 x 15 in (52 x 37 cm)

This painting exploits the qualities of gouache paint to achieve an accurate portrayal of the tonal relationships. A ground tint was first laid, in a warm but essentially neutral color This provided the measure for balancing a scale of light, dark and mid tones. White paper is often too harsh and gives a false impression of the way colors interact. The gouache was laid wet into wet and wet over dry, which allowed the artist to blend the colors and overlay light tones on dark where necessary. Gouache is sufficiently opaque to mask previous layers of paint completely.

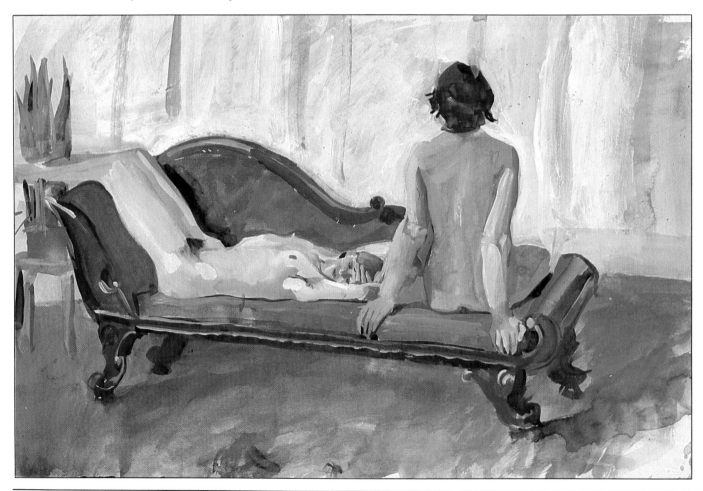

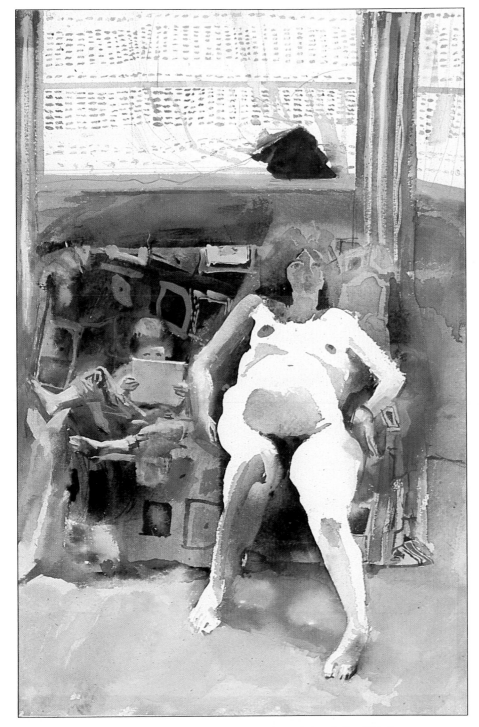

MOTHER AND CHILD
18 x 22 in (45 x 55 cm)

A combination of gouache and watercolor in this family portrait enables the artist to produce a rich variety of tone and density in the paint. Light tones describe both highlights, in the figures, and local color as in the curtains. This light is created by leaving paper bare or with thin washes of watercolor and also by laying the gouache in opaque, flat masses and streaks. The female figure is dominant in the composition, but the scale and simplicity of this form are balanced by more detailed treatment of the child and the busy patterning of the sofa cover and net curtains. The details of this patterning show the contrast between the texture of washed in and solid color (**right center**) and a wet wash laid into a patch of paint which is only partially dry, allowing the color to bleed (**right below**). The detail at the top of the page demonstrates the covering power of gouache. White paint laid over a dry red wash covers the underlayer completely.

CHILDREN

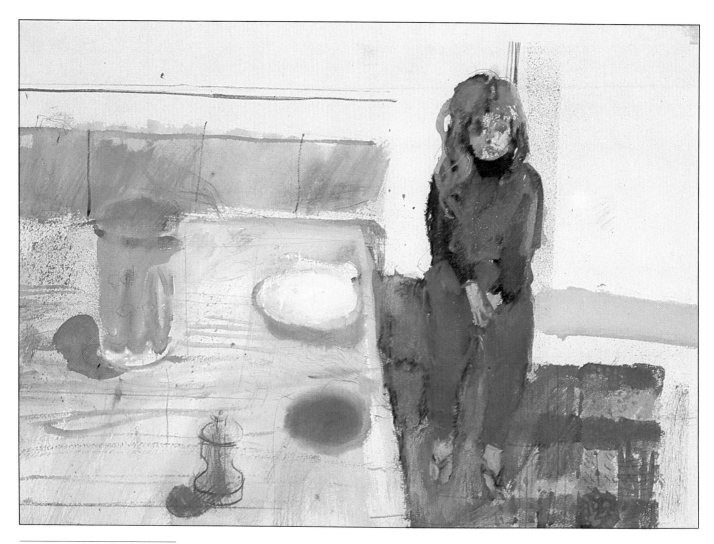

LITTLE GIRL BY TABLE
18 x 12 in (45 x 30 cm)

In this gouache painting the patient posing of the young subject is captured with a minimum of elaboration. Masking fluid was used to draw in her facial features and an indication of generalized shapes, then rubbed away when the painting was finished and dry. The perspective of the table and floor were adjusted to give a formal quality to the patterns and shapes.

Children pose a particular problem for any artist, the most obvious being the difficulty in getting them to hold a pose for any length of time. One solution is to choose an easy pose that can be drawn over a period of time in short sittings; another is to draw from photographs. Familiarity with the subject is a great help; perhaps it is worth considering choosing your own child or a brother or sister as a model.

Pay attention to the differences in anatomical features between children and adults. At birth the head is disproportionately large and the limbs relatively small. If possible, make posing fun, or seize any opportunity as it presents itself; this was the case with *Jasper Jumping on the Bed* where the painting was stimulated by the action of the child. Do not reprove the child if he fidgets; when posing is turned into a chore the resulting painting will be lifeless.

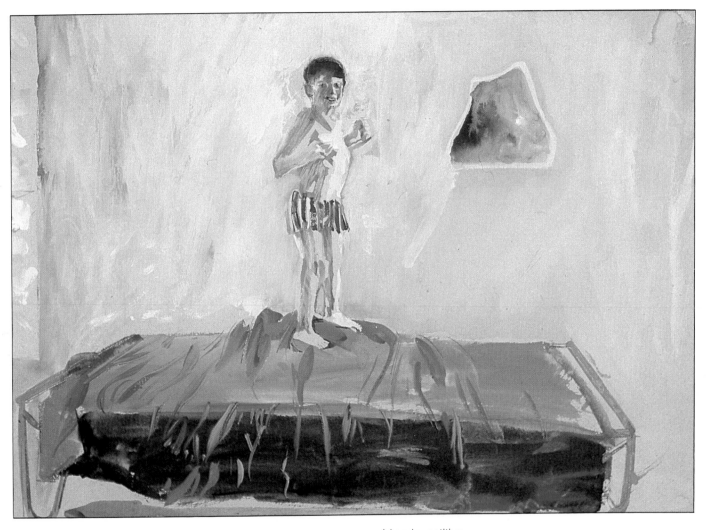

JASPER JUMPING ON BED
22 x 15 in (55 x 37 cm)

This painting represents an attempt to capture movement by working from life as the child jumped up and down on the bed. Children are rarely inclined to keep still long enough to pose in the conventional sense, but such rapid and repetitive movements provide useful practice in drawing and painting. Each stage of the activity is repeated at intervals so by acute observation a good deal of information can be gathered and transposed, even in quite a short period. Although it can be frustrating the discipline is invaluable.

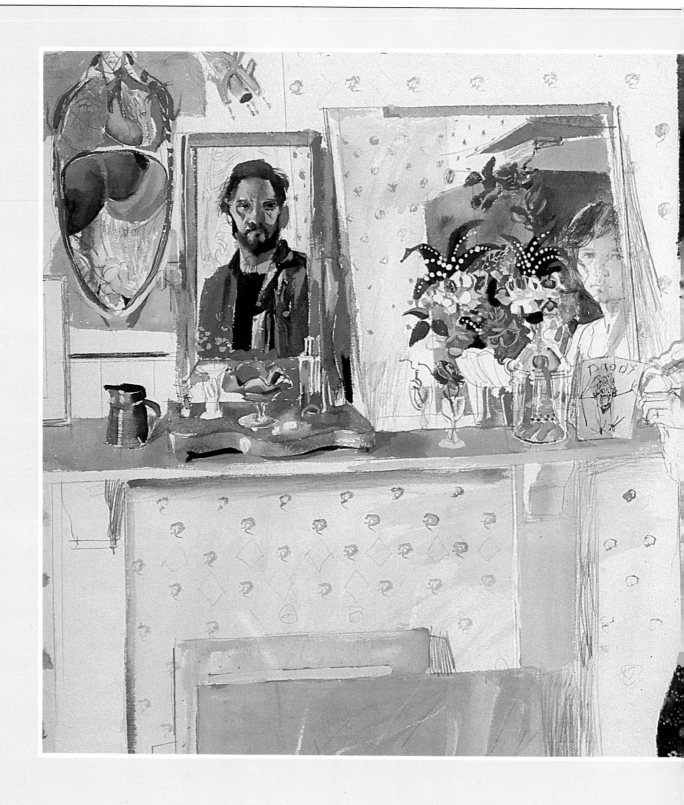

PORTRAIT PAINTING

ONE OF THE REQUIREMENTS of painting portraits is that you should be able to achieve a reasonable likeness of your sitter. But this is not the only object; a good portrait should capture something over and above the mere physical attributes, giving some impression of the personality and character of the person you are painting. In some cases this may present the artist with the problem of reconciling his own view of the subject with the subject's idea of the way in which he would like to be seen!

Try to persuade members of your family to act as models. This has the advantage that you already know them very well indeed and can concentrate on the technicalities of getting a likeness. Another way to practice is by painting a self portrait, safe in the knowledge that your sitter will be available for as long as you have the energy to paint.

You will have to consider such matters as the best way in which to light your sitter, the general composition of your painting, whether fairly traditional or relying for its impact on an unusual juxtaposition of shapes, and whether or not you are going to include any extraneous objects or background details to give added interest.

Above: An interesting combination of portrait and self portrait, the portrait painted both as a profile, full length, and as a more full face reflection. Further visual interest is provided by the 'busy' wallpaper and the collection of ephemera on the mantelpiece.

PORTRAIT

Although portrait painting is often associated with oils, a number of artists have specialised in water-color portraits. Ambrose McEvoy (1878-1927) developed a technique that was at once immediate and informative, allowing for the development of detail within the character study while retaining the freshness that is so engaging and so characteristic of the medium.

The qualities of watercolor seem to be ideally matched to the subject; its transparency and soft, glazed washes capture the bloom of flesh and the freshness of application is an ideal method of depicting the living surface of the skin. If, however, the paint is densely applied and turgid, the result becomes the antithesis of this, unless gouache rather than pure watercolor is being used. The portraits on pages 140 and 141 provide good examples of the difference

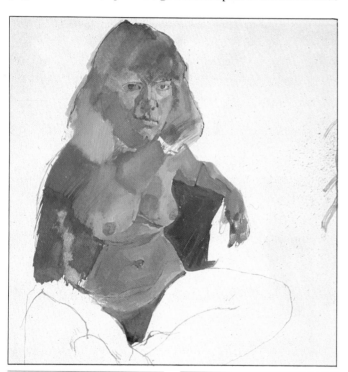

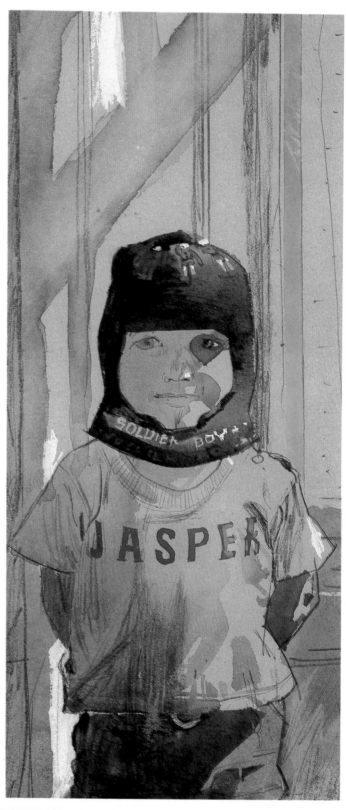

CROSS-LEGGED FIGURE
12 x 18 in (30 x 45 cm)

In this portrait the subject has been used as a point of departure from which to explore an elaboration of ideas and invention of form; usually the reverse process is employed. Line and gouache have been used to consolidate the form.

JASPER
14 x 12 in (35 x 30 cm)

Charm and the innocence of childhood are the theme of this watercolor. By placing the small boy against a tall window his short stature and vulnerability are emphasized. Mixed techniques have been used; the color has been overlaid in washes, and line drawing and pen work used to good effect.

GIRL WITH VASE OF FLOWERS
18 x 26 in (45 x 65 cm)

Variation in line describes much of the form in this sensitively drawn portrait. The color has been applied with pastel or a sponge and is used locally with a freedom and generosity which contrasts with the economy of the pencil line. Such apparent freedom, however, does require control; test your sponge for degree of saturation on a spare piece of paper. Some of the color has been blended with the tips of the artist's fingers. The pencil

work has been carried out in two stages, some before the application of any color, and a more emphatic descriptive line later applied, over the dry color.

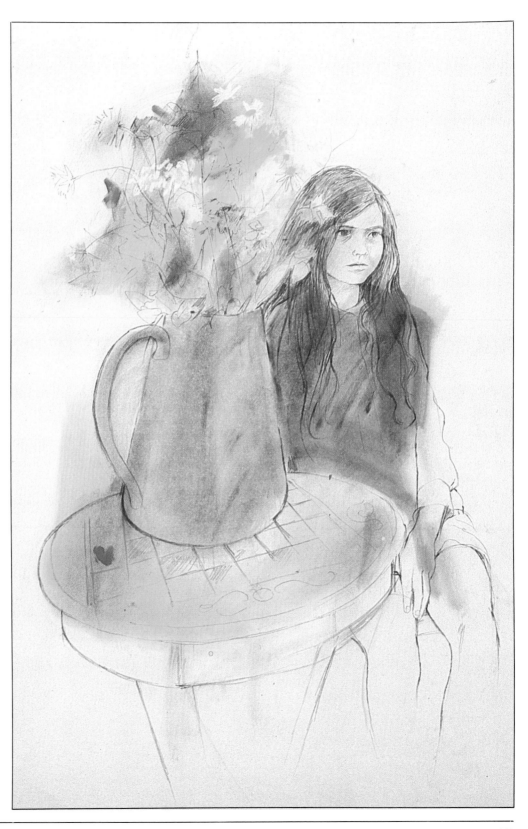

1. Use a medium pencil, possibly a 2B, to make your initial drawing. This should be as accurate as possible; check in particular the placement of the ear in relation to the back of the head and the eyes, nose and mouth. Leave enough space for the cranium.

2. Putting in the first background color is critical – not the color itself but the painting in of the line which is going to make the entire profile. Start building skin tone, trying to get some sense of bone structure.

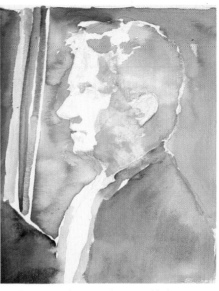

3. The rest of the background is less critical, though still important. Block in the dark tones overall, giving the dramatic effect required in this type of picture.

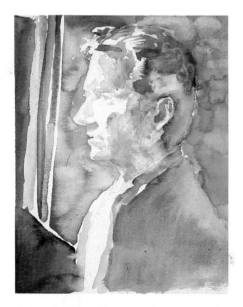

4. Continue working on skin tones and the delicate process of building up the face. This is an investigative process requiring care and experimentation. Use cotton buds or tissue to wipe out areas.

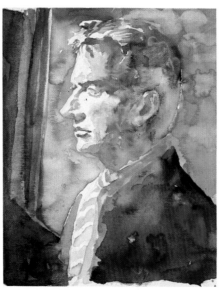

5. A wide variety of colors can be used to achieve the detail in the face – try Crimson, Cadmium orange, Pale green, Deep violet, Burnt Sienna and Payne's gray. Build the colors up subtly, moving them around and using them in an extremely diluted form.

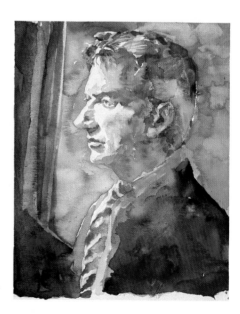

6. The refining process can be continued indefinitely. At the last, put in the pupil of the eye.

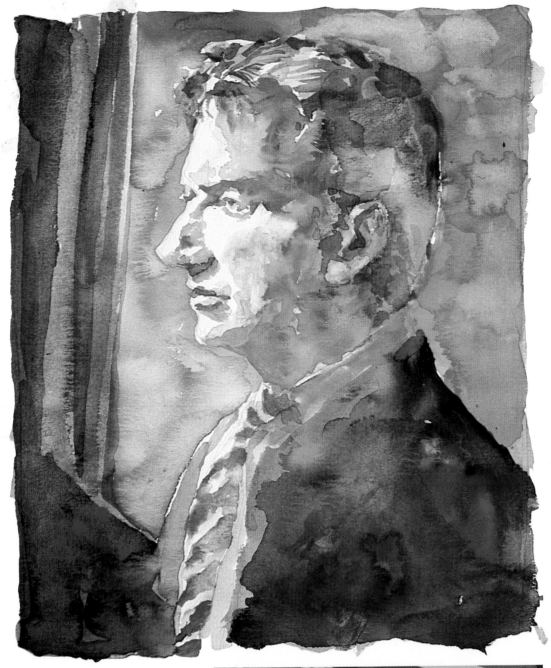

MALE PORTRAIT
10 x 12 in (25 x 30 cm)

When setting out to
paint a portrait it is necessary
to consider the kind of effect
you want to achieve.
Sometimes the sitter will want
to be painted against a
particular background, with
significant paraphernalia. In
this case, the effect is a
dramatic one, with the head
being brought out of a dark
ground which is not
particularized but
nevertheless gives the portrait
much of its atmosphere.
Whatever the style of a portrait
it is important always to try to
get a feeling of how the head
sits on the body and the angles
between the head, neck and
shoulders.

Above and left: Use either a
brush, tissue or cotton bud to
move color around and build
up skin tones. In laying the
early washes with a brush, be
certain to leave areas of white
where highlights occur. Later,
when putting in darks, paint
can be wiped out with a tissue.

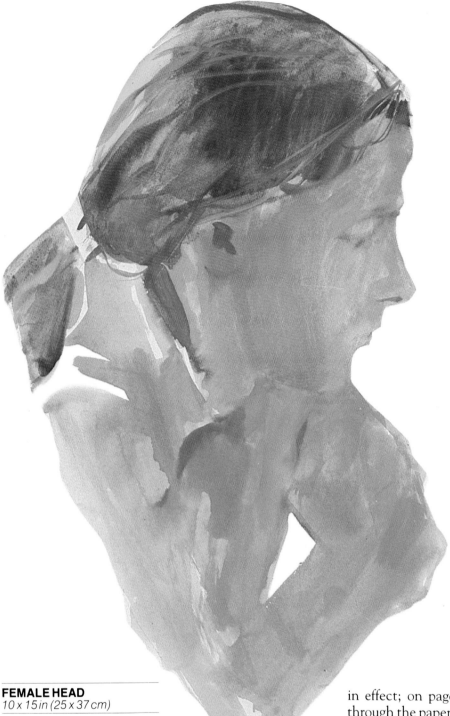

FEMALE HEAD
10 x 15 in (25 x 37 cm)

In this gouache portrait the contour of the head and the line traveling from the forehead, down the nose and around the mouth and chin is described with great accuracy. A well-drawn outline is often as indicative of the volume and position of the head as any tonal changes which occur across the form. Within the shape the wet gouache is freely handled and the brushwork is vigorous. The planes of the face and neck are modeled by moving through warm and cool colors which are not intended to reproduce skin tones, but give a general impression of local color. Finer brushwork is used in the hair to indicate the texture of separating strands.

in effect; on page 141 the light of the pigment shines through the paper to create vibrancy and sparkle while on page 140 more vigorous brushwork is used to create the same breath of life.

The most difficult aspect of portrait painting lies in capturing the particular facial expression which best characterizes the person being painted. If you do not know your subject well, it is advisable to spend some time talking to him and making notes. Portraits can serve different purposes; a work commissioned for official or commemorative purposes may be carried out from an initial sketch or entirely from photographs whereas with a more personal commission, the subject may be available for sittings.

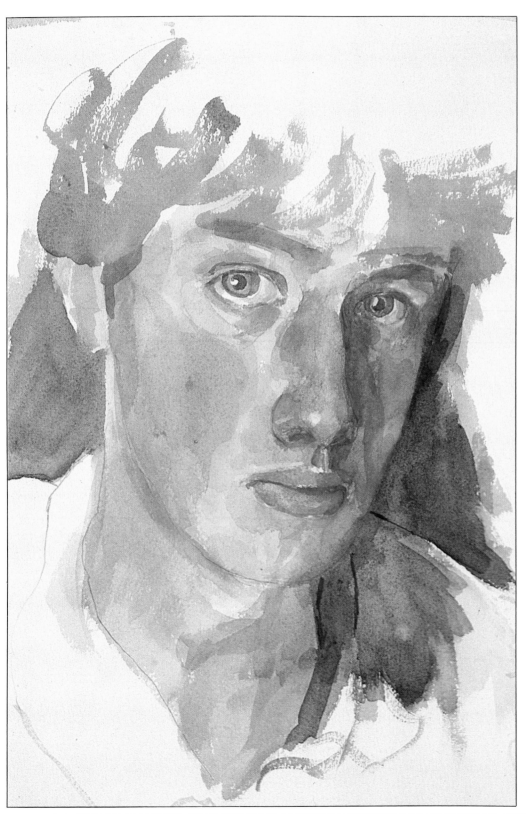

SELF PORTRAIT: CHARLES
14 x 22 in (35 x 55 cm)

Portraiture requires intense concentration, especially when watercolor is the medium as the effect of color washes is spoiled if alterations have to be added by overpainting. The shadows and highlights in the face must be observed very carefully and a correct tonal scale built up very slowly, with successive layers of thin paint. In this self portrait, an overall wash of light flesh tone was applied initially, leaving the paper bare to indicate highlights such as on the nose and upper lip. The areas for the eyes were also left white, so the detail could be developed gradually. No white paint has been added and the luminous whiteness of the eyeballs is created by contrast with the delicate shading of lids and pupils. Precise interpretation of the tones in the curves and hollows of the face is the key to achieving a natural likeness. The use of cool or complementary colors, such as green and blue, in areas of deep shadow has the effect of enlivening the paint surface. As a rule pure black, even applied as the lightest wash, tends to deaden rather than shade a color.

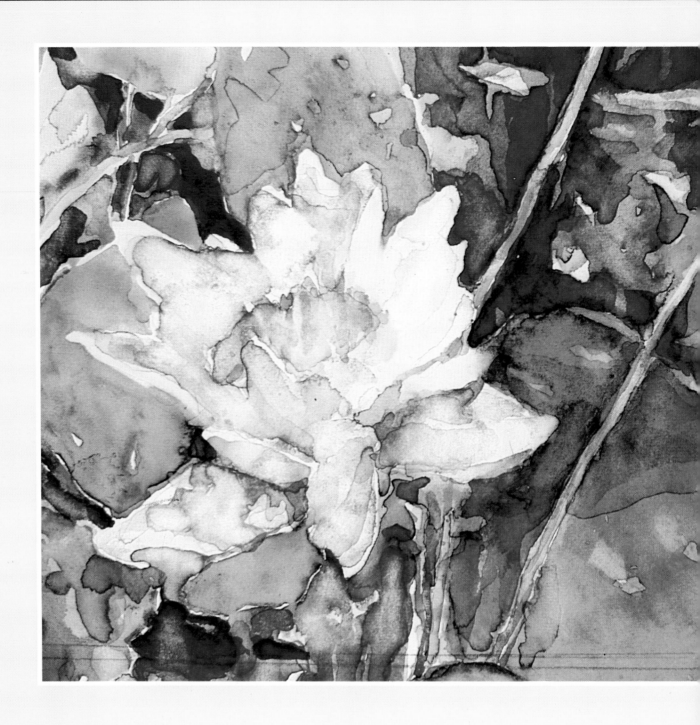

Above: One way of preventing plants or flowers from wilting is to paint them in their natural environment. This picture of waterlilies makes an unusual composition and the closely observed detail is characteristic of much still life painting. The wet into wet washes make maximum use both of the white of the paper and the transparency and translucency of the paint.

Still life
and
Natural History

NO MATTER how cramped the area in which you paint or how short the amount of time at your disposal, still life is a subject which can be attempted by any artist and which provides unlimited scope. One of the greatest advantages is that you need be dependent neither on the human element, in the form of models or sitters, nor on the weather, as would be the case for the artist intent on painting landscapes.

Pay attention, instead, to the intricacies of setting up your group, whether it be a fairly traditional arrangement of fruit or flowers, a collection of related objects carefully selected and positioned or simply a single, striking object. There is no end to the choice, and plenty of evidence to prove that you can make an interesting still life out of the most mundane of objects.

STILL LIFE

*I*f still life is chosen as a subject, the artist has a wide number of possible themes to choose from. Historically the still life has been drawn and painted by many great artists. Whole schools of art dedicated solely to the subject have flourished, while other painters have incorporated it into larger compositions.

Practical considerations

Lack of space in which to paint is often a problem for the amateur artist, but still life painting provides plenty of scope. The eggbox on page 144, for instance, is a prime example of a challenging subject that occupies little space; simple in theme, its differing contours and textures provide sufficient interest to encourage the artist to produce a sensitively wrought piece of work.

Finding a theme

Most still life paintings have a theme. The kitchen provides suitable subjects in the way of crockery, utensils or food; flowers or fruit provide scope for including small insects, wasps or butterflies; bloodthirsty scenes of flayed oxen and butchers' carcasses are traditional still life material. Outside the more usual range of subjects, groups may present interesting color themes and juxtapositions of shapes and tones so that bizarre and unlikely items can be incorporated into successful still lifes.

A color theme is often the only link between a group of objects and the subtle variation of color within a very limited range can be both challenging and instructive. Animate and inanimate objects can be combined, with

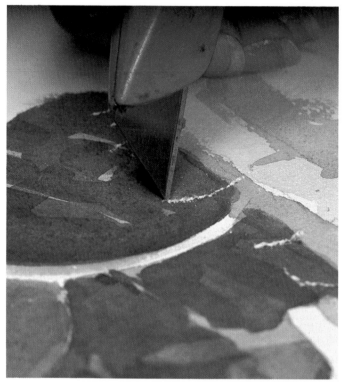

Above: Use a knife to scrape back to the white of the paper and leave light areas on the wheel. This is an alternative to leaving these parts clear of paint as the successive washes are applied.

1. Draw the outline of the steam engine, laying in the background washes of the trees and grass in Cobalt blue and Lemon yellow and touching in the yellow highlights on the engine.

2. Block in the mid-tones on the engine, using a mixture of French blue and Raw umber, and Light red to simulate rust. Wipe off areas to give lighter tones where necessary.

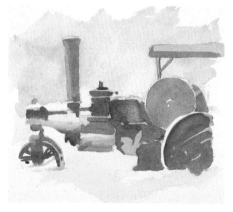

3. Lay a darker wash over the engine, observing carefully the areas of highlight and shadow and using Viridian, Light red, French blue and other dark tones to depict the subtle differences of browns.

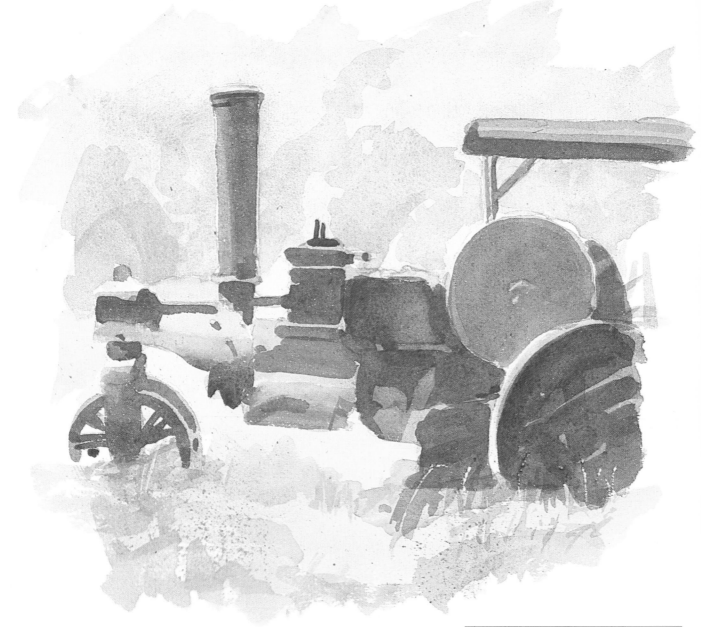

TRACTION ENGINE
13 x 11 in (32 x 27 cm)

The limited palette used in the painting of this traction engine has helped to maintain a color harmony, yet a sufficient variety of colors has been used to enable the subtle differences in browns to be depicted. Wet washes have been allowed to dry with hard edges and have been overlaid to strengthen some areas and build up the forms of the engine.

4. Increase the depth of color in the background and foreground, working clouds and areas of shadow.

textures ranging from that of a sponge, for instance, to the dimpled skin of an orange, to the hard surface of shiny plastic, with only a color theme to supply the link in your composition.

Setting up your group

A simple group will usually make the most suitable arrangement, indeed a single object may require more intense concentration on the part of the artist and yield the greatest satisfaction. It is not necessary to paint objects life size on the picture plane. By varying the scale you can discover a new potential for the still life, providing new identities and making discoveries.

The way in which you set up your still life will have a considerable effect on the finished work and must be well thought out in advance. Look at your group from several angles and consider the possibilities. Once you have set up your group, you may find that by walking round the table and looking from a different position you strike upon a more successful, less formalized arrangement.

1. Lay a complete wash of the lightest blue in the egg box over everything except the eggs. Use a mixture of Cobalt blue, French ultramarine and Light red – when the red and ultramarine are mixed they tend to separate out to a mottled cardboard effect.

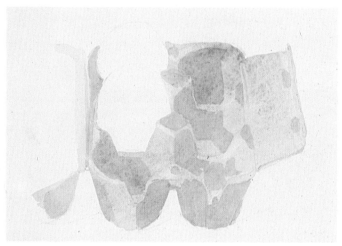

2. The second wash of the same color should be stronger and should make an attempt at putting in some of the darker areas and trying to get the structure of the egg box.

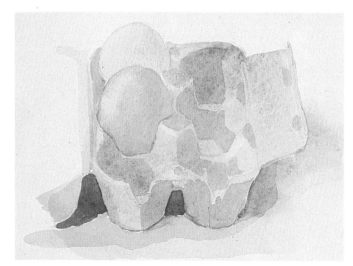

3. Eggs have no edges so should be painted in one smooth movement, without lifting the brush from the paper. For the underwash, use Vermillion, Yellow ocher and Lemon yellow; the second wash should be a stronger mix with less yellow.

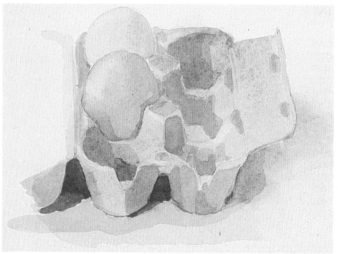

4. Continue to put in darks on the egg box using the same mixture of colors. There are two shadows – artificial light causing a yellow shadow and natural light producing a blue one. Try to differentiate between them without giving them undue importance.

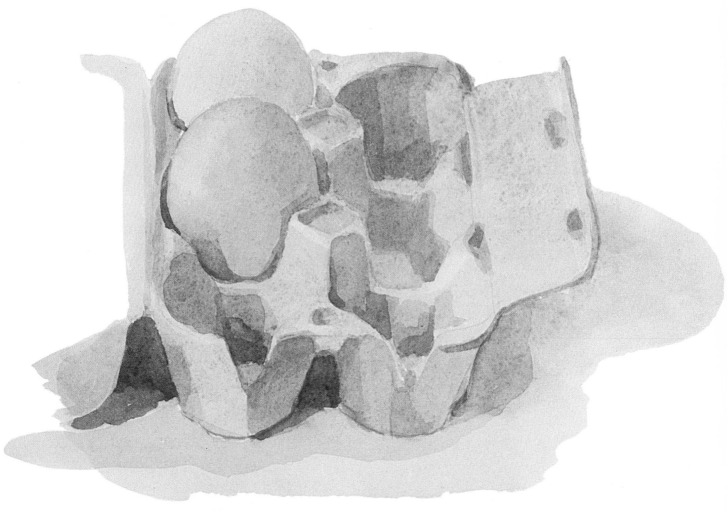

EGG BOX
10 x 8 in (25 x 20 cm)

This subtly toned watercolor of eggs in a box shows how the simplicity and delicacy of the egg forms can be retained while the more sturdy but intricate structure of the egg box is also effectively handled. The shadows cast by the box serve to anchor it firmly on the surface on which it stands, an important factor when a light-colored background is used as it is essential that the object should be given the appearance of stability.

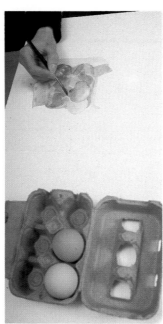

Far left: White makes a good background for a watercolor. It is a clean, unfussy medium and any lavish drapery would be inappropriate. Decide what angle you want to draw from; in this case you should be able to see the interesting shape of the edge of the egg box. With fairly small delicate objects such as this it is better to get close enough so that you can really see what you are doing.
Left: When painting fairly· delicate watercolors it is essential to use a good quality brush which comes to a natural point.

PLANTS AND FLOWERS

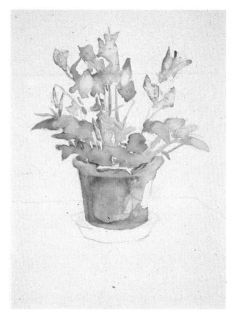

1. Make a careful drawing then start putting in color of flowers. This has to be kept very pure, so use clean water. The negative and positive shapes of the flowers and the intervals between them are the main source of interest.

2. Start to work in the shapes of the leaves. At this stage do not worry too much about keeping inside your pencil lines; work the mid- to light tones, using Emerald green and Payne's gray cut with Terracotta and plenty of water.

3. Lay the first wash over the pot, again using plenty of water and moving colors around on the paper.

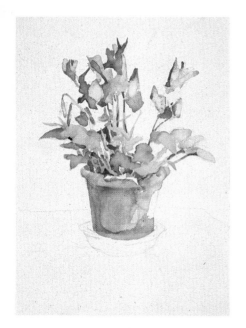

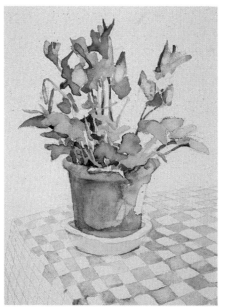

4. Work back a little into the greens, and into the pinks using Cadmium red medium and Bright purple lake. Keep your water clean and make the shapes as interesting as possible.

5. Barely color the dish in which the pot stands. For the cloth, aim for a general sense of perspective rather than perfect regularity; it is helpful to draw a grid; checks become smaller, closer together and lighter as they recede.

CYCLAMEN
12 x 16 in (30 x 40 cm)

This is a complex work demanding an initial organization of shape and space before color and tone can be added. Accurate drawing is all important and it is a good idea to take a second look after a break to check the initial marks you made on the page; if your initial drawing has been correct it will make it easier to relate shapes to each other as these become more complex. In this watercolor, the table cloth was put in as an afterthought, providing added color and interest and altering the character of the work.

Flowers in vases or fruit arranged in bowls or in heaps on a table cloth have the advantage of being a manageable size, readily available and enjoyable in their own right. Problems arise, however, if you have to do your painting in short bursts over a period of time; you will be unable to prevent your group from going rotten or wilting before you have finished.

Paul Cézanne, the great 19th-century painter, worked very slowly and is reputed to have used wax imitations of fruit to overcome this problem; good quality silk flowers can also provide a good alternative to the real thing. Whereas with a group of inanimate objects these problems do not arise and you will be able to leave your setup intact almost indefinitely, when painting perishable goods you will have to think of solutions to the inevitable problems.

Plants in pots tend to be much sturdier than cut flowers, and providing you look after it properly and select a healthy specimen in the first place the same plant will survive several painting sessions. If you particularly want to paint flowers, do not feel compelled to buy a whole bunch; a

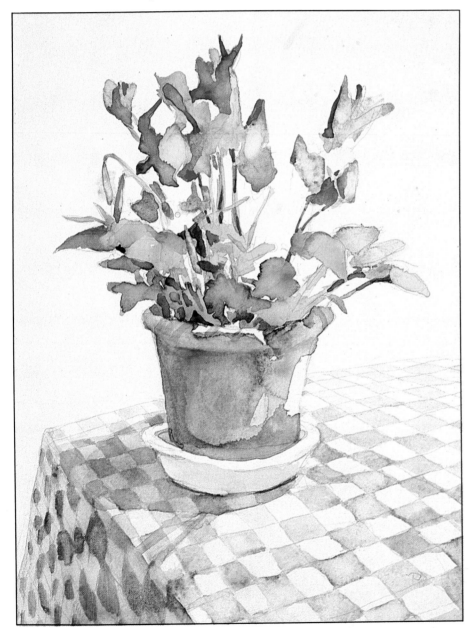

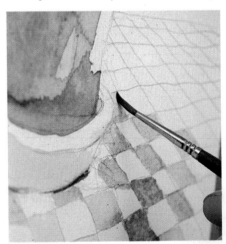

Above: Use a brush with a good point to paint in the color of the table cloth but do not worry unduly about keeping within your pencil lines as a little irregularity will not spoil the finished effect.

Above: When painting the pot, use plenty of water and allow the different colors to bleed into each other until you are happy with the effect. If too much water or paint is added it can be wiped off with a tissue.

1. This watercolor is executed on a toned paper which provides a neutral but complementary ground from which to work the tonal contrasts of the flower. Sometimes paint is applied in a fairly wet wash; at other times fairly solid.

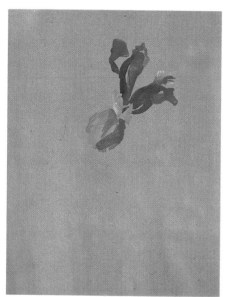

2. Continue to let wet color take the shapes, allowing it to roll into other areas of still-wet paint.

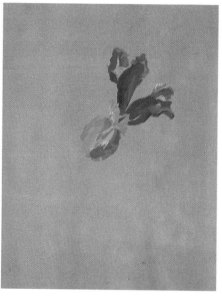

3. Start to pick out details, trying to capture the overlapping and folding nature of the petals. Add the complementary color, yellow, always paying attention to the overall tonal scheme.

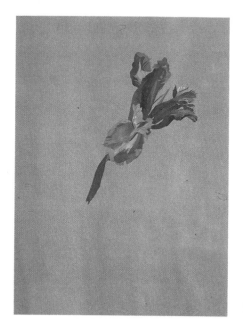

4. Introduce the green of the sepals and stem. Continue to work at bringing out the texture in the flower, flooding areas with water so that wet paint bleeds into dry, or else waiting until washes are dry and using small, definite touches of dry paint to pick out details.

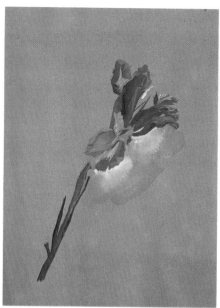

5. Refine the forms, putting in more of the stem and concentrating on highlights. Begin to bring the background up to the edges of the forms, using varying shades of white. Correct shapes and forms as you do this to give them a crisper effect.

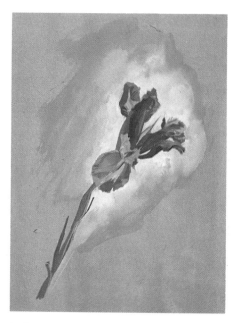

6. Continue to refine shapes, using white to work around the edges of the flower to add definition.

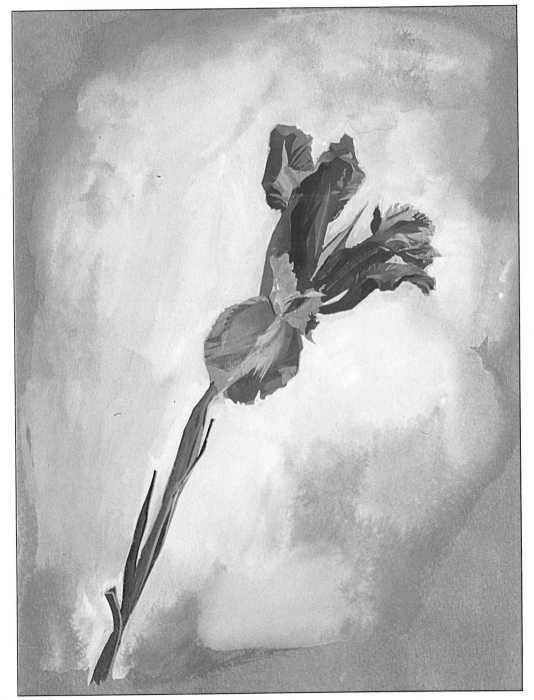

Above: Areas of contrasting color being put in with a small brush, sometimes working fairly dry to define detail and in other areas flooding wet paint over the support. Note the great variety of tones in the white paint, ranging from the thinnest covering of the toned paper to the purer, more dense wash used to throw up the blue of the flower.

IRIS
10 x 10 in (25 x 25 cm)

Although compositionally a simple study, this work requires careful examination and analysis of tone in order to make a successful rendering of the structure of the iris. It is important to establish in your mind the difference between color and tone; an understanding of the subtle gradations of tone will enable you to make the petals come forward or recede. A study of this sort, using tone to describe form, is a good forerunner for more complex subjects.

FOREST AND FERNS, VERMONT
9 x 10 in (22 x 25 cm)

This woodland scene with fern fronds has been handled with a brush loaded with a delicate wash rather than by putting in a great deal of detail with dry paint. The intricate pattern of the ferns has, however, been achieved, created out of negative shapes by allowing the dark background to jut into the yellow of the fronds. The

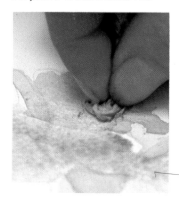

tree trunks give some structural balance to the work, acting as a background to the lattice work of the ferns and providing a solid middle ground for the distant trees and leaves. The color of the trunks is built up with a series of washes, starting with a light Yellow ocher, adding a slightly blue tinge and working through Payne's gray and Indigo to Burnt umber. **Above:** The color is put on with a lot of water and allowed to move around and blend; where necessary, pick up excess color with a piece of tissue or cotton bud.

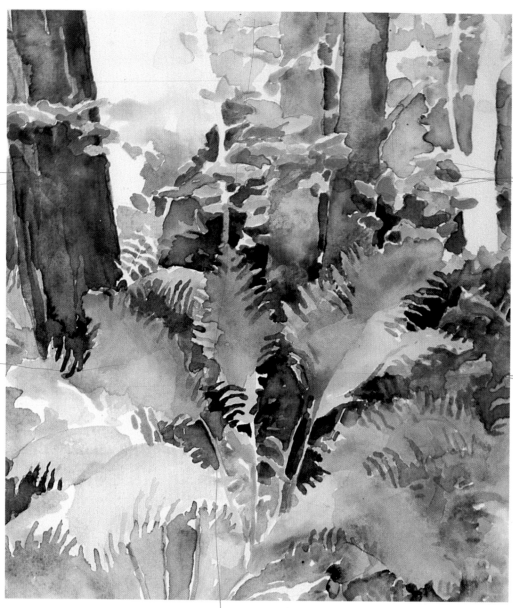

single bloom can make an interesting still life, and if you work in a reasonably cool temperature it will be less likely to wilt before you have finished your painting.

One alternative often overlooked by painters is the possibility of painting a still life out of doors rather than in the studio. This is necessarily much more likely to be an appealing prospect in summer than in colder weather. You may decide to make sketches and color notes rather than to produce a more finished painting, but either way it will certainly be both pleasant and instructive to paint out of doors, in a natural environment.

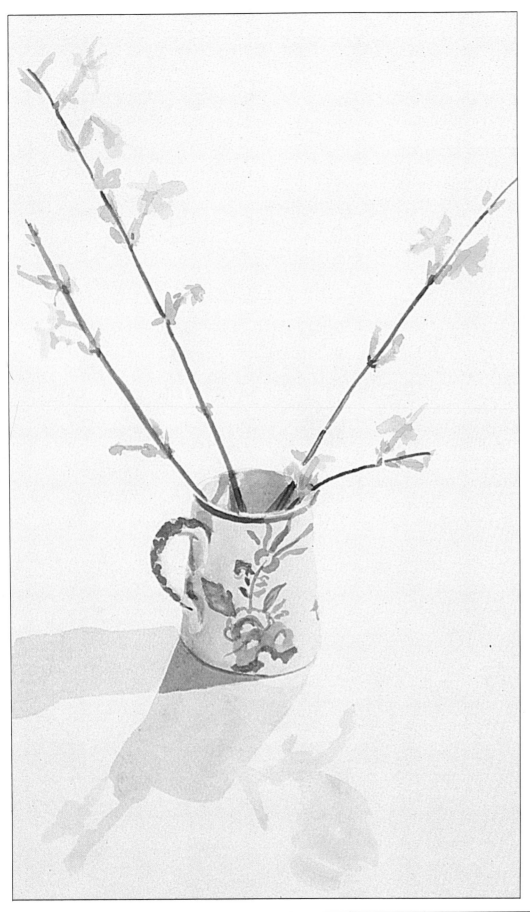

JUG OF FORSYTHIA
12 x 16 in (30 x 40 cm)

Light, delicate still lifes painted on white paper need some sort of firm ground on which to stand otherwise the objects tend to look as though they are floating in mid-air. In this case, two different light sources give two stabilizing shadows. Paint the shadows in one flat wash and leave to dry; one is the same color as the cup, Cobalt blue, and the other is a mixture of Yellow ocher, Light red and Cobalt blue. The delicate handling of the paint serves the subject well. Put in the stems of the winter jasmine in one smooth line, leaving gaps. Use a very transparent, thin clear yellow wash for the jasmine flowers. **Above:** The darker area where the two shadows merge should be carefully defined.

BIRDS AND ANIMALS

This is a challenging and absorbing subject for the still life artist and watercolor is a particularly suitable medium, being easily portable for use in the field. It should not be restricted to the ornithological enthusiast making visual notes of his sightings; watercolor is an invaluable aid to identification or can be used to put in areas of local color or create an atmospheric impression. Used in the studio, watercolor is the ideal medium for making careful copies of natural features such as plants, rocks and shells or birds and animals.

When speed is of the essence, for example when painting moving animals, start your work when the animal is in

OWL STUDY

20 x 30 in (50 x 75 cm)

It can be difficult to study birds from life and photographs present certain inadequacies and distortions. This detailed color study was made from a dead owl which the artist had found, so it was possible to examine the elaborate arrangement of the feathers quite closely. The rich texture and clear colors of gouache enabled the artist to build up a

complex representation of the bird but at the same time he paid careful attention to qualities of the painting itself, achieving a dramatic image with the clear, light shape of the owl against the heavy, dark background. The warm brown and beige tones in the feathers are contrasted with cool tones. The detail of the feathery texture is created by fine lines of opaque paint applied over dried washes and areas of flat color.

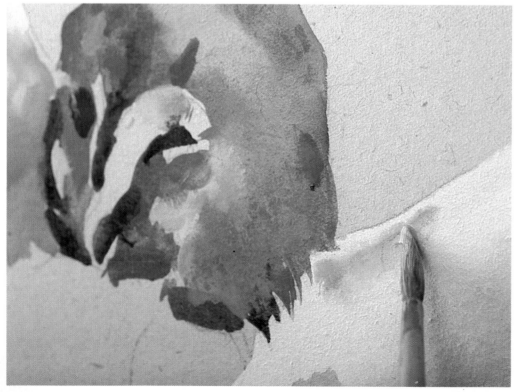

Details of the work in progress show how the basic colors were blocked in with wet washes to describe the overall shape before textural brushwork was applied to delineate the feathers. From a loose pencil sketch of the shape and features of the bird, the rich colors of the head feathers were indicated (**top**) with washes of Yellow ocher and Burnt Sienna heightened by contrast with blue-gray shadows. The painting is on tinted paper, so areas of pure white were also washed in, at first quite thinly (**left**). When a general impression of the overall shape and tonal range of the bird was established, the background color was carefully washed in around the outline of the form (**above**) so that the density of color and tone could be developed coherently from the extremes of light and dark.

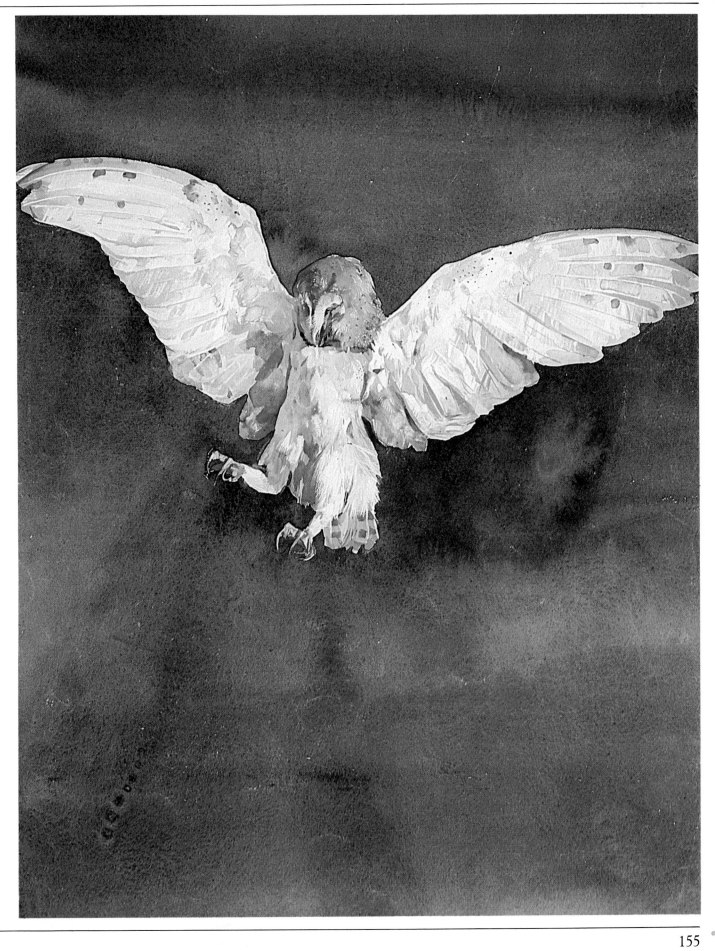

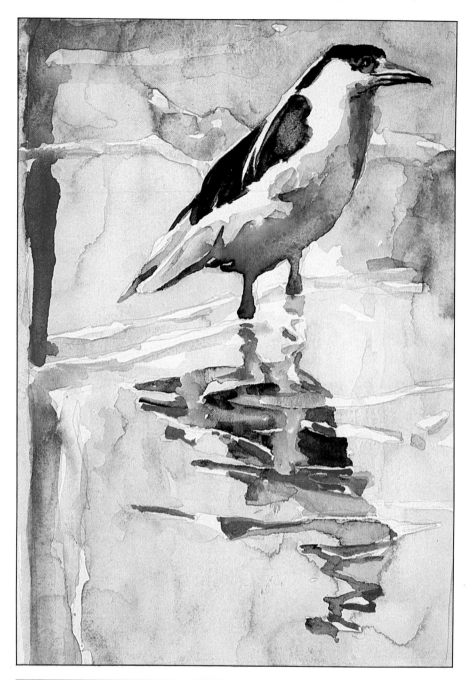

WATER BIRD
7 x 10 in (17 x 25 cm)

When drawing wildlife, it is possible to make quick sketches in the field to note color, movement and poses but quite often easier to work from photographs. In this case, a photograph of a bird wading in the shallows provided a ready-made composition. The reflections do not have to be very exact, but the vertical has to be right below the part that is reflected.

Right: Work carefully around the outline of the bird when laying in the background color.

1. Make a drawing of the bird, paying particular attention to the area where the legs are attached to the body, the general stance of the bird, the size of the head in relation to the rest of the body and the shapes of the markings.

2. Put in the background underpainting, working carefully around the shape of the bird using a combination of Payne's Gray, Cobalt and Indigo. The bottom part of the picture can be left lighter as the bird provides plenty of interest.

3. Start painting the bird, taking care to leave white areas, particularly around the eye, under-feathers, beak and comb. At this stage the beak is curling too much and will have to be straightened out.

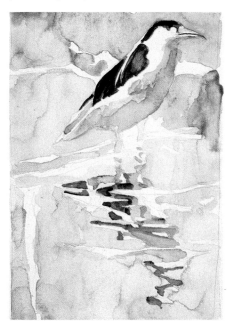

4. Put in darks under the feathers and wings, intensifying the black on the back so it is really dark and rich. The reflection can be as abstract as you like to make it – as long as it is believable.

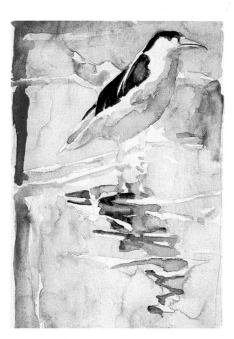

5. Use Cobalt violet and Yellow ocher to work across the direction of the water and provide contrast. The Ultramarine on the left hand side balances the bird and provides another vertical.

6. Fill in some of the reflections so that they are less broken up; aim at a suggestion of multiplicity but not lots and lots of tiny shapes. Leave the eye of the bird until last.

the desired position. Patience will usually be rewarded by the same position being resumed before too much time has elapsed and a surprisingly detailed result can be achieved. Many paintings of natural history subjects using living animals as models have a spirit and vitality reflecting outdoor life.

Other examples are more concerned with capturing the intricacies of the subject. Working from stuffed and mounted specimens has long been an alternative and is a worthwhile practice in its own right, enabling the artist to

explore the complexities of texture and anatomical details. Many museums have excellent collections of prime specimens and allow artists to work from them.

When buying fish or fowl, take the opportunity of making anatomical drawings before cooking; you may sometimes come across small dead birds and animals and these also provide an opportunity for close, detailed work. Intelligent observation and an awareness of basic structure should enable you to make a fairly accurate attempt at painting birds and animals that are anatomically accurate.

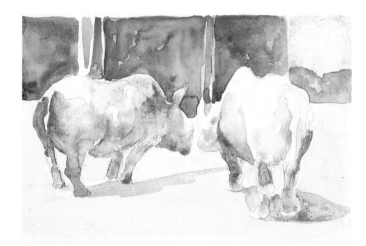

1. Make your drawing, concentrating on the basic shapes of the animals rather than on details. It does not matter if the background color, very light Yellow ocher, goes over the outline because everything else is going to be darker.

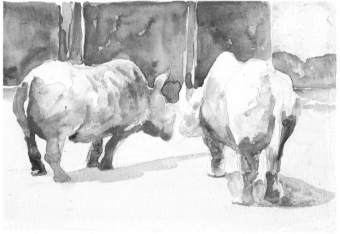

2. The first quick underpainting of the rhinos is essentially experimental. It is difficult to get the color right; try Payne's gray, Yellow ocher, Red oxide and Burnt umber, wiping out with tissues where necessary.

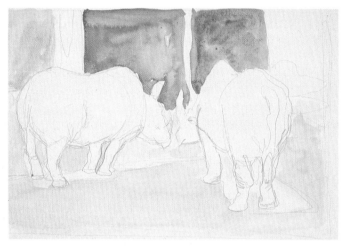

3. Put in shadows; a mixture of Turquoise and Cobalt blue gives a sunny effect. Make the background more definite. Experiment with complementary colors – greens and reds – to find an interesting combination.

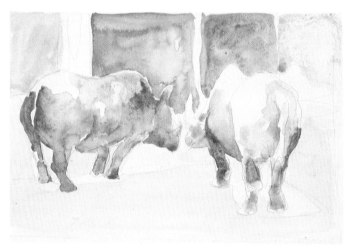

4. Strengthen the architecture of the animal by putting in more darks. Finish off the painting by refining shapes, for instance putting in a reddish brown color beside the rhinos' heads to focus attention there.

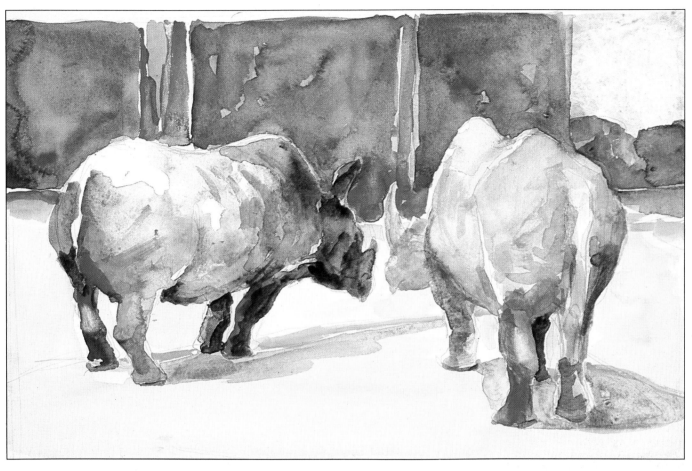

RHINOCEROSES
14 x 9 in (35 x 22 cm)

One of the most difficult aspects of painting animals is getting them to stand still for long enough to enable you to make a drawing. Work quickly, on large sheets of paper, perhaps attempting several drawings at once and waiting, if the animal moves away, until it returns to the desired position. Fortunately, rhinoceroses are slow moving! The background is an important element in this painting and the final effect has been arrived at not by starting out with any preconceived ideas as to how it should look but by experimenting with colors and shapes until an interesting result has been achieved.

Left: Caran d'ache color pencils are water soluble and are useful for putting in small refinements and modifying tone during the later stages.

Above: Build up the color of the rhinos by working areas of paint with plenty of water, allowing the wet paint to mingle and bleed.

THE FINISHED PAINTING

YOU MAY HAVE no more ambitious plans for your finished picture than that it should grace the walls of your own studio or perhaps be given to a friend as a present. But even if you have no intention of submitting it to galleries, any drawing or painting will look much better if it is properly mounted and framed. These jobs can be handed over to a professional, and indeed many small specialist firms will be happy to discuss alternatives with you and give you the benefit of their experience. It is quite possible, however, to do the work yourself, saving money and adding another dimension to the business of making a picture.

Even if much of your work remains unframed and unmounted, try to cultivate good habits in looking after your pictures. It seems a great pity to expend a lot of effort on producing a drawing or painting and then either to lose it under a pile of unsorted papers or to allow it to become damaged by one of the accidents which are almost inevitable when inks, paints, water and other spillable materials are in use. Always take the trouble to put work away carefully in a safe place such as a portfolio or plan chest.

Above: A well chosen frame and mount improves the best of watercolors. In this case the frame, though not elaborate, is gilded and the mount also has gilding on its skilfully cut beveled edges; both mount and frame complement the delicate tones of the picture.

Mounting

When you have finished your watercolor and allowed it to dry thoroughly, your first task is to cut it from the board. This requires caution. The edges of the stretched paper should be cut with a sharp Stanley knife or scalpel, but in doing this the released tension is so great that the paper may tear, thus ruining all your efforts. To avoid this, cut opposite ends of the paper rather than working around the rectangle or square with your knife. Once the watercolor has been removed, trim the edges with your knife, a straight edge and a set square; this will make mounting easier.

If you were lazy about cleaning your drawing board the last time you used it you may find that any remaining pieces of gummed tape have stuck your paper to the board. The only solution is to take a sharp single-edged razor blade and carefully edge the paper off the board; two pairs of hands may be useful for this task. Before mounting and framing, store your finished watercolors, with tissue paper between each one in a portfolio or large drawer. Be certain to keep them clean and dry.

Watercolors are best shown with window mounts – in other words the mounting card is cut to a shape which will 'frame' the painting and placed on top of it rather than left intact as a sheet and used as a base onto which the painting is stuck. Not only does this method overlap the edges of the painting to give a cleaner, more finished effect; it also enables the mount to act as a buffer, protecting the work from the glass.

Light-toned or neutral colors are usually more suitable for mounts; black, white and dark colors tend to dominate and detract from the subtlety and color of your painting. A strong work, however, may be able to stand up to a darker mount and it is a good idea to try your painting against various sheets of colored paper before you decide.

Sometimes a colored line or lines are drawn around the inside edge of the mount, surrounding the painting, pro-

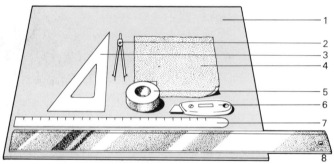

Above: If you plan to mount your paintings yourself it is worth investing in the correct equipment; this will help ensure that you make a good job of finishing off your work.
1. Cutting board
2. Dividers
3. Set square
4. Fine sandpaper
5. Masking tape
6. Craft knife
7. Long steel ruler
8. Long straight edge.

Cutting a window mount
1. Cut the board to size. To mark inside edges of frame, cut a template by measuring width of the borders outward from a hole cut in a piece of card. Place flush with each corner in turn and mark through hole with pin.

2. The 4 pin pricks mark the inside corners of the borders. Cut from one pin prick to another using a stanley knife and metal rule.

3. Check the fit of your picture under the window; double sided tape is helpful in positioning it accurately. Tape securely on the back.

4. This mount has been cut with a bevel edge, at an angle of about 45°. It takes practice to cut a bevel edge successfully.

5. The mounted picture. The border is slightly deeper at the bottom in order to make it appear that the painting is centrally placed.

viding support and emphasizing the horizontal and vertical planes. They can be drawn with a sharp colored pencil or a ruling pen or brush and ruler and should echo some of the color characteristics of the watercolor, providing a visual link between the painting and the mount. A cautious approach is essential; always practice on a spare piece of card, mark your lines out faintly with pencil before you start and use a set square and ruler.

Take care over the positioning of your painting in its mount. If you are uncertain, experiment by moving your work around on a piece of colored card of a similar tone to the mount until you are satisfied with the position and proportion. Mark this position roughly, then work out the cutting edges accurately, making your exploratory markings in pencil on the back of your mounting card. Remember that in order to make the painting look as though it is in the center, more of the mount should be visible at the bottom of the picture than at the top; if this is not done, the picture will appear to be 'sinking' to the bottom of the frame.

Once you are satisfied with the position and markings you are ready to cut the mount using a sharp knife and a steel ruler to guide your blade; if your blade is as sharp as it should be it will cut through a metal or plastic ruler. Always work from the back, cutting through to the front of the mounting card, so that if your knife slips any scratches or scores will not be visible.

Some mounts are cut with a bevel edge but it takes a great deal of practice to do this satisfactorily by hand; mechanical devices are available, or it can be done by a professional framer. Although a bevel edge looks neater and more professional, a well cut straight edge is perfectly satisfactory. Place your painting behind the mount, using small pieces of easily removable tape until the exact positioning has been achieved and it can be secured more permanently.

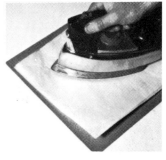

Dry mounting with an iron
1. Cut a sheet of shellac tissue slightly larger all round than the picture you intend to mount and tack it to the centre back of the picture using the point of a fairly cool iron and pressing lightly.

2. Trim off the edges to the exact size of the print, using a steel ruler and scalpel.

3. Position the print and tissue on your mounting card, already cut to size, and lift the corner of the picture to enable you to tack each corner of the tissue to the mount, again using the point of the iron only and a medium heat.

4. Lay a sheet of heat resistant paper over your picture to protect the surface and iron over this protective layer, exerting firm pressure and working from the center outward.

Mounting with rubber gum 1. Use a card or spreader to apply the gum to the mount in smooth upward and downward strokes.

2. Cover the entire card, then apply gum to the back of your picture in the same way.

3. Place tracing paper between the glued surfaces, peeling it back as you apply pressure through another sheet of paper.

4. Use a cow gum rubber to clean off excess glue from the borders of the mount.

FRAMING

Although a professional framer will provide you with advice on mounting and framing, it is considerably cheaper and much more satisfying to frame your work yourself. An increasing variety of framing materials and ready-made frames is available in artists' materials stores and these help to make your task easier. If you feel hesitant about mitering, the shop where you bought the framing will often be willing to do this for you if you present them with a ready-prepared list of measurements. When measuring, check and double check several times until you are satisfied that they are absolutely accurate.

Two types of glass are available; picture glass, which is simply a lightweight glass, and non-reflective (polarized) glass. Non-reflective glass, as its name suggests, prevents glare and reflection but some artists consider that it has an unpleasantly rough surface and makes close examination of the work difficult. Perspex can also be used. Although it is light and unbreakable, it is extremely susceptible to scratching, can discolor over a period of time and is also expensive. Once your painting is glazed and framed, use hardboard as a backing. Plywood can warp and is not sufficiently stable, while cardboard is certainly too soft.

Give some thought to the type of molding you choose; many different types, sizes and colors are available. Fashions change, and the heavy rich moldings of Victorian times have largely been superseded by simpler designs. Similarly, gilding is no longer indispensable, many frames now being finished in natural wood or covered with canvas or hessian.

Left: As with mounting, the correct tools for the job will help to ensure successful framing.
1. Clamp
2. Tenon saw
3. Metal ruler
4. Hand drill
5. Square
6. Pincers
7. Stanley knife
8. Punch
9. Claw hammer
10. Miter saw guide.
Below: Moldings are available in a wide variety of styles.
1. Box
2. Reverse
3. Flat
4. Half round or hockey stick
5. Raised bead and flat
6. Box
7. Spoon
8. Composite.

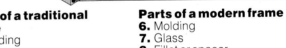

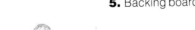

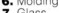

Above: Parts of a molding:
1. Outside molding edge
2. Molding profile
3. Total molding height
4. Total molding width
5. Rabbet
6. Molding inside edge
7. Lip of rabbet
8. Fluting
9. Beading
10. Ridge
11. Molding face

Parts of a traditional frame
1. Molding
2. Glass
3. Mount
4. Picture attached to conservation board
5. Backing board

Parts of a modern frame
6. Molding
7. Glass
8. Fillet or spacer
9. Picture attached to conservation board
10. Backing board.

Cutting a miter 1. Secure a length of molding in the miter clamp, protecting it with small pieces of spare wood.

2. Measure the length of molding you need from the inside edge of the mitered rebate.

3. Mark the next cut; this mark must be visible when you are cutting, so transfer it to the top side of the molding. It is most important to work accurately; always use a set square to fix the angle at 45°

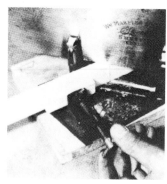

4. Move the molding slightly in the miter clamp so that you can cut exactly where you have made your mark. Repeat the process of marking and cutting for the other three sides of the molding.

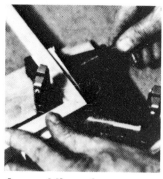

Assembling a frame
1. Assemble an 'L' shape in the miter clamp by putting together one long and one short side of the frame. Tighten the clamp securely and check the fit.

2. Release the clamp and remove one of the pieces of wood; spread glue evenly over the mitered faces of the piece of frame.

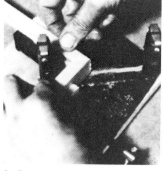

3. Replace the glued piece of wood in the clamp, pushing it firmly against the other piece. Tighten the clamp securely again and wipe away excess glue that has been squeezed out before it dries.

4. Moldings tend to split when panel pins are driven straight in; in order to prevent this, drill shallow holes before you endeavor to insert the pin.

5. Insert the panel pins at a slight angle toward the outside of the molding; this also helps to prevent splitting, and it makes the joint stronger. Your joint should now be firmly secured.

6. Repeat this process with the other two sides of the frame, then bring the two 'L' shapes together and glue them firmly.

An alternative method of securing a miter 1. Make two horizontal cuts and force some glue into them. Insert small pieces of veneer into the cuts and wipe off surplus glue before leaving to set securely.

2. Cut away the excess veneer, then sand with fine sandpaper until the pieces of veneer are absolutely flush with the molding.

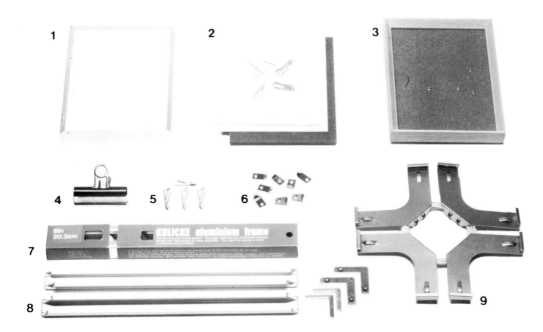

Left: Ready made framing kits include: **1.** Emo interchangeable metal frame **2.** Emo framer's pack **3.** Ready made frame **4, 5** and **6** Bulldog, spring and mirror clips **7** and **8** Kulicke and Daler metal frame kits **9.** Hang-it frame kit. **Below:** The way in which you mount your picture can make an enormous difference to the final effect. Too small a mount (**left**) can make a picture look rather cramped. Beveled edges (**center**) give your mount a much more professional finish but they are difficult to cut accurately without a great deal of practice and are not essential. When drawing lines around your mount (**right**) choose a color which sets off your picture to best advantage.

EXHIBITING

Many artists are content with 'exhibiting' the results of their efforts and commitment on their own walls. In many cases, however, their work would be worthy of a wider audience and suitable for submission to exhibitions, whether public or restricted. The mystique which surrounds the world of exhibitions is enough to put most artists off, but even at the national level it is not only the professional or highly experienced artist who will succeed in having his picture hung and even purchased. At a local level, certainly, art societies, libraries and neighbourhood galleries are always open to the submission of work. Lists of future exhibitions are published regularly, showing submission fees, venues and size restrictions.

Right above: There are several ways in which you can present work to potential exhibitors. Transparencies are particularly convenient, and black card window mounts look effective as long as you are not planning to send them through the post, in which case greater protection is essential (**see opposite**). A portfolio with a ring binder system will protect your pictures; pages from your sketchbook can also be included, and work that has been mounted. **Right:** If you are lucky enough to have your pictures hung in an exhibition you may have no choice as to the way in which the gallery is arranged and the facilities for lighting they have at their disposal. A tremendous variety of lighting is available, one of the most popular systems being the ceiling spotlights shown here. The background against which your work is hung and the method by which it is suspended are other matters over which you may have no control. Try to ensure that your pictures are hung on a white or neutral-colored wall in such a way that the method of support is as inconspicuous as possible.

PHOTOGRAPHIC RECORDS

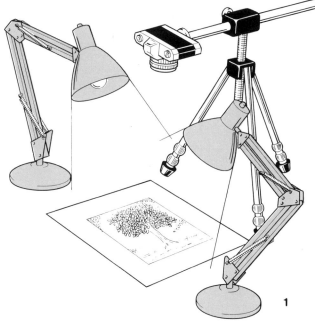

It is useful to keep a comprehensive photographic record of all your work and slides are probably the most convenient method. The quality of your photographs is important and it is best to mount your camera on a tripod so that it is steady throughout the exposure; a pair of angelpoise lamps should provide sufficient light (**1**). Slides should be viewed through a proper projector (**2**) or with the aid of a light box and eye glass (**3**); if you plan to submit your work to galleries and exhibitions, the administrators will have such aids at their disposal. Mount your slides carefully using plastic slide mounts with glass windows (**4**); this type of mount provides by far the best protection for your slide. Make sure the slide is dust free before clipping the sides of the mount together as any specks will show up badly when the slide is projected. Label each slide clearly (**5**) and record the details in a card index so that you always have a record of your work. If sending slides to a gallery, make sure they are clearly marked with your name, the title of the picture and date painted, as well as its dimensions and the medium used.

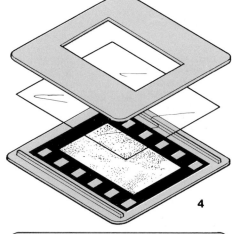

GLOSSARY

Alla prima A direct method of painting in which an image is developed in wet pigment without reliance on preliminary drawing or underpainting.

Aquarelle A painting executed in transparent washes of watercolor or a drawing colored with thin washes of paint.

Aqueous A term which refers to a pigment or medium soluble, or capable of being suspended, in water.

Binder A medium which can be mixed with powder pigment to maintain the color in a form suitable for painting or drawing. For example, gum is the binder used for making both watercolor paint and pastel sticks. Oil binders produce materials with different properties.

Blocking in The technique of roughly laying out the forms and overall composition of a painting or drawing in terms of mass and tone or color.

Body color Paint, such as gouache, which has opacity and therefore covering power. In watercolor this can be achieved by adding white to eliminate transparency. Body color may be used to add highlights or color.

Broken color This is an effect achieved by using colors in a pure state, without blending or mixing them, and dragging paint of a stiff quality across the support so that previous layers can be seen through the new application.

Calligraphic A term referring to a linear style of painting or drawing characterized by flowing, rhythmic marks.

Charcoal A drawing material made by reducing wood, through burning, to charred, black sticks. All charcoal tends to powder but sticks are available in different thicknesses so the qualities in a charcoal drawing can be varied.

Chiaroscuro This term literally means 'light-dark' and originally was used in reference to oil paintings with dramatic tonal contrasts. It is now more generally applied to work in which there is a skilfully managed interplay of highlight and shadow.

Collage This word derives from the French verb *coller* which means 'to stick'. Collage is a technique of creating an image or composition by glueing down scraps of paper, fabric and other materials. It is often used in conjunction with painting and drawing techniques to extend the range of color or texture in the work.

Complementary colors There are three basic pairs of complementary colors, each consisting of one primary and one secondary color. These are opposite colors in that the primary is not used in mixing the secondary, thus blue and orange (red mixed with yellow) are complementary colors. On an extended color sphere, a warm red-orange is opposite green-blue.

Composition The arrangement of various elements in a painting or drawing, for example, mass, color, tone, contour etc.

Cross hatching A technique of laying an area of tone by building up a mass of criss-cross strokes rather than with a method of solid shading.

Dry brush A means of applying watercolor with a soft, feathery effect by working lightly over the surface with a brush merely dampened with color. The hairs may be spread between finger and thumb.

Earth colors A range of pigments derived from inert metal oxides, for example, ochers, siennas and umbers.

Ferrule The metal section of a paintbrush which holds hairs.

Figurative This term is used in referring to paintings and drawings in which there is a representational approach to a particular subject, as distinct from abstract art.

Foreshortening The effect of perspective in a single object or figure, in which a form appears considerably altered from its normal proportions as it recedes from the artist's viewpoint.

Fresco A technique of painting in which color is applied to a ground of fresh plaster. As the plaster dries the paint is fixed in the surface through a chemical change occurring. True fresco was one of the main art forms in Italy from the thirteenth to the sixteenth centuries, used extensively for the decoration of walls in church interiors. There are few modern examples.

Fugitive color Certain pigments are inherently impermanent or the color may fade due to the action of natural elements, especially sunlight. A paint or dye which is short-lived in its original intensity is known as fugitive.

Gouche A water-based paint made opaque by mixing white with the pigments. Gouache can be used, like watercolor, to lay thin washes of paint but because of its opacity it is possible to work light colors over dark and apply the paint thickly.

Grain The texture of a support for painting or drawing. Paper may have a fine or coarse grain depending upon the methods used in its manufacture. Some heavy watercolor papers have a pronounced grain which can be exploited to achieve effects of highlights and broken color in painting.

Graphite A form of carbon which is compressed with fine clay to form the substance commonly known as 'lead' in pencils. The proportions of clay and graphite in the mixture determine the quality of the pencil, whether it is hard or soft and the density of line produced. Thick sticks of graphite are available without a wooden pencil casing.

Ground The surface preparation of a support on which a painting or drawing is executed. A tinted ground may be laid on white paper to tone down its brilliance.

Gum arabic A water soluble gum made from the sap of acacia trees. It is used as the binder for watercolor, gouache and soft pastels.

Half tones A range of tones or colors which an artist can identify between extremes of light and dark.

Hatching A technique of creating areas of tone with fine, parallel strokes following one direction.

Hue This term is used for a pure color found on a scale ranging through the spectrum, that is red, orange, yellow, green, blue, indigo and violet.

Impasto A technique of applying paint thickly so that a heavy texture is discernible, created by brush or knife marks. Gouache, having more body than watercolor, is suitable for this technique and impasto is commonly used in oil painting.

Local color The inherent color of an object or surface, that is its intrinsic hue unmodified by light, atmospheric conditions or colors surrounding it. For example, a red dress, a gray wall.

Masking A technique of retaining the color of the ground in parts of a painting by protecting it with tape or masking fluid while colors are applied over and around the masked areas. The mask is peeled or rubbed away when the painting is dry. This practice gives the artist freedom to work over the whole surface without losing shapes or areas of highlight.

Medium This term is used in two distinct contexts in art. It may refer to the actual material with which a painting or drawing is executed, for example, gouache, watercolor or pencil. It also refers to liquids used to extend or alter the viscosity of paint, such as gum or oil.

Modeling In painting and drawing modeling is the employment of tone or color to achieve an impression of three-dimensional form by depicting areas of light and shade on an object or figure.

Monochrome A term describing a painting or drawing executed in black, white and gray only or with one color mixed with white and black.

Not A finish in high quality watercolor papers which falls between the smooth surface of hot pressed and the heavy texture of rough paper.

Ochers Earth colors derived from oxide of iron in a range from yellow to orange-red.

Opacity The quality of paint which covers or obscures a support or previous layers of applied color.

Palette The tray or dish on which an artist lays out paint for thinning and mixing. This may be of wood, metal, china, plastic or paper. By extension the term also refers to the range of colors used in making a particular image or a color scheme characteristic of work by one artist.

Pastel A drawing medium made by binding powder pigment with a little gum and rolling the mixture into stick form. Pastels make marks of powdery, opaque color. Color mixtures are achieved by overlaying layers of pastel strokes or by gently blending colors with a brush or the fingers. Oil pastels have a waxy quality and less tendency to crumble but the effects are not so subtle.

Perspective Systems of representation in drawing and painting which create an impression of depth, solidity and spatial recession on a flat surface. Linear perspective is based on a principle that receding parallel lines appear to converge at a point on the horizon line. Aerial perspective represents the grading of tones and colors to suggest distance which may be observed as natural modifications caused by atmospheric effects.

Picture plane The vertical surface area of a painting or drawing on which the artist plots the composition and arranges pictorial elements which may suggest an illusion of three-dimensional reality and a recession in space.

Pigment A substance which provides color and may be mixed with a binder to produce paint or a drawing material. Pigments are generally described as organic (earth colors) or inorganic (mineral and chemical pigments).

Primary colors In painting the primary colors are red, blue and yellow. They cannot be formed by mixtures of any other colors, but in theory can be used in varying proportions to create all other hues. This is not necessarily true in practice as paint pigments used commercially are unlikely to be sufficiently pure.

Resist This is a method of combining drawing and watercolor painting. A wash of water-based paint laid over marks drawn with wax crayon or oil pastel cannot settle in the drawing and the marks remain visible in their original color while areas of bare paper accept the wash.

Sable The hair of this small, weasel-like animal is used in making soft brushes of fine quality which are usually favored by watercolor artists.

Scumbling A painting technique in which opaque paint is dragged or lightly scrubbed across a surface to form an area of broken color which modifies the tones underneath.

Secondary colors These are the three colors formed by mixing pairs of primary colors; orange (red and yellow), green (yellow and blue) and purple (red and blue).

Spattering A method of spreading paint with a loose, mottled texture by drawing the thumb across the bristles of a stiff brush loaded with wet paint so the color is flicked onto the surface of the painting.

Stippling The technique of applying color or tone as a mass of small dots, made with the point of a drawing instrument or fine brush.

Study A drawing or painting, often made as preparation for a larger work, which is intended to record particular aspects of a subject.

Support The term applied to the material which provides the surface on which a painting or drawing is executed, for example, canvas, board or paper.

Tone In painting and drawing, tone is the measure of light and dark as on a scale of gradations between black and white. Every color has an inherent tone, for example, yellow is light while Prussian blue is dark, but a colored object or surface is also modified by the light falling upon it and an assessment of the variation in tonal values may be crucial to the artist's ability to indicate the three-dimensional form of an object.

Tooth A degree of texture or coarseness in a surface which allows a painting or drawing material to adhere to the support.

Transparency A quality of paint which means that it stains or modifies the color of the surface on which it is laid, rather than obliterating it. Watercolor is a transparent medium and color mixtures gain intensity through successive layers of thinly washed paint. When an opaque paint like gouache is laid in this way the colors tend to be devalued or hidden.

Underpainting A technique of painting in which the basic forms and tonal values of the composition are laid in roughly before details and local color are elaborated. This was originally an oil painting technique where an image executed in monochrome was colored with thin glazes but the term has come to have a more general application.

Value The character of a color as assessed on a tonal scale from dark to light.

Wash An application of paint or ink considerably diluted with water to make the color spread quickly and thinly. Transparency is the vital quality of watercolor and ink washes whereas gouache washes are semi-transparent.

Watercolor Paint consisting of pigment bound in gum arabic, requiring only water as the medium or diluent. Transparency is the characteristic of watercolor as compared with other types of paint and the traditional technique is to lay in light tones first and build gradually to dark areas

Watermark The symbol or name of the manufacturer incorporated in sheets of high quality watercolor paper. The watermark is visible when the paper is held up to the light.

Wet into wet The application of fresh paint to a surface which is still wet, which allows a subtle blending and fusion of colors. Watercolor artists often prefer to lay washes wet over dry so that a series of overlapping shapes creates the impression of a structured form.

INDEX

CREDITS

p 7 Norfolk Museums Service (Norwich Museum); **p 8** Holbein Stadelsches Kunstinstitut, Frankfurt; **p 10** Albertina Gallery, Vienna; **p 11** Albertina Gallery, Vienna; **p 12** By courtesy of the Trustees of the British Museum; **p 13** Victoria and Albert Museum, Crown Copyright; **p 14** British Museum; **p 15** Victoria and Albert Museum, Crown Copyright; **p 16** Victoria and Albert Museum; **p 17** Victoria and Albert Museum; **p 18** Victoria and Albert Museum, Crown copyright; **p 19** Norfolk Museums Service (Norwich Castle Museum); **p 21** Top left T. Dalley, artist's collection, Bottom Marc Winer; **p 57** British Museum; **p 75** Ralph Steadman for *Weekend Magazine*; **pp 84-5, 86-7, 90-1, 96-7, 104-5, 122, 127, 128-9, 138-9, 142, 148-9, 152, 156-7, 158-9** Marc Winer; **pp 88, 93, 95** John Newberry; **pp 65, 92, 100, 102-3** Moira Clinch; **pp 141, 144-5, 146-7, 153** Charles Inge; **p 160** Alastair Campbell, private collection;

QED **pp 24-5, 30-1, 34-5, 162-3, 164-5, 166-7**

Other watercolors and demonstrations by Stan Smith and Kate Gwynn